A Simple Guide
to
Digital Photography

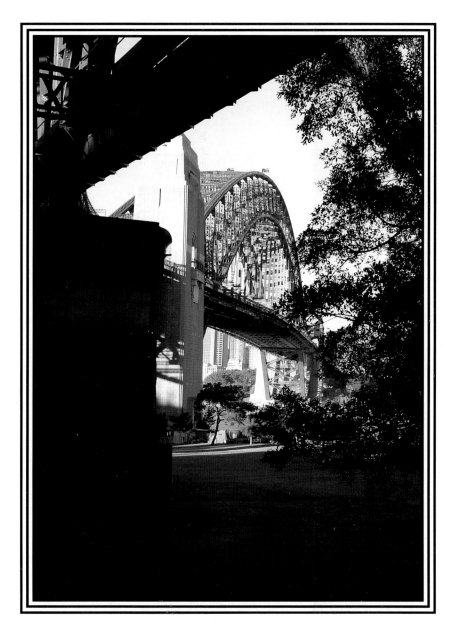

Bill Corbett

First published in the United States in 2002 by Amphoto Books,
an imprint of Watson-Guptill Publications,
a division of BPI Business Media, Inc.,
770 Broadway, New York, New York 10003
www.watsonguptill.com

First published in Australia in 2001 by 4cProjects Ltd
154 Upper Washington Drive, Bonnet Bay, NSW 2226

Library of Congress Control Number: 2001094988

ISBN 0-8174-5890-5

Pre-press Production: APP Printing Pte Ltd (Singapore)
Manufactured in: Singapore.

Author: Bill Corbett
Photography: Bill Corbett (unless otherwise credited)
Editor: Mark Swadling
Design: Mark Swadling, Bill Corbett

1 2 3 4 5 6 / 07 06 05 04 03 02

PREVIOUS PAGE: Sydney Harbour Bridge
THIS PAGE: Sydney Opera House

Contents

Dylan

Introduction

Not so long ago I wrote and published a book entitled '*A Simple Guide to 35mm Photography*'.

I wrote this book because I had a long-held belief that most books attempting to explain photography to the public were too complicated for the average person.

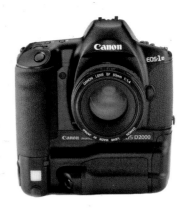

Canon Digital 35mm SLR camera (Canon Australia Pty Ltd)

I promised in this book to keep things simple and easy to understand.

This was reasonably difficult, as photography involves several sciences such as physics, chemistry and optics, and putting all the necessary information together in an easy to understand format was quite a challenge.

However, judging from the reaction of booksellers, retail camera shops, photographic manufacturers, and most importantly the public, it appears that I succeeded in my endeavors to make photography more easily understood by the people kind enough to have purchased a copy of the book.

Now I have been asked to perform a similar task in the field of digital photography - fast becoming a major player in the photographic world.

It's no wonder! Lets face it,-what could be more convenient that taking a photograph and either downloading it to your computer to view or displaying it on your television screen?

No waiting until the film's finished to see the results of your photographic labors. No sending the film to the local lab and hoping the operator had a good night's rest and that your prints don't come out with a green/red/blue cast.

If your digital results are out of kilter somewhat there is a whole array of image manipulation programs on the market that allow you to correct faults and further enhance your photos, all in the convenience of your own home - photographic heaven. What joy!

Using your computer you can e-mail the image to family and friends, or print a hard copy using one of the new generation of digital printers that are in the market place.

Photoshop® image editing software

Even if you don't own a computer you can take the camera's memory card to your local photo lab and have them print out your pictures for you in the same way as if you had used film.

Digital color printer

No more film!

Think of the savings in film cost! Once you expose a film that's the end of the story. If you want to take more photographs you must buy a new film.

Not so with digital. You simply transfer the current images on the camera's memory card to a computer or other storage device, erase them from the card, and pop the card back in the camera ready for your next batch of images.

So digital photography promises convenience, ease of use, and cost savings.

The question is, are these promises fulfilled? More importantly, is the quality produced from a digital camera as good, better, or worse than photographs produced by traditional film cameras?

This book examines these questions in some detail. It does it in a simple, easy-to-understand manner that I trust will be understood by people everywhere. I also trust you find the book enjoyable.

There is nothing worse than wading through a book to teach yourself a skill, only to find that it is written in such a ponderous and complicated manner that you get tired and confused after only two or three pages. I have tried to avoid that here. I hope that I have succeeded.

I have said that I intend to keep this book simple and easy to understand, but, I hear you cry, how can you do that when this book has to cover both photography *and* computers?

Photography is complicated enough but computers are another matter. First computers come in so many variations that it impossible to keep up with them, and they seem to change every day.

Second the computer industry seems to be staffed with people who speak a totally different language from the rest of us. I call it computer speak

Less kind people call it technobabble. I know that each new industry that emerges develops its own language and acronyms, but why do they presume that the rest of us understand what they are bleating on about?

They write books like Understanding your Computer or some such promising title. When you read these books you find that you generally get totally lost in the introductory chapter.

In this book I am keeping the computer speak to a bare minimum and at the end of the book you will find a glossary of terms (photographic and computer) that will translate many of the terms you may find out there in the digital and photographic world into understandable English.

I also look at the question of digital photography in what I hope is a logical manner.

The first thing I discuss in this book is 'What is digital photography?' It seems logical that if you are going to discuss a subject in some detail then you had better define what it is you are going to talk about.

I will also look at the claimed advantages and dis-advantages of digital photography.

From there we delve into the specifics such as photographic equipment, accessories, computer equipment, storage, printing your work, scanning and much more.

After we finish covering the equipment we then will look at the photographic side of the equation and cover such subjects as exposure, light, composition, and perspective.

Each chapter will refer back to the claimed advantages and disadvantages of digital photography so that you can get a good feel for the subject yourself.

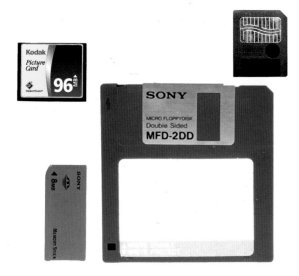

Various image recording media for digital cameras

Adam: "This doesn't taste very nice, mum"

A typical home computer setup

Hopefully, by the end of this book, you will have a good idea if digital is the way for you to go or if you are better served sticking with the traditional film camera for the moment.

Whichever way you decide, please remember that photography, for the vast majority of people, is simply a tool to record the many varied, and hopefully happy, elements of their lives.

Therefore any book such as this is simply designed to make the recording of your life easier, giving you better results and more enjoyment. I trust that this book will assist you in this regard.

One final note for this chapter.

Sometimes the most memorable pictures that you take do not come out exactly as you would have wished.

One of the features of digital cameras, as discussed later, is their ability to instantly discard an image with which you're not happy. A word of warning here. Sometimes the first look at an image is disappointing. On reflection later you may find that you wished you had kept the image and not, so quickly erased it.

An example:

At about age 20 months my third son, Adam, was given his first taste of an orange. To say that the taste did not please him is an understatement! The look on his face made me grab my camera and shoot off the shot you see on page 7.

In terms of lighting it is not too bad since there was no flash employed. But, as you can see, my focusing was out a tad. I (naturally) blame this on the haste of the shot! A very poor excuse, I'm afraid.

Regardless of focus imperfections the shot remains one of my all time favorites as it captured a moment in time that can never be repeated - which is what photography is all about.

So don't discard that not-so-perfect shot too quickly. You may find that, over the years, it's imperfections are far outweighed by the memories it evokes.

I trust that this book will help unravel the mysteries of digital photography for you and assists in adding to your enjoyment of photography over the years ahead.

Bill Corbett

What Is Digital Photography?

Pantheon Interior, Paris

Before we delve into the subject of what digital photography is in any depth, we should examine what are claimed to be the advantages and disadvantages of this relatively new development.

Some of the advantages of digital photography:

• The most obvious advantage is that digital photography is immediate. You can take the photograph and see the result almost instantly. No waiting for film and print to be developed.

• You also have almost immediate control over the quality of the image. With an image-editing program you can, if necessary, alter your final image in a multitude of ways that hopefully will improve the final result. This can also be done with conventional film photography, but it involves time delays and extra expense with film development and scanning or, alternatively, darkroom manipulation if you are into developing and printing your own work.

• Film and development are not required, which can be a considerable cost saving over the years, especially to the avid photographer. In fact, if you work it out, the savings in film and development costs can reasonably quickly cover the cost of the new equipment.

• No waste—with film photography if you take a bad shot you have wasted both the film and the developing and printing costs. With digital photography this is not the case. You simply delete the unwanted image from the camera's memory and shoot again (please, however, remember my comments on this subject in the introduction).

• With a digital camera the exposure latitude of the imaging sensor is greater than that of conventional film. Therefore you get a better rendering of detail in both the highlights and shadows. This is discussed in greater detail in Chapter 8, "The Correct Exposure."

Some of the disadvantages of digital photography:

• Print quality: With the lower-priced digital cameras the amount of information stored in the image file is quite small. When it comes time to make a hard copy print you will be pushed to get a reasonable-quality print over about 3 X 2 inches. This is not the case, however, with the better-featured digital cameras (which, of course, cost more), which can produce quite large hard copy prints of excellent quality.

• You may need to do some work with an image-editing program to bring your images up to a satisfactory standard. This is more the case with the budget-priced cameras rather than the better-featured models. Items such as focus, color balance, and contrast may need a bit of tweaking.

• Time delay: With digital cameras there can be a time delay from when you take the shot until the camera's processor stores it. During this short time you will be unable to take another photograph. Some digital cameras do, however, have a burst facility that will allow you to take a number of sequential shots. Also this time delay is reducing as better-featured models come onto the market.

• With digital photography the equipment required is different from conventional film photography. Ideally, as well as the digital camera you will need a computer and a reasonable-quality digital printer. In addition, you would want to have some image-editing software (although with many digital cameras an entry-level image-editing software package is included) and some extra portable storage of some kind.

• New skills: Although digital photography is in many ways similar to conventional photography, there are a number of new skills that need to be learned mainly in the area of computing and image editing. The up side is that this can be fun and will certainly help improve your image taking abilities.

Digital photography is not that different to conventional film photography.

Where the difference lies is how the image is recorded. With conventional film photography you trip the camera's shutter and light, reflected from your subject, passes through the camera lens and exposes the film. This is called a latent image.

The film is then processed and prints, or slides, are produced, depending on the type of film involved.

A negative image on film (LEFT) and a slide (RIGHT)

With a digital camera there is no film, although the other aspects of capturing an image remain the same (shutter speed, aperture, and so on).

Instead, with a digital camera, the light coming through the lens is captured on an imaging array of sensors that are, in reality, simply light-sensitive computer chips.

These computer chips, when struck by light, emit an electrical current. Low light means a low current, strong light means a strong current.

The camera's processor analyzes and converts this electrical charge into a digital format (pixels) that is stored in the camera's memory for later retrieval.

Currently there are two types of computer chips that can be found in digital cameras.

The first variant is called a CCD chip. CCD is computer speak for Charge-Coupled Device.

The second type of light-sensitive computer chip is called a CMOS chip. computer speak for Complementary Metal-Oxide Semiconductor, which is quite a mouthful (you think they could have called it something simple like Fred!).

Having got that out of the way the only thing you really need to remember is that currently there are two types of light-sensitive chips in digital cameras, one called a CCD and the other CMOS.

But, while we are on the subject of the image recording chips, which is the better, CCD or CMOS?

At the current time the vast majority of digital cameras employ the CCD technology.

The arguments in favor of the CCD chip are:
• The CCD chip is more sensitive than CMOS chip. This means that a camera using CCD technology is better able to record detail in low light situations.
• The CCD chip produces a cleaner image than the CMOS variant. The CMOS chip can sometimes have a problem with what's called computer noise. Computer noise can make an image appear less crisp than it should. This becomes more evident as you try to enlarge the image.

The arguments against the CCD chip are:
• It is more expensive than the CMOS chip, which, of course, translates to a more expensive camera.
• It is more power hungry than the CMOS chip.

• It can sometimes suffer from a condition called "blooming" that creates an unwanted halo around any particular bright highlight in your shot. This can normally be corrected with an image-editing program.

The arguments in favor of the CMOS chip are:
• It is cheaper to produce than the CCD chip, resulting in cameras that employ the CMOS technology being cheaper than their CCD counterparts.
• It uses less power than the CCD chip so you can shoot for a longer period of time without having to replace, or recharge, your batteries.
• It does not suffer from "blooming," as can the CCD chip.

The arguments against the CMOS chip are:
• Poorer performance in low light situations compared to the CCD chip.
• Possible introduction of "noise" into the image.

So which type of chip is best? Up until now the likes of Canon, Nikon, and Fuji have employed CCD chips in their cameras. Having said that, Canon just announced a new digital SLR camera that uses a CMOS chip.

Canon has done a lot of work on the CMOS chip and believes that it has overcome the problems discussed earlier.

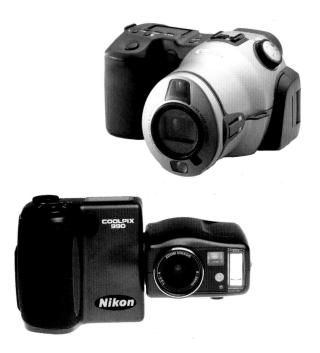

Canon (TOP) and Nikon (BOTTOM) digital cameras

Given Canon's enviable reputation in the photographic world one would have to take them at their word.

Another factor is the size of the chip. The bigger the chip, the better the response in low light situations.

A new variant, called Super CCD, is about to appear. Developed by Fujifilm, this new chip supposedly offers superior performance to the current CCD chips. Utilizing an octagonal honeycomb layout this new chip promises up to 2.3 times the image quality of the conventional CCD chip.

What it will cost, and how this will affect the price of the camera is unknown at this point in time, but I expect we will see it sooner rather than later.

How a digital camera perceives color

The perception of color by the human eye is very similar to how a digital camera perceives and records color.

Light can be broken down into three primary colors: red, green, and blue. By combining these three colors in varying intensities all the colors of the spectrum, from white through to black, can be produced. Images created this way are known as RGB Images (indicating red, green, and blue).

Television sets, computer monitors, and scanners all create images using RGB technology, as do digital cameras.

Computer monitors use RGB to display images and data

Adobe Photoshop™, one of several image-editing programs that allow editing of individual color channels

The human eyeball has three receptors that each measure one of these three primary colors. The red receptor measures the strength of red light, the green receptor measures the strength of green light, and the blue receptor measures the strength of blue light.

Then that wonderful organ in your head, the brain, combines the information from these receptors into one multicolored image.

Similarly a digital camera records the brightness value or light strength of each of these three colors in a separate section of the image file. These are known as color channels. It then mixes them together to create the full-color image.

By the way, the more feature-packed image-editing programs allow you to edit each of these three color channels independently of the others.

So now that you have a basic understanding of how a digital camera both captures an image and works out the colors, we had better have a look at one of the most important factors in digital photography, namely resolution.

Image Resolution

Image resolution is one of the critical factors in digital photography.

First let us look at how a digital image is constructed.

Any digital image is composed of thousands upon thousands of tiny squares of color, which are known as pixels.

If you have an image-editing program such as Adobe Photoshop you can see this very easily.

Simply call up one of your favorite photos and then enlarge it on screen. As it increases in size you will start to see the individual pixels appear. When the image is reduced in size the pixels blend into one another to form the image.

A pixilated image

In a way pixels are very similar to the silver halide grains in conventional film. With conventional film the silver halide grains that make up a film image can start to appear as you progressively enlarge the photo.

Note that each individual pixel can display only one color.

Let us define what we mean by resolution.

Resolution, in its basic form, simply means how sharp you image looks, especially when it is printed in hard copy (photo).

Resolution is defined by how many pixels per inch (ppi) your image has both in its height and width.

TOP: 300 ppi (pixels per inch)
BOTTOM: 120 ppi

A budget-priced digital camera

The quality and resolution of your image is dependent on the size of the CCD or CMOS chip that your camera uses.

Typically, a budget-priced digital camera might create images that are 640 pixels wide by 480 high. So, therefore, an image created by this type of camera will comprise some 307,200 pixels (640 X 480).

At the other end of the scale a professional digital back for a studio camera can create images that are comprised of 6,000,000 pixels. Obviously an image with 6,000,000 pixels, as opposed to 307,200 pixels will contain much more data and produce a cleaner, and sharper, image.

Unfortunately the cost of all this resolution is quite high and cameras and special digital backs with this sort of performance are currently out of most peoples price range (unless you can sell one of the kids, hmm!).

However, I do expect that the prices of digital cameras will decrease over time in much the same way as the prices of computer equipment has come down over the years.

By the way, most manufacturers use the term *megapixels* when referring to resolution. A megapixel is 1,000,000 pixels. So if a camera maker tells you that such and such camera has a resolution of 2.6 megapixels they simply mean 2,600,000 pixels. It sounds better!

What I was discussing, in the preceding paragraphs, was with regard to the ability of the camera to capture and record data.

Let's say you own the budget-priced digital camera we discussed previously. Now we have worked out that it can record image 640 pixels wide by 480 pixels deep.

But what does this mean (in terms of image size) when it comes time to either display your work on a computer or television screen, or print a hard copy photograph?

For instance, if you plan to use a computer or television to display your photograph, then at the maximum you only need a resolution of between 72 to 96 ppi (pixels per inch).

A digital printer that will print at 300 ppi

Even budget-priced digital cameras will see a reasonably sized image rendered on a computer monitor.

This is because computer monitors and television sets are set up to display between 72 and 96 ppi anyway. Any more ppi is a waste.

Digital printers are another matter, however. They are generally set up to give the best results at 300 ppi. Give them less and you might well start seeing the pixels appear on the photograph. Giving them more doesn't help either as they will try to get rid of the extra pixels and, most likely, degrade the sharpness of your image. Digital printers are discussed in more detail in Chapter 7, "Image Editing and Printing."

So the moral of this story is simple. The amount of resolution you need is totally dependent on the end use, and the size of the image. If the image is going to a computer or television screen you need considerably less resolution than if it is to be digitally printed into a hard copy photograph.

So how can you tell what size image you can produce from a digital camera on either a computer screen, television, or in a hard copy print?

Actually it's simple. Let's look at that budget-priced model again.

You will remember that its resolution was 640 pixels wide by 480 pixels high.

To work out the image size on a computer monitor or television screen that requires 72 ppi, simply divide the width and height specifications by 72.

The camera produced an image with a width of 640 pixels; 640 pixels divided by 72 equals 8.89. Therefore your image on the screen would be approximately 8.9 inches wide (225 mm).

The same formula applied to the height gives us 480 pixels divided by 72, which equals 6.67 inches high (170 mm).

Therefore your screen image will be some 8.9 inches wide by 6.7 inches high (225 x 170 mm).

But look what happens if you want to print a hard copy photograph of this same image. Remember, to get the best result you will need a resolution of 300 ppi. Any less and your image can start to deteriorate in quality.

How much your image will be effected depends, to a large degree, on the quality of the printer that is being used.

With a width of 640 pixels and a requirement of 300 ppi, the width of your printed copy is only 2.13 inches or 55 mm (640 divided by 300).

The height is similarly restricted to 1.6 inches or 40 mm (480 divided by 300)

Therefore at a perfect resolution of 300 ppi your printed photograph is limited to a maximum size of 2.13 inches wide by 1.6 inches high (55 x 40 mm. Well, at least it will easily fit into your wallet!

*Photograph measuring
2.13 by 1.6 inches (55 x 44 mm)*

Now there are a couple of things that you can do to improve this situation somewhat.

Using an image-editing program, such as Adobe Photoshop, you could either resample or resize your image. But be careful here!

The first option, resampling, means that the software looks at your image and either adds or deletes pixels depending upon if you are resampling the image size up or down.

Increasing the image size this way is known as upsampling and, of course, if you decrease the image size it is known as downsampling.

The problem here is that even the high-end image-editing software can sometimes do a poor job of adding pixels to your image. This can be especially true if your image has a great deal of intricate detail. It can do a better job if your image has large areas of color with not too much detail.

Before you attempt resampling it is a good idea to make a copy of your image first!

Resizing can sometimes be the better option. Resizing means that the computer will increase or decrease the size of the image without adding additional pixels.

When it increases the image size it simply makes the pixels bigger to fill up the new space created by the increase in size. If you are reducing the image size it shrinks the pixel size to fit within the new boundaries.

Whichever way you alter the image size, up or down, the pixel count remains the same!

Please be careful with this as not all image-editing software packages allow you to keep the original pixel count when you resize! It would be a good idea to consult the software manual or help system to ascertain the program's ability to hold the pixel count, while resizing.

Also note that when you resize up (create a bigger hard copy photo), and hold the original pixel count, that the pixels per inch (ppi) decreases, which, as discussed earlier, can effect hard copy image quality.

A digital photo (original, inset top) that has been both resized (above left) and upsampled (above right).
In this case the difference is negligable although this is not always the case.

Sometimes you should try both resampling and resizing to see which gives the best result.

Again it would be a good idea to make a copy of the image before resizing (or resampling), just in case.

Let's say you have an image from the camera whose pixel count tells you, that at 300 ppi, your image will be 3 by 2 inches (76 x 51 mm).

Now this is not big enough for your purposes. You want to produce a hard copy print that is at least 4 inches wide by 2.66 inches high (112 x 66 mm). That is an increase in size of some 33%.

Well, you can resize the image easily enough, but be aware, that when you do that the ppi will reduce from 300 ppi to 225 ppi. Now how much the final quality of your hard copy image will suffer as a result of this drop in ppi depends on a number of factors, which include:

- The quality of the original image
- The amount of detail in the image
- The quality of your digital printer

The examples on the previous page show an image taken at 300 ppi then resampled and resized up (reduced ppi). Please be aware, however, that a great deal rests on the original image, and the printer. You will need to experiment with your own images.

You will note that up to this point I have been dealing with a budget-priced camera. The old saying "You get what you pay for" applies to photography (both conventional and digital), in spades.

If we take a more realistic approach we might say that we are not going to buy a budget-priced digital camera, nor are we going to sell the house (and perhaps the kids!) and purchase a top-of-the-line model.

Instead we are going to buy a mid-range digital camera, which we hope will give us all the capacity we need.

So out to the camera store we go and purchase a mid-range Canon/Nikon/Minolta/Olympus/Leica/Fuji digital camera.

A Canon mid-range digital camera

What size hard copy print does this give us, both before resizing and after?

You might notice that I am ignoring displaying the image on a computer monitor or a television screen at this point.

This is because even the most basic digital camera should give a reasonable-sized image on the screen.

The real problem is with the hard copy print. How big can you go without incurring problems with pixilization? Pixilization is the term used when the individual pixels start to appear in your image.

Well, a mid-range digital camera should give you a pixel width of around 1600 ppi by a pixel height of 1200 ppi.

If we want to print this image out in hard copy we need to divide these pixel sizes by 300 to estimate the optimal print size.

1600 divided by 300 equals 5.33 inches in width (132 mm). As far as height is concerned, 1200 ppi divided by 300 equals 4 inches (112 mm).

Therefore at the optimal printing ratio of 300 ppi this camera will give you a hard copy print of 5.33 inches by 4 inches (132 x 112 mm).

Now if that print fits neatly in you wallet I want to meet you! And at this stage we haven't tried resizing or resampling the image.

Let's say we do resize the image using the same proportions that we used previously (an increase of some 33%).

This then will take the image to a size of some 7 inches wide by 5.3 inches high (179 x 132 mm). A big difference to the budget-priced camera!

Keep in mind that digital camera manufacturers most often state their products' resolution capabilities in either one or two ways. They might state that their camera has a resolution of 1600 pixels wide by 1200 pixels high. Alternatively they may simply state that the camera produces a file (image) of 2 Megapixels.

Naturally they will state it in whichever way it looks best to the buying public!

In addition some digital cameras have an on-board computer chip that automatically resamples the image to produce a bigger file that can be used to produce bigger prints.

A digital printer will also refer to its resolution in its manuals. But instead of referring to pixels per inch (ppi) it will talk in terms of dots per inch (dpi).

They do this just to confuse us!

Photograph measuring 7 inches by 5.13 inches

Are pixels per inch (ppi) and dots per inch (dpi) the same thing?

Not quite, although the concept is similar.

Digital printers produce images by printing many small dots of color ink and the higher the dots per inch (dpi) the smaller the individual dot. One image pixel can comprise a number of dots.

Therefore you would be justified in thinking that a digital printer using 600 dots per inch (dpi) would render a better image than a model using only 300 dpi.

Unfortunately not so! You see different digital printers use different technologies to print the images and you can find that a 300 dpi printer will produce a better print that a 600 dpi model.

Check out the chapter on printers for more information on this subject.

A PC monitor

A Macintosh monitor

Storage

Now is probably the ideal time to look at how a digital camera stores the images you take.

Many digital cameras allow you the choice of several different settings in relation to resolution. This allows the photographer to choose the setting necessary for the intended use of the image.

Typically you might have a choice of between three or more settings. Various camera manufacturers label these in different ways for example:

Good, better, best

Basic, normal, fine

The smallest resolution (good and basic in the above examples) should be adequate for displaying the image on a computer monitor or television screen but you should check the camera manual to be sure.

Also note that selecting a smaller resolution on the camera will enable you to take, and store, more photos in the camera's memory system. But make sure that the resolution you select is enough for the intended use of the image, as discussed previously.

It can be a good idea to use the setting one up from what you think you will need. Admittedly this will give you more resolution than you may need but you can always resize the image down, with no harm.

Using a resolution that results in the image being too small for its intended use will result in you having to either resample or resize it up, which may affect the image's final quality.

The final size of the image you display will depend on the medium you use for the display (computer monitor, television, or hard copy print) and your image-editing software, as discussed previously.

With computer monitors the number of pixels that they are set to display varies slightly depending upon the manufacturer.

Macintosh monitors are normally set up to display at 72 ppi. A monitor for a PC, however, will normally be set to 96 ppi.

Storage of the digital image (in camera).

There are several different types of on-board storage disks for digital cameras. Each different make of camera will normally use only one of the options outlined below so you cannot normally purchase a digital camera and then change the type of storage disk it uses. You are usually stuck with whatever type the manufacturer specified.

The **CompactFlash** card is a smaller version of the PC Card (see next). They have a hard outer case with pin connectors at one end and are approximately 1.5 X 1.4 inches (35 x32mm). CompactFlash Cards are available with various memory capacity ranging from 4MB (4 megabytes) up to a current maximum of 128MB. Even larger sizes are apparently around the corner. Current users of the CompactFlash include Canon, Nikon, and Kodak.

PC Cards, which used to be called PCMCIA Cards, are still used by some older digital cameras, including the Kodak DC-50.

A bit larger than a credit card they are the same type of card that laptop computers use. If you have a digital camera, which uses PC Cards, and need extra cards, you should first ascertain if your camera uses Type I, II, or III cards.

Floppy Disks (1.44MB) are used in the Sony Digital Mavica camera to store its images. These are cheap but will only hold 1.44 megabytes of data per disk.

Therefore if you are using one of these cameras and plan to do quite a number of shots, you would be well advised to take a handful of disks with you.

SmartMedia Cards are manufactured in two different forms to accommodate different types of cameras. The first type is for a camera that uses an electrical current of 3.3 volts and, the second, 5 volts.

They come in different capacities ranging from 4MB up to 32MB. SmartMedia Cards are slightly smaller than the CompactFlash Card, and also thinner.

SmartMedia Cards are currently used in cameras from Minolta, Toshiba, and Olympus.

The **Sony Memory Stick** is a new entry in the digital storage stakes. It will only work with Sony digital cameras, computers and other Sony devices, such as the Sony CyberFrame.

Longer and narrower than the CompactFlash Card it is currently available in capacities that range from 4MB up to 32MB.

Iomega Click Disks are another new entry in the on-board camera image storage stakes. At least one camera manufacturer has produced a digital compact that stores the images on an Iomega Click Disk. The click disk holds 40 megabytes and can be easily loaded onto a computer's hard disk via an Iomega Click Drive.

As you can see, there are a number of storage devices that different camera manufacturers employ to store the images you take.

The number of images that a particular card can store depends on a few factors that include:
- The storage capacity of the card (such as 4MB, 32MB, 96MB, and so on)
- The resolution value that the camera is set to record

For instance, the Nikon D1 camera has six possible resolution settings. Depending on which resolution setting you choose a 96MB CompactFlash Card will be capable of storing between 12-265 images. Naturally storing more images results in a lower resolution for each image.

The reasons that a memory card, such as a CompactFlash, can store such a diverse number of images are as follows:
- The number of images that can be stored will increase as the resolution of the image is decreased. Therefore if you only want to view your images on a computer monitor or television you only need 72 dpi (or 96 dpi for a PC Monitor). So each image file is therefore smaller and many more can be stored on the card.
- Digital cameras use files types such as "JPEG" to store images. A "JPEG" image is one that has been compressed, and this image format is widely used on the World Wide Web (WWW). Compression rates for JPEG are from 100% to 10% However, be aware that an image that has been compressed into a "JPEG" can suffer some image deterioration. The better digital cameras allow you to take an uncompressed image in a format such as "TIFF," which is not compressed and therefore not subject to image deterioration. When you take an image in this format you will be using a reasonably large file to store it so the number of images that the card in your camera can store will be at a minimum.

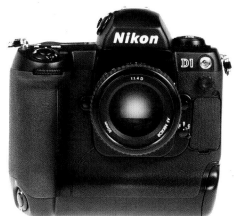

A Nikon D1 SLR Digital Camera

Each digital camera is different and you should look at the product specification to ascertain the maximum capacity of its storage media.

Of course, you can always purchase more storage capacity (extra cards) to increase you picture taking capacity. However, they are not cheap!

Alternatively, you could use other devices to download the images from a memory card that is full. This is discussed in more detail in Chapter 5, "Useful Accessories."

Memory cards need to be handled with some care. Please read the instructions on handling that accompany these products.

Now you should have a good idea of how a digital camera works. You have read how it captures an image, converts it into pixels, and stores it for later retrieval.

In addition, you have had an overview of the different on-camera storage media that hold your images for later downloading into a computer or television.

You have also read how to calculate what size image you will get, depending on your camera type, resolution settings, and final usage (monitor display or hard copy photo).

This information was placed before you first so that when we discuss cameras and equipment in the chapters to follow you will be better able to understand the different capabilities of each particular piece of equipment.

Before I finish this chapter there is one more matter to discuss in regard to the subject of "What is digital photography?"

To date I have only been discussing pure digital cameras. These are models that do not use conventional film and record the images electronically, via either a CCD or CMOS Chip.

Conventional slide film that can be scanned and digitized, as can normal color (or black-and-white) negative film

There is, however, another aspect to the subject of digital photography.

That aspect is where conventional film is scanned and converted into a digital image.

In other words the image is taken on a conventional film camera, developed and then, using a scanner, digitized. This can be done with either black-and-white film (negatives) or color print film (negatives), or either black-and-white or color slide film (transparencies). Scanning a hard copy print is also possible.

This aspect of digital photography is covered, in some detail, in a new book, *A Simple Guide to Digital Scanning,* which is due out in early-2002.

Now let us look at the different types of digital cameras.

A film scanner that can scan slides and negatives into a computer

The Digital Camera

Country porch with pooch, Northern California

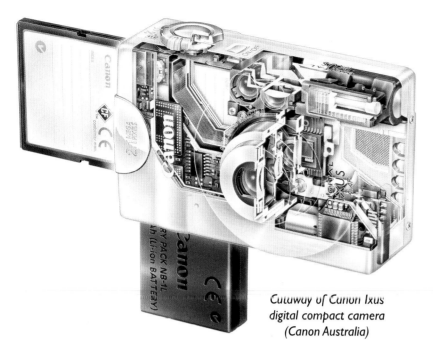

Cutaway of Canon Ixus digital compact camera (Canon Australia)

Digital cameras come in all shapes and sizes to meet the needs of the photographer. From the budget-priced up to the "take a second mortgage on the house" super duper SLR (single lens reflex) models, they are all there, competing for your hard-earned money.

So we had better take a good look at the digital camera and examine the various types available.

Digital Compact Camera

The digital compact camera is similar in many ways to the compact camera that uses 35mm film. Both are reasonably compact (hence the name!) and come in a myriad of different models, each with different features.

All have a fixed lens, usually a zoom, which provides a variable field of view depending on the lens specification. At least one model has attachable converters that can give you a lens range from fisheye through to long telephoto.

To simplify the subject we will look at three different digital compact cameras. These three cameras represent three different levels of features (and cost!).

We will start with a basic model then move on to a mid-level variant and finish with a top-of-the-line model.

We will examine their features and capabilities so that you can get a feel for the camera and its potential to satisfy your individual photographic needs.

Prices for each model vary in different countries but in general you can count on a mid-level model costing around two to three times more than a basic model while a top of the line digital compact camera could cost up to four times more than the basic model.

There are cheaper models on the market than the type used to illustrate the basic model. However, they have limited resolution and are more suited for publishing pictures on the World Wide Web (WWW) than producing hard copy prints.

Please remember that the models used in these examples are representative of the type of digital camera (basic, mid-level, top of the line) being discussed. There are many cameras that would fit into each section and the models discussed are used as examples only.

Two special controls found on digital cameras need to be discussed before we look at the cameras themselves.

Canon D2000 digital SLR camera (Canon Australia)

ISO Control

With film cameras the film speed (ISO setting) is normally set automatically by the camera's DX function. If the camera has no DX function you set the film speed manually.

Film speed is simply a way of expressing a particular film's sensitivity to light. The higher the film's speed (ISO number), the more sensitive to light the film. For instance a film with an ISO rating of 200 is twice as sensitive to light compared to one with an ISO rating of 100.

Digital cameras don't use film but their imaging sensors still need to be rated for their sensitivity to light. They do this by way of an ISO control.

For instance, the Canon Ixus digital compact camera is set to an ISO setting of 100 and cannot be altered.

The Nikon D1 digital SLR has an ISO control that allows the choice of four settings: ISO 200, 400, 800, and 1600.

So each digital camera is different in regard to ISO settings and this should be taken into account when purchasing one.

You should also check out what the camera manufacturer recommends when using ISO numbers that are higher than recommended (if your camera allows) as there is a possibility of computer 'noise' being generated and affecting your images.

White Balance (WB) Control

With film cameras the light conditions dictate the type of film you use. The vast majority of film sold is rated for daylight and is also suitable for flash photography.

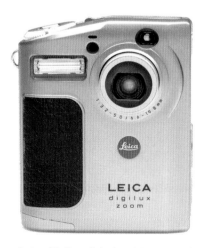

Leica Digilux digital compact camera

With digital cameras it is different. The camera will either be preset, or it will allow for the adjustment of the white balance to suit varying lighting conditions.

White balance is the term used in digital photography to express how the imaging sensor will react to different types of light.

Different types of light (daylight, fluorescent, tungsten and so on.) will render the color of an image differently. Although the human eye automatically adjusts for different lighting situations, imaging sensors don't and therefore some adjustment is required. Each digital camera handles this differently.

The more budget-priced models are preset to a daylight/flash configuration. More advanced digital cameras will allow the photographer to choose from a number of white balance selections which could include auto white balance, incandescent, fluorescent, direct sunlight, flash, overcast or preset white balance.

Again, any intending purchasers of a digital camera should give some thought to the lighting situation they anticipate operating in, ensuring that the camera will handle it.

The Basic Digital Compact Camera

The model I have chosen to illustrate a basic, good quality digital camera is the Kodak DC215 Zoom Camera. It may have a different name in some countries. Other digital camera manufacturers also have models with similar specifications.

According to the manufacturer, this camera will allow the user to produce hard copy photos of around 5 X 7 inches (127mm X 178mm).

It utilizes an 8MB Kodak picture card for storage of the images and, depending on the image quality settings, will store between 26 to 115 images.

The camera has a 1.8 inch TFL LCD (liquid crystal display) on the rear for review and preview, and also has an in-built flash that has an effective range of around 10 feet (3 meters).

This type of camera is a good entry-level model, and provided all you want are postcard-sized prints and a limited zoom range, it will serve you well. It is also a good type of camera if you are thinking of entering the digital photography world, but are not yet convinced to shell out considerably more of your hard-earned cash on a fully featured model. Controls for this camera are illustrated overleaf.

Basic Camera (Front View)

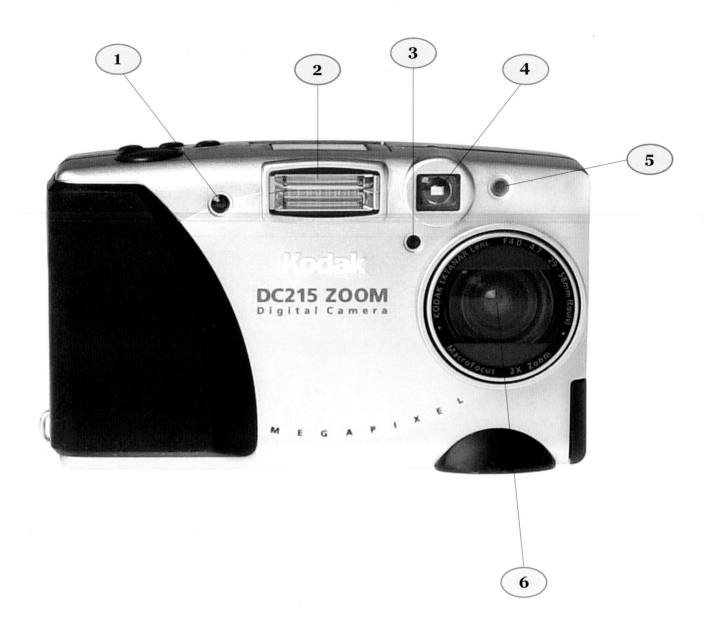

(1) Self-Timer Light
This light is activated when you engage the self-timer control (18). The light stays on for 8 seconds and then blinks for the final 2 seconds. This allows time for the photographer to be in the shot when using a tripod.

(2) Built-In Flash
Maximum effective range of 9.84ft (3m) when the lens is set to wide.

(3) Light Sensor
Used by the camera to calculate exposure settings.

(4) View Finder (Front)
See (8) View Finder (Rear)

(5) Flash Sensor
Used to automatically calculate the duration of a flash cycle when taking flash photographs.

(6) Camera Lens
Equivalent to 29mm to 58mm on a 35mm camera (moderate wide-angle to normal view).

(7) Ready Light
This light blinks as an image is stored on the camera's memory card. When the light is steady the next shot can be taken.

(8) View Finder (Rear)
You look through this to compose the picture if you are not using the LCD screen for this purpose.

(9) Power Switch
Turns the camera off and on.

(10) Lens Zoom Control
Moves the lens between wide and tele to either bring you closer to the subject (tele) or take you further away (wide).

(11) LCD Screen
This screen displays the various menu functions built into the camera. It will also preview the scene you are about to photograph and play back images stored in the camera's memory card.

(12) Scroll Buttons (Sideways)
Allows the user to scroll through the images stored in the camera's memory card.

(13) Slider Switch
Allows the camera to be set up for capturing images, reviewing images already captured, connecting to a TV or computer or adjusting various preferences such as quality and resolution.

(14) Do It Button
Used to select various options with different menus. Rather like the enter button on a computer.

(15) Scroll Buttons (Up and Down)
Allow the user to scroll (up and down) through the various options in the camera's setup menus.

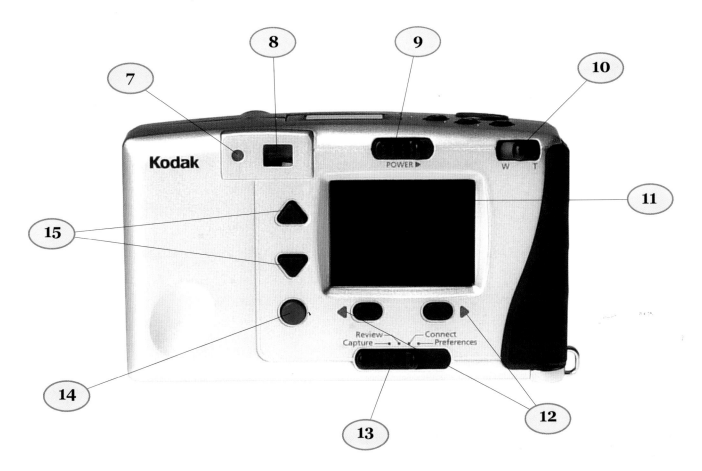

Basic Camera (Back View)

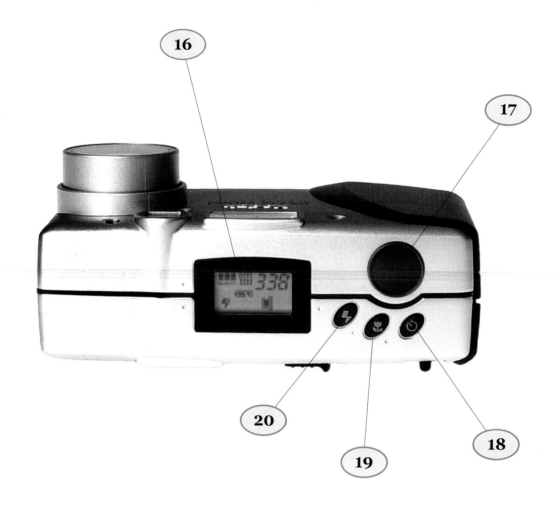

Basic Camera (Top View)

(16) Status Display
Shows the camera's status such as pictures remaining, quality setting, resolution setting, battery level, flash mode in use, and memory card status.

(17) Shutter Button
This is the button to press to take the photograph.

(18) Self-Timer Button
Turns the camera's self-timer function on and off.

(19) Close-Up Button
Turns the camera's close-up function on and off.

(20) Flash Button
Allows the photographer to select from five settings with respect to the camera's built-in flash.

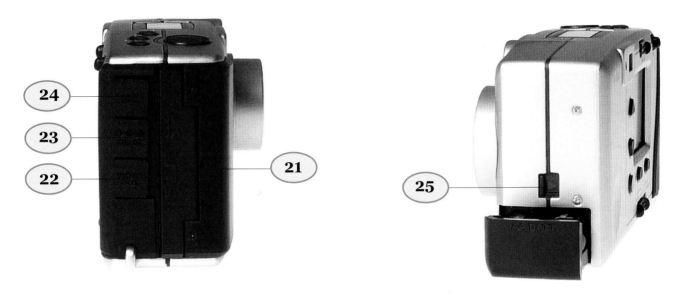

Basic Camera (Side View)

(21) Camera Memory Card Door
The CompactFlash Memory card goes here.

(22) Video Out Port
Used to connect the camera to a television set, for running a slide show.

(23) AC Adaptor Port
Used to connect the camera to the household power supply with the optional AC adaptor.

(24) Serial Port
Used to connect the camera to a PC or Mac computer.

(25) Battery Chamber Release Switch
Used to release the battery chamber to either install or change batteries.

(26) Tripod Socket (BELOW)
Used to attach the camera to a tripod.

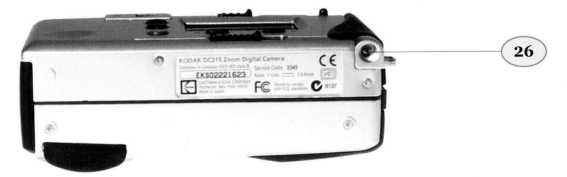

Basic Camera (Bottom View)

Buddha, Hong Kong

Mid-Level Digital Compact Camera

For an example of a mid-level digital compact camera I have chosen the newly released Canon Powershot Digital Ixus. The name may vary slightly from country to country. The camera has an effective image sensor of just over two megapixels.

Depending upon which compression setting is chosen the photographer can record between 4 and 46 images on the 8 megabyte CompactFlash card supplied. Using a higher-capacity CompactFlash card of 48 megabytes the camera's capacity increases to between 31 and 289 images, again dependent on the compression setting selected.

The Ixus has a 35-70 zoom lens (35mm equivalent), which, by means of a built-in digital tele-converter (2X or 4X), can extend the effective focal length of the lens to 280mm (moderate wide-angle to medium telephoto view).

A built-in flash is controlled by the camera's sensor and has an effective maximum range of 9.8 feet (3 meters).

With a 1.5 inch LCD monitor, the camera is powered by a rechargeable battery and will take approximately 85 frames with the monitor on, or around 270 with it off.

The camera also comes with some interesting software programs to enhance the photography experience.

One such program is called Stitch Assist. This software allows you to take successive frames and then stitch them together to create a panorama image.

The camera is small, stylish, and an excellent example of a good mid-level digital camera.

Mid-Level Digital Compact Camera (Front View)

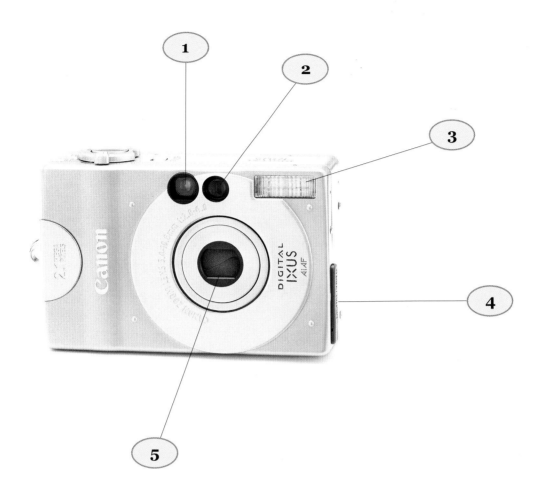

(1) View Finder (Front)
See (7) View Finder Rear.

(2) AF (Auto Focus)
Auxiliary light emitter. This is used by the camera to assist in focusing. Also this light acts as a red-eye reduction lamp. It fires a number of pre-flashes to help reduce or eliminate the red-eye effect. Finally it acts as a self-timer lamp which blinks when the camera's self-timer function is activated.

(3) Built-In Flash
The camera has five different flash modes that can be used depending on the situation at the time.

(4) Digital/Video Terminal
Used to connect the camera to a TV or computer.

(5) Lens
Zoom lens with a equivalent 35mm focal length of 35mm-70mm. However this camera also has a two times (2X) and four times (4X) digital teleconverter to extend the final focal length to a maximum of 280mm.

(6) Indicator Lights

These two indicators light up in the following situations:

Upper Indicator Light
• green - ready to record (take picture);
• flashing green - camera warm up/ recording to CompactFlash card/ reading CompactFlash card/ deleting CompactFlash card images;
• red - ready to record with flash;
• flashing red - ready to record but camera blur (shake) warning/low light warning indicated;

Lower Indicator Light
•macro mode selected.

(7) Optical View Finder (Rear)

The photographer can look through the view finder to compose the shot. Alternatively the LCD monitor can be used to compose the shot. The view finder has brackets engraved within that show the auto focus/metering area of the shot.

(8) Mode Switch

This switch is used to switch between the shooting and replay modes of the camera.

(9) CompactFlash Card Slot Cover Lock

Used to unlock the card slot cover to insert or remove CompactFlash cards.

(10) Strap Holder

Used to attach the camera strap.

(11) DISP (Display) Button

Turns the camera's LCD monitor on and off.

(12) Menu Button

Displays the camera's menu on the LCD monitor.

(13) Macro/Infinity/Right Button

Sets the camera up for macro shots or normal (infinity) shots. Note when in macro mode the LCD monitor should be used to compose the shot, and not the optical view finder. This eliminates any problems with composure caused by the parallax phenomenon (see end of this section). When the camera's menu is displayed the right button allows the photographer to select from various options on the screen.

(14) Continuous/Self-Timer/Left Button

When depressed this button switches the camera to self-timer mode - the picture will be taken ten seconds from when the shutter is depressed. When pressed again the camera switches back to continuous shooting mode. The left button also allows for menu option selections when the camera's menu is displayed on the LCD monitor.

(15) Set Button

When depressed this button will cycle through the camera's five flash settings:
• auto - the flash fires automatically as required by the light level;
• red-eye reduction - fires a series of pre-flashes to reduce the red-eye effect;
• on - the flash fires with every shot;
• off - the flash will not fire;
• slow-synchro - adjusts the timing of the flash to slow shutter speeds, reducing the chance that the background will be dark when shots are taken at night or in rooms with artificial lighting (use a tripod in these situations).

(16) LCD Monitor

Displays the shots taken and menu. Can also be used to compose the shot.

Mid-Level Digital Compact Camera (Back View)

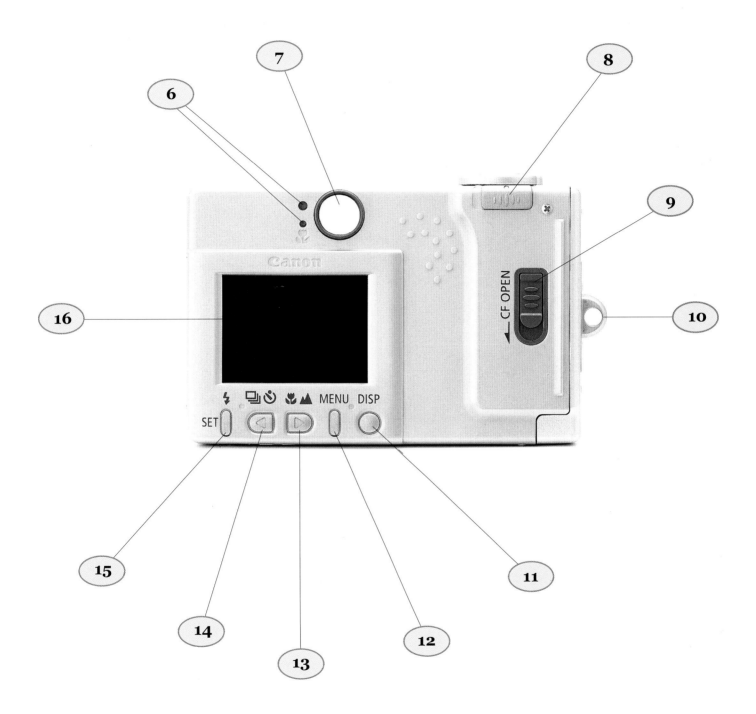

Mid-Level Digital Compact Camera (Top View)

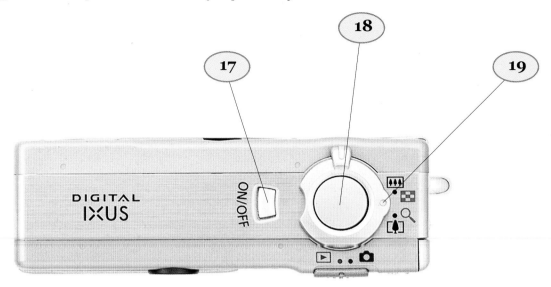

(17) Main Switch
Turns the camera on and off.

(18) Shutter Button
Pressing the button halfway focuses the camera and sets exposure and white balance. Fully depressing the shutter takes the shot. If you keep the shutter button depressed after taking the shot the image is displayed on the LCD monitor. Depressing the Set Button (15) and the Left Button (14) will erase the image should it not be required.

(19) Zoom Lever
Used to zoom the camera's lens between tele and wide.

(20) Tripod Socket
Used to attach the camera to a tripod.

(21) DC Coupler Terminal Cover
Used to connect the camera to the optional electric power adapter kit.

(22) Battery Cover
The camera's battery is inserted here.

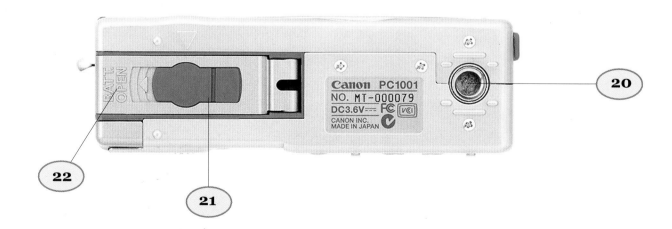

Mid-Level Digital Compact Camera (Bottom View)

Top-of-the-Line Digital Compact Camera

If you are really into photography and require a digital camera that has all the bells and whistles then you will most probably want to look closely at a top-of-the-line compact digital camera.

Of course you could also look at a SLR digital camera and we will do that next. However the difference between the cost of a top-of-the-line digital compact camera and a SLR digital camera is significant, at this point in time, and needs to be seriously considered when making a purchase.

Most of the major camera manufacturers produce a top-of-the-line digital compact camera. Models abound from companies such as Nikon, Canon, Olympus, Fuji, Leica and more seem to be released each week.

To give you an idea of what to expect from a camera from this class I have chosen the recently released Nikon Coolpix 990.

This camera, like others in this category, is a serious piece of photographic equipment.

First let's talk resolution, which, by now, you may have gathered is one of my favorite subjects in digital photography.

The Nikon Coolpix has a 3.34 megapixel CCD sensor. That's 3,340,000 pixels! 3,145,728 pixels are for capturing the image and the remainder are used for other camera functions, such as metering the scene.

The camera has a 1.8 in. LCD (liquid crystal display) for seeing what you have just shot and many other features that we'll get to in a moment.

Image storage is via a CompactFlash card. Images can be stored in four modes: fine (TIFF format - uncompressed), fine (JPEG 1/4 compression), normal (JPEG 1/2 compression), basic (JPEG 3/4 compression).

Depending in which format you store the images, you will be able to store between 6 and 240 images on a 96 MB CompactFlash card. Nikon supply a 16MB CompactFlash card (this could vary in different countries) with the camera, which can store between 1 and 40 images.

A built-in flash provides light for distances up to 30 feet (9 meters).

Another great feature of this camera is the accessories that can be added to improve the picture-taking experience. Included are fisheye converters, wide-angle converters, telephoto converters, and slide copy adapters.

Another great feature of this camera is its unique swivel lens arrangement.

If you're in a crowd and cannot get a clear view of the scene in front, you can simply swivel the lens and hold the camera over your head with the LCD monitor facing down.

Compose the shot using the monitor and presto, goodbye crowd.

Nikon have obviously gone all out to give the compact digital photographer all the bells and whistles that you would normally only expect on a digital 35mm SLR camera.

A look at the controls and their functions will explain some of the many features found on this class of camera.

Storm clouds over Luna Park, Sydney

(1) DC-In Terminal
Used to connect the camera to a television set to view images.

(2) Lens
A 3X zoom lens equivalent to 38-115mm in a normal 35mm camera. Also built-in is a digital 4X tele-converter which takes the lens out to the equivalent of 460mm. If you then add the optional 3X tele-converter you can extend the lens out to a massive 1380mm. At the other end of the scale you can go down to a 8mm (35mm format equivalent) with the optional fisheye converter.

(3) View Finder Window (Front)

(4) Built-in Flash Gun (Speedlite)

(5) Red-Eye Reduction/Self-Timer Indicator
Blinks for 10 seconds during self-timer operation and sends pre-flash to help with red-eye reduction.

(6) Photocell
Used to measure light from the flash gun.

(7) Anti-Slip Camera Grip

High-End Compact Digital Camera (Front View)

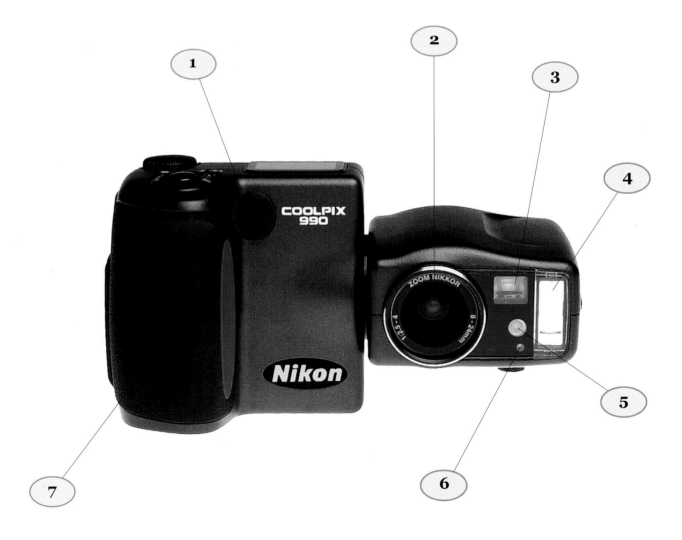

High-End Compact Digital Camera
(Back View)

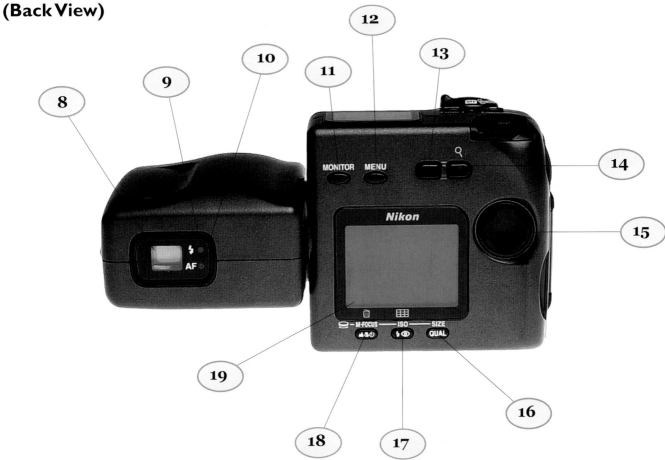

(8) View Finder Eyepiece
Used to view the scene you are photographing. Alternatively you can use the rear LCD (19) for this purpose.

(9) Flash Ready LED (Light Emitting Diode)
Lights up to indicate that the flash is ready.

(10) In-Focus LED
This green LED lights up when the camera focuses correctly on the subject.

(11) Monitor Button
Used to turn the LCD monitor on and off.

(12) Menu Button
Used to access various menu functions.

(13) Lens Zoom In Control

(14) Lens Zoom Out Control

(15) Multi-Selector
Used to choose one of five focus areas.

(16) Quality Control Button
Used to set the image quality/size (resolution)

(17) Flash Sensitivity Button
Range of ISO settings between 100-400.

(18) Focus Mode/Delete Button
Sets the focus mode and is also used to delete unwanted images

(19) LCD Monitor
Used to view the scene and also playback images taken and stored on the CompactFlash card. In addition the monitor also features an array of shot information and playback functions.

High-End Compact Digital Camera (Top View)

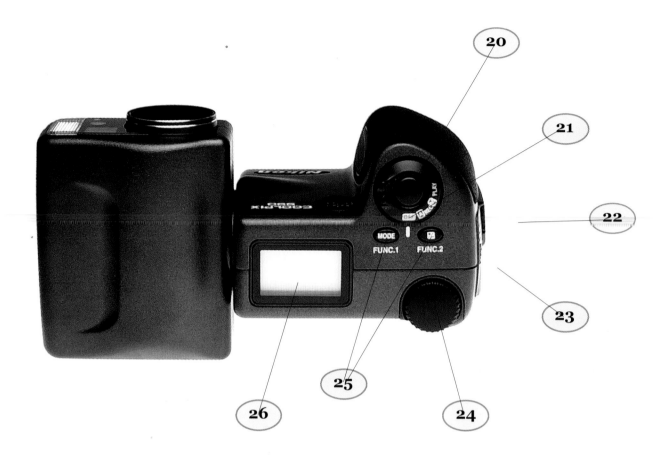

(20) Shutter Release Button
You press this to take the picture.

(21) Selector Switch
To set shooting mode. You can set either full automatic or manual mode.

(22) Video Output Terminal
This connects the camera to a television set to play back images. The terminal is switchable between NTSC and PAL depending on the system in use in your country.

(23) Digital Output Terminal
This is the terminal that is used to connect the camera to a computer. It is USB and serial port compatible.

(24) Command Dial
Used to adjust various camera settings.

(25) Preferred Function Button
Allows you to customize preferred functions.

(26) Control Panel
Displays various information regarding the current state of the camera.

High-End Compact Digital Camera (Bottom View)

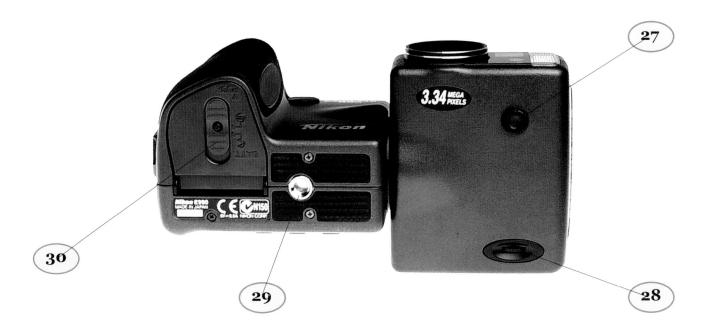

(27) Multi-Flash Sync Terminal
Allows the attachment of external speedlites
(flash guns)

(28) Diopter Adjustment Control
Allows adjustment of the view finder to suit
personal eyesight requirements.

(29) Tripod Socket

(30) Battery Compartment

**(31) CompactFlash Card Compartment
(BELOW)**

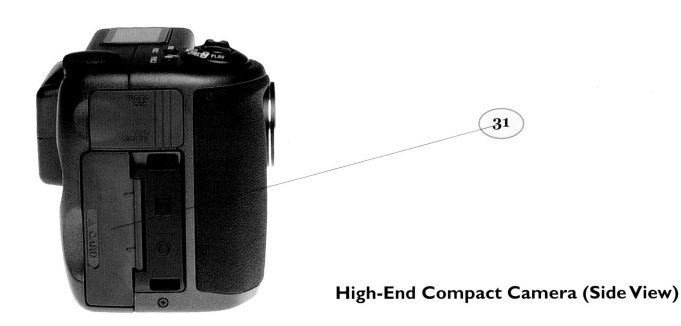

High-End Compact Camera (Side View)

This camera has a range of accessories such as fisheye converter, wide-angle and telephoto converters which help make it a complete photographic system that will handle

most tasks the photographer could require.

Because of its swivel lens set-up the Coolpix 990 can be used at any angle which is a very useful feature in tight shooting situations.

This digital camera, and others in this class from Canon, Olympus, Leica, Fuji etc, give the photographer all the tools needed to fully enjoy the new world of digital photography.

Parallax Phenomenon

Compact cameras, whether film or digital, have the potential to create subject-framing errors. This condition is known as parallax error or the parallax phenomenon.

Parallax error can cause you to chop the head off your subject or lose other parts of your subject that you thought were in the image.

This is because with a compact camera you are viewing the scene through a separate view finder and not the lens, as is the case with a SLR camera.

The view finder on a compact camera has a slightly different angle of view to the lens. To compensate for this there are normally engraving marks in the view finder to assist you in correct framing. Unfortunately in the haste to take a shot these marks are sometimes overlooked, resulting in an image with some things missing.

So it is important to get used to using these marks to frame your image. Make it a habit to use them, and after a while it will become instinctive.

Close-ups and macro photography are especially prone to parallax error with compact cameras.

Some digital compacts allow you to frame your image using the monitor on the back of the camera and this avoids the parallax error problem.

One camera manufacturer (Olympus) has released a compact model that utilizes a view finder that looks through the lens, similar to an SLR camera. This camera thus avoids the parallax error completely.

ABOVE: Some of the Nikon Coolpix swivel positions

The SLR Digital Camera

The SLR (single lens reflex) digital camera is similar to the SLR film camera with its ability to use inter-changeable lenses and a whole host of accessories designed for the avid photographer.

The use of through the lens viewing eliminates the parallax error problems discussed in the previous section on digital compact cameras.

However the price of a digital SLR is another matter. At the current moment there are a number of models on the market. Their price (depending on the country you live in) can range from around US$5000 upwards to US$20,000.

Also there are a limited number of models on the market at this point of time.

That makes it pretty difficult for me to show you a basic and mid-level model at this time. They simply don't exist, so all the digital 35mm SLRs on the market would have to be classed as top of the line.

Unless you make your living with a camera, or are a well-heeled and committed amateur photographer, you may want to think very carefully before committing your funds to one of these wonderful products.

Still, the cost of these cameras is steadily falling and I would expect this trend to continue as more and more people add digital to their photographic repertoire.

Even as I write, Canon and Fuji have announced two new well featured digital SLR cameras and it seems that their price is down by about 20% compared to current offerings. Again both of these new releases would be classed as top of the line.

I have used a Nikon D1 to demonstrate the controls and features of an advanced digital SLR camera. At the time of writing this camera had established a big reputation for digital SLRs.

Naturally an SLR digital camera will just about take the full range of lenses and accessories that form the SLR system applicable for the model. This gives the photographer a wide range of tools with which to be creative.

The D1 records an image with up to 2.7 million pixels. The CCD chip is quite large at 23.7 X 15.6mm, which is exactly 66.66% of a full 35mm film frame.

This large CCD chip no doubt accounts for the excellent images that this camera can produce.

ABOVE RIGHT:
Fujifilm Finepix S1Pro

ABOVE LEFT:
Canon D30

RIGHT:
NIKON D1

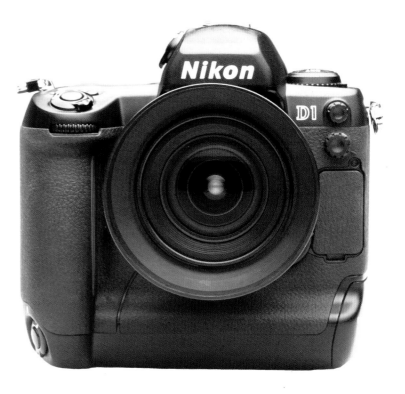

SLR Digital Camera (Front View)

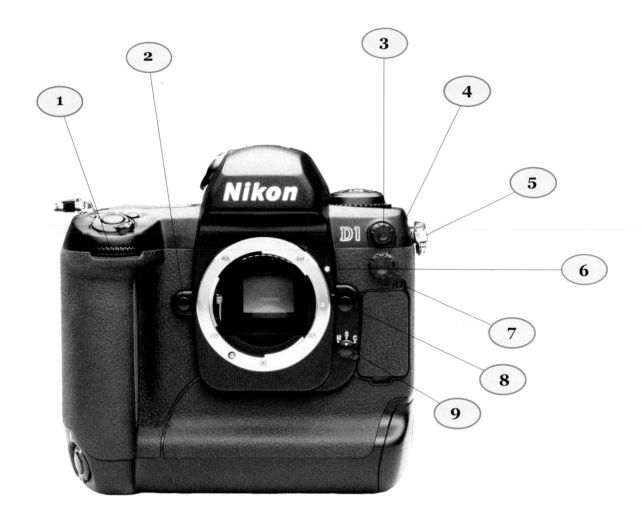

(1) Sub-Command Dial
This control sets various functions including aperture depending on the exposure mode selected.

(2) Depth of Field Preview Button
When depressed this button will close down the aperture to the selected f-stop. By looking through the view finder when this button is depressed you will see the depth of field applicable to the f-stop selected.

(3) Sync Terminal for External Flash Gun
Used with a flash gun that's not mounted on the camera's hot-shoe (15).

(4) 10-pin Remote Terminal
Used to connect a cable release to the camera for hands-free photography.

(5) Eyelet
One of two eyelets to attach the camera strap.

(6) Lens Alignment Mark
Used to align the camera with a lens (which has a similar indicator) when attaching the lens to the camera body.

(7) Self-Timer Lamp
Blinks when the self-timer function is in use.

(8) Lens Release Button
This button must be depressed before attempting to remove a lens from the camera body.

(9) Focus Mode Selector Switch
Allows selection between three focus modes: manual, single auto focus, and continuous auto focus.

"Pretty flowers Mum", Notting Hill, London

SLR Digital Camera (Top View)

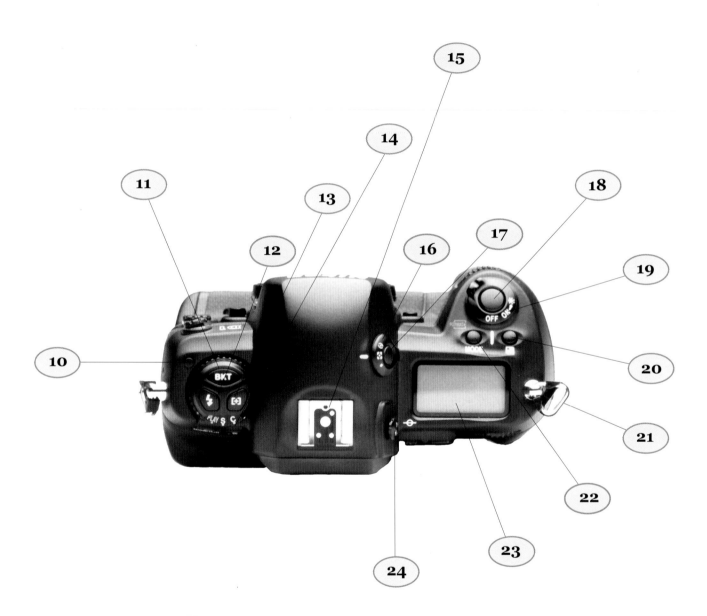

(10) Mode Release Pin
This pin must be depressed before the mode dial (14) can be shifted.

(11) Auto Bracketing Button
Allows the photographer to set the camera up to automatically bracket a shot to allow for difficult lighting situations (see Bracketing Chapter 8 "The Correct Exposure).

(12) Flash Sync Mode Button
Selects the flash mode from five choices: front curtain sync, slow sync, rear curtain sync, red-eye reduction, and red-eye reduction with slow sync.

(13) AF (Auto focus) Area Mode Button
Sets the auto focus mode of the camera.

(14) Mode Dial
Allows the photographer to set the mode for the camera. Modes available are single shot, continuous shooting and self-timer mode. This control also has settings to allow the playback of shots on the LCD and for connection to a computer.

(15) Hot-Shoe
Allows for the attachment of a flash gun.

(16) Metering Selector
This control allows the photographer to choose between three metering modes: color matrix metering/3D color matrix metering, center-weighted metering, and spot metering.

(17) Metering Selector Lock Button
This button must be depressed before altering the metering selector (16) setting.

(18) Shutter Release Button
When lightly pressed this activates the camera's metering and focuses the lens (if camera is in auto focus mode). When fully depressed the shutter release button activates the camera's shutter and takes the photograph.

(19) Power Switch
Turns the camera on and off. Also illuminates the top control panel (23) when required.

(20) Exposure Compensation Button
Allows the photographer to compensate for difficult lighting situations and set the camera's meter to a value that can be either + or − by up to 5 stops.

(21) Eyelet
Second eyelet for camera strap.

(22) Exposure Mode Button
This button allows the photographer to select between four exposure modes: programmed auto, shutter-priority, aperture-priority, and manual exposure. It also doubles as one of two format buttons. See (26).

(23) Top Control Panel
Displays various information in regard to the camera's settings.

(24) Diopter Adjustment Knob
Allows the photographer to adjust the view finder to accommodate individual differences in vision.

SLR Digital Camera (Back View)

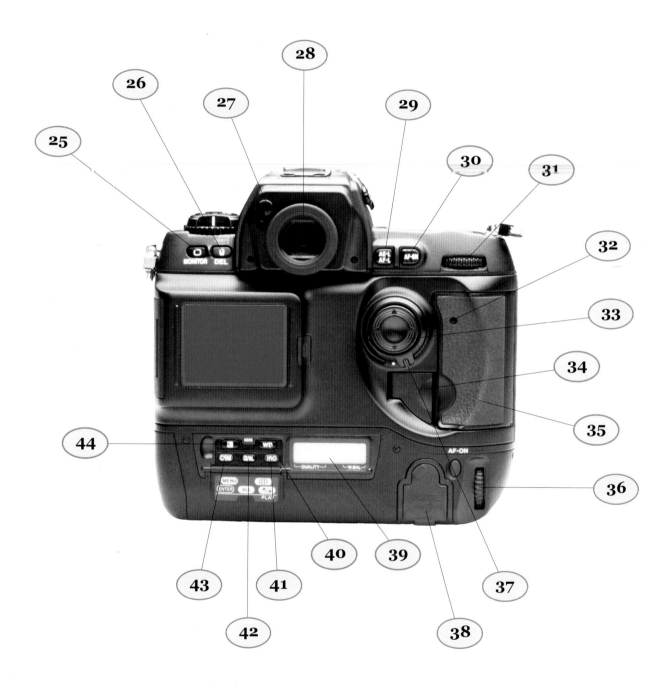

(25) Monitor Button
Turns the rear monitor LCD on and off.

(26) Delete Button
Used to delete unwanted images from the camera's memory. It also doubles as one of two format buttons that when pressed will format a CompactFlash card for the camera.

(27) Eyepiece Shutter Lever
When activated this lever closes a shutter within the view finder to prevent light entering the camera when the photographer has taken his or her eye away from the view finder.

(28) View Finder Eyepiece
The photographer views the scene from here.

(29) AE/AF Lock Button
This button, when depressed, locks the auto exposure (AE) and auto focus (AF) so that the photographer can recompose the shot but still retain the original settings.

(30) AF Start Button
The AF (auto focus) start button turns the camera's auto focus functions and metering functions on in the same way as lightly depressing the shutter button. This button also acts as a cancel button when viewing images on the LCD monitor in playback mode.

(31) Main Command Dial
This dial is used to set shutter speed in manual mode and performs numerous other functions in concert with other command buttons.

(32) Memory Card Access Lamp
This light blinks when the card is in use.

(33) Focus Area Selector
This control allows the selection of the focus area within the view finder. In playback mode it allows the scrolling of the images captured in the camera's memory.

(34) Card Slot Release Button
This button must be depressed to open the cover for the CompactFlash card.

(35) Cover for CompactFlash Card

(36) Main Command Dial (Vertical)
Performs the same functions as the main command dial (31) when the camera is in the vertical shooting mode.

(37) Focus Area Selector Lock
Used to lock and unlock the focus area selector.

(38) IEEE 1394 Connector Cover
Connects the camera to a computer via a six-pin IEEE 1394 cable.

(39) Rear Control Panel
Displays various information mainly in regard to the camera's set up.

(40) White Balance Button/Thumbnail Button
Sets the camera's white balance function to the prevailing light conditions. The camera can be set up in the following white balance modes: auto white balance, incandescent, fluorescent, direct sunlight, flash, overcast, shade, and preset white balance. (Note: white balance is discussed in more detail in the Chapter 5, Useful Accessories). In playback mode this button will display thumbnails (small photographs) of the images in the camera's memory.

(41) Sensitivity Button
Sets the sensitivity of the camera to light. This control acts in the same manner as ISO does in regard to film. ISO settings are as follows: 200, 400, 800, and 1600. This button also allows the selection of multiple images in playback mode.

(42) Image Quality Button
Allows the photographer to select from various image quality settings as follows: hi (raw), hi (YcbCr TIFF), hi (RGB TIFF), fine (JPEG 1/4), norm (JPEG 1/2) and basic (JPEG 3/4). This button also doubles as a select-all command in playback mode.

(43) Custom Settings Button
Allows the setting of various custom settings. Also operates as an execute command in playback mode.

(44) Command Lock/Menu Button
Locks the camera's shutter speed so that it is not accidentally changed.

Base View (not shown)

On the base of the camera is a tripod socket and at the front (on the base) is a shutter release button (with lock) for vertical shooting. This control operates exactly as the shutter release button on the top of the camera (18). The NiCad battery pack fits into the camera from the side closest to the LCD screen.

Things to Consider When Purchasing a Digital Camera

1. Should you purchase a compact digital camera or the much more expensive (at the moment) 35mm digital SLR camera?
2. What is the resolution you will require (how large a print do you want)?
3. Do you require a camera that has the capabilities to go from wide-angle to long telephoto or is a more modest field of view coverage adequate for your needs?
4. What on-board (camera) image storage capacity do you need?
5. Do you require the camera to allow manual override settings or is a fully automatic camera sufficient for your needs.
6. Do you need flash coverage greater than the 10ft (3m) average that most compact digital cameras have?
7. If you are going to print your own work, does the camera come with at least a basic image editing program or will you have to spend more money in this area?
8. What is the expected capacity of the camera's batteries and what is the cost of purchasing spares?

These questions should be considered carefully before committing your hard-earned cash into the digital photography world. Hopefully this book will help you make a reasoned decision in this regard.

Historic House, Chicago, Illinois, USA

Lenses for the Digital Camera

Ferris wheel, Luna Park, Sydney, Australia

The lens is the camera's eye on the world. Like the human eye it is very important and must be cared for and protected.

There are many lenses on the market, all of which have different capabilities and uses.

Understanding lenses and their capabilities is an important part of photography and will assist you greatly in producing better-quality images. So let's begin.

Occasionally in this chapter (and elsewhere in this book) I will be using the expression "angle of view" in reference to lenses. Angle of view simply refers to the view that is available through the lens, or put another way, it is what the lens can see.

For instance, a wide-angle lens is said to have a wide angle of view (naturally) because it will present a view that covers more of a scene than does the human eye. Conversely a telephoto lens is said to have a narrow angle of view because it will present a restricted view of the scene, in comparison to the human eye.

I also use the term "focal plane" in this chapter, and elsewhere in this book. The focal plane (sometimes also called the "film plane") is that point where the lens focuses the image it is transmitting, onto the CCD or CMOS imaging sensor.

Also, in this chapter, the term "fast" is used in relation to lenses. A fast lens is one that will let in more light (have smaller f-stop numbers), in comparison to other lenses. For instance a 50mm lens with a maximum aperture (smallest f-stop number) of f1.8 is said to be faster than another 50mm lens with a maximum aperture of f2.

Focal length is another term that pops up in this chapter, and elsewhere in this book. Focal Length refers to the distance between the rear lens element and the film plane, when the lens is focused on a subject at infinity.

Before we get into the subject of lenses for the digital camera in detail we had better have a look at the question of "angle of view" in relation to the digital camera.

With a 35mm film camera the size of each frame (negative or slide) is 36mm X 24mm. So when the lens transmits the reflected image to the film plane it is this area (36mm X 24mm) that is exposed to the light and captures the image.

Some of the many lenses available for 35mm digital SLR cameras

With digital cameras it is a slightly different story. You see the CCD or CMOS imaging sensors are all currently smaller that a 35mm film frame.

For instance the sensor on the Nikon D1 digital SLR camera is 23.7mm X 15.6mm. Other digital cameras have different sized chips of even smaller proportions.

"So what?" I hear you say. "How does this affect me?" Well let's say you have a Nikon D1 digital camera (lucky you!). Attached to this camera is a standard 50mm lens. Now as you will read a little further on in this chapter, the 50mm lens is called a standard lens because its angle of view is approximately that of the human eye. So looking through the camera's viewfinder will give you a view similar to that your eye gives.

But the 50mm lens transmits an image to the camera's focal plane that will cover an area of 36mm X 24mm (standard 35mm film frame size). However, as we already stated, the cameras CCD imaging sensor is only 23.7mm X 15.6mm, which is, of course, smaller than 36mm X 24mm. Therefore part of the transmitted image will not be recorded on the CCD sensor and the angle of view changes.

The result of all this is that you need to apply a factor (depending on the size of the camera's CCD or CMOS chip) to interpret what angle of view a particular lens will give with your digital camera.

With the Nikon D1 example, for instance, that factor is 1.5. To use this factor you simply multiply the lens size by this factor to give the equivalent digital camera focal length.

Film Frame and Image Sensor size comparison

- - - - - - - - - - - - *35mm film (36X24mm)*
———————— *Nikon D1 (3.7X15.6mm)*
·························· *General digital camera (8.8X6.4mm)*

| Lens Focal Length | 35mm Film Lens Classification | Equivalent Digital Focal Length (X 1.5) | Digital Lens Classification |
| --- | --- | --- | --- |
| 20mm | Wide Angle | 30mm | Moderate Wide Angle |
| 30mm | Moderate Wide Angle | 45mm | Standard Lens |
| 50mm | Standard Lens | 75mm | Long Standard/Short Telephoto |
| 100mm | Short Telephoto | 150mm | Short Telephoto |

The table above gives examples of how this works.

You can see from the above that with the Nikon D1 each lens needs to be multiplied by the 1.5 factor to give its effective focal length.

Each digital camera is different in this regard depending on the physical size of its CCD or CMOS imaging sensor. Fortunately the camera's manufacturers normally quote the equivalent 35mm lens specifications in their manuals so calculating the digital angle of view specifications for different lenses is quite a simple task.

In this chapter when I talk about the focal length of a lens I will use the 35mm (film) lens specification for simplification. You then need to apply the factor to calculate the angle of view for a lens with a particular digital camera.

Now on to the subject of lenses.

So what is a lens?

Put simply, a lens (in photographic terms) is an instrument that can collect light being reflected from your subject, and focus that light at the position within the camera known as the focal plane. The focal plane is the position, directly behind the shutter, where the CCD or CMOS imaging sensor is positioned. This allows a sharp image of the scene being photographed to be recorded.

The lens is usually made of metal (sometimes plastic) and normally contains several pieces of glass (again sometimes plastic) of different shapes, known as lens elements.

Convex (left) and concave (right) lens elements

I could go on for pages and pages explaining in great detail how these various lens elements work. I could wax lyrical on the different effect that each lens element has on light and how, in the end, you end up with a sharp focused image.

The good news is that I won't. Suffice to say that a lens will collect light being reflected from your subject and focus that light on your film. That really is the essence of the matter.

The lens has a built-in internal control called the aperture. The aperture controls the amount (quantity) of light that is allowed to pass through the lens, and eventually strike the film.

Cut away of a lens (Maxwell Optical Industries)

Lens aperture

The aperture does this by either opening or closing (thus making either a larger or smaller hole for the light to pass through), and allowing more, or less, light to pass through, as the case may be.

Obviously as the opening made by the aperture gets smaller, less light will be allowed to reach the sensor. As the aperture gets larger, more light will be allowed to strike the imaging sensor.

Minimum, medium, and maximum lens apertures

To control the size of the aperture some lenses have a rotating ring on the lens barrel called the aperture selection ring (naturally), which when rotated will either open up (let more light in) or stop down (let less light through) the lens.

2 • • 2.8 • • 4 • • 5.6 • • 8 • • 11 • • 16 • • 11 • • 22

Representation of aperture ring showing f-stops.

35mm digital SLR camera lenses either have an aperture selection ring or, alternatively, a master control on the camera body that controls the aperture size.

However, most compact digital cameras do not have an adjustable aperture. Instead they tend to have a fixed aperture that is not adjustable by the photographer.

This fixed aperture does adjust if the lens is extended. This is because as the lens is extended the light has further to travel and so is effectively reduced in intensity at the focal (or film) plane.

Notice that the aperture selection ring has numbers engraved on it. Typically these numbers could run like the example illustrated above.

These numbers are known as f-stops and if a lens is set at 8, it is said to be set at f8.

Each f-stop will allow a different quantity of light to pass through the lens. The dots between the f-stops represent fractions (normally thirds) of an f-stop, and allow small adjustments to be made to exposure calculations.

A 50mm lens set at f8 allows exactly the same amount of light to pass through to the focal plane, as does a 200mm lens, also set at f8. This rule applies to all f-stop numbers, regardless of the focal length of the lens.

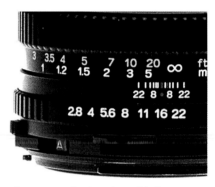

Aperture selection ring with f-stops indicated in white on lower ring

200mm lens and 50mm lens both set to f8

Yet when you look at the photograph above it is obvious that the aperture opening on the 200mm lens is larger that on the 50mm. If that is so, how is it that they both let the same amount of light through? Surely the 200mm lens with its bigger opening will let more light through.

Not so, because light lessens in intensity the further it has to travel. The 200mm lens is considerably longer that the 50mm model. Therefore the light has to travel further to reach the focal plane and so, on the 200mm lens, the aperture opening needs to be bigger at f8 to allow the same quantity of light through as a 50mm lens also set at f8.

Let's go back to that f-stop table illustration.

These numbers will vary somewhat, depending on the lens involved. However, there are two important rules that you need to understand in relation to f-stops.

The first rule is that each f-stop number represents either a doubling, or halving, of light allowed to pass through the lens.

The second is that a larger f-stop number does not mean more light, it means less light!

So if you combine these two rules you get the situation that if your lens is set on, say f8, and you change it to f5.6 (a smaller f-stop number), you allow twice as much light to pass through the lens. Conversely, if you change the aperture from f8 to f11 (a bigger f-stop number), you allow only half as much light through the lens.

This is a very important feature of how a lens operates and you need to understand it!

Remember a smaller f-stop number means more light while a larger f-stop number means less light.

This now brings us to two other features of lenses—focus and depth of field.

I will be going into more detail about both of these subjects in later sections of this book, but we need to discuss them here as well.

Focus

In the majority of cases it is desirable that the subject you are photographing is recorded on the imaging sensor in sharp detail. This is called having the subject in focus.

If the subject is not in focus, there could be three reasons for this (presuming the lack of sharpness is not deliberate).

The first reason for lack of sharpness is camera shake, which would cause your photograph to come out blurred. Camera shake is normally caused by the use of a shutter speed that is too slow for a hand-held camera.

Any shutter speed less than 1/30 of a second is considered to be a risk in relation to camera shake. But to be safe, 1/60 of a second would be better!

However, this is when using a 50mm standard lens. If you are using a lens with a longer focal length, then to be sure of eliminating camera shake, you should use a minimum shutter speed that is the equivalent to the focal length of the lens in use. If you are using a 105mm lens you should use 1/125 of a second shutter speed. With a 250mm lens a shutter speed of 1/250 of a second, and so on.

Country restaurant out of focus (left) and in focus (right)

Subject movement frozen (left) and blurred (right)

The second reason for lack of sharpness is subject movement combined with, again, a shutter speed that is too slow to freeze the subject. A minimum shutter speed of 1/60th of a second is considered necessary to freeze subject movement. Of course if you are trying to capture the Concorde traveling at Mach 2 you might want to try a higher shutter speed to be safe.

You need to also remember the camera shake problem here as well. A shutter speed of 1/60 of a second should freeze the movement of, say a car, but if you are using a 250mm focal length lens then camera shake could rear its head again.

So to freeze movement remember that a minimum shutter speed of at least 1/60 of a second is required, with the overriding factor that if the lens in use has a focal length in excess of a standard lens (50mm) then use a minimum shutter speed equivalent to the focal length of the lens.

A digital compact camera will not, normally, allow you the luxury of adjusting your shutter speed. However, some models do have a camera shake warning light. If this is the case, and the camera shake warning light blinks, you should brace both yourself and the camera.

Chapter 6, "Troubleshooting and Maintenance," shows several ways you can can brace a camera in this situation.

Note that some manufacturers are now producing lenses that incorporate features designed to assist with the camera shake problem. There are several of these lenses now on the market and they are normally labeled "image stabilized."

This new feature greatly improves the camera shake problem but unfortunately is limited, at the current moment, to a restricted number of lenses. However, I am sure that in time this worthwhile feature will become more prevalent in the market.

The third reason for lack of sharpness is the lens being incorrectly focused on the subject. While the human eye automatically adjusts its focus depending on the distance to the subject it is viewing, the camera lens normally needs some help with this function.

However, this is not always the case. Some compact cameras do not have a focus control function; instead they are designed so that everything from about 4ft (1.2m) to infinity (∞) is in focus. This is accomplished with a combination of lens design and aperture settings within the lens itself.

Others have an autofocus function which automatically focuses the camera for you. A focus lock facility is handy here in case you want to recompose the photo once it's in focus.

Canon 100-400 image stabilized lens

Other compact cameras have various symbols to help achieve focus. For instance, the symbol of a head would indicate a distance of some 4ft; a head and half body would indicate a distance of some 6ft (1.8m); while a symbol of mountains would indicate infinity (∞).

You should check your camera manual for precise instructions on focusing your camera.

This lack of focus control on most modern compact cameras is both a blessing and a curse. It is a blessing because you don't have to think about focusing at all, just point the camera and fire away.

It is a curse because firstly, if you want to take a close-up of that beautiful flower or insect you cannot get closer than about 4ft (1.2m), which in close-up terms is not all that close. Some compact cameras do, however, have a macro mode that will allow the camera to take this type of shot.

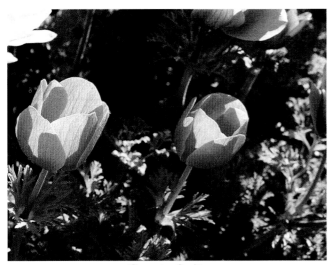

Closeup of tulips

It is also a curse because sometimes you may wish to isolate a subject from either the foreground or background (and sometimes both).

There are two ways to achieve this. The first way is to use a long focal length lens to bring the subject toward you and fill the frame. An example of this technique is shown above right.

Notice how the depth of field is very shallow. Depth of field, discussed later in this chapter is, in essence, simply what is in focus, within your photograph, both in front of, and behind, your point of focus. The longer the focal length of a lens the shallower the depth of field becomes.

Mother and child (Steve Hlavenka)

The second way to isolate the subject is by having the foreground and background out of focus, so that only the subject stands out.

If your camera's lens is in focus over its entire field of view that is not possible, so you are left with a photo that is spoiled by distracting foreground or background.

But 35mm digital SLR camera lenses are a different kettle of fish. They will normally have manual focus ability and most, combined with the correct camera body, will also have an autofocus capability.

This means that the photographer can select a point of focus utilizing the focus ring on the lens barrel (in manual mode) or, in autofocus mode, have the camera automatically focus on the desired point of focus.

The ability to select a point of focus combined with the control of depth of field (which I will discuss next) gives the photographer much greater control over how the final image presents to the eye.

Isolated subject (Izzy Perko)

Depth of Field

Depth of field is a photographic term that defines what is in focus within your shot both in front of, and behind, your point of focus.

Point of focus is simply the area of the subject that you use to focus the lens.

For instance in the photograph of the young girl below the point of focus is her eyes. As you can see the remainder of her face and body are also in focus but all other detail is not as sharp. Therefore in this shot depth of field can be said to extend from approximately three inches in front of her eyes to perhaps five inches behind.

This shot was taken with the child in a doorway. It is an excellent example of using natural light and framing to produce a lovely soft portrait.

Child in doorway (Steve Hlavenka)

Depth of field is controlled by:

1. The focal length of the lens you are using—the greater the focal length, the less the depth of field.

2. The aperture setting of the lens you are using—the higher the f-stop, the greater the depth of field. For instance using an f-stop of f16 results in greater depth of field than using f5.6. Conversely if you use f2 this would give far less depth of field than an aperture of f8.

It should be noted that depth of field does not extend equally in front of and behind the point of focus.

Rather, as a general rule, the depth of field produced by a particular lens will extend approximately one-third in front of the point of focus and two-thirds behind. The illustration below shows clearly this one-third/two-third ratio and the effect different focal length lenses have on depth of field.

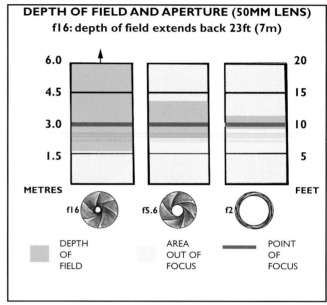

The one-third/two-thirds rule

In the illustration below I show the effective depth of field of three different focal length lenses, all set to f8. Note that the longer the focal length of a lens becomes, the less the depth of field at a given aperture setting.

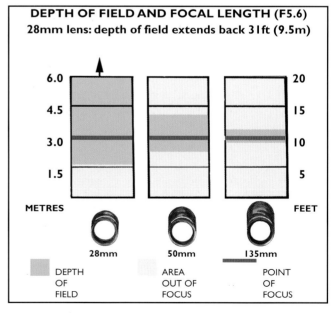

Focal length and depth of field

So if depth of field is what's in focus both in front of and behind the point of focus, how do we know what the depth of field at any given lens setting is?

On a digital compact camera you don't. Sorry, but compacts don't have the necessary facilities to enable the user to gauge the depth of field of any particular shot. You will have to take potluck and wait to see your photographs developed.

However on a 35mm digital SLR camera it is a different story. Most 35mm digital SLRs have a nice little button called a depth of field preview button.

The way this button works is simple: press it in and the aperture in the lens will stop down (close) to whatever f-stop you have set (say f8). Your viewfinder darkens because, with the aperture stopped down, less light is coming through the lens.

Looking through the viewfinder, with the depth of field preview button pressed in, will give you a very good indication of what is in focus in your shot and what is not. In other words, you will see the depth of field applicable to your particular lens and f-stop selection.

The lens on your 35mm digital SLR, for example, may be a 50mm f2. This means that its maximum aperture (which lets the most light through) is f2 and its minimum aperture (which lets the least amount of light through) may be f22.

When you look through the camera's viewfinder (and presuming you are not holding in the depth of field preview button) the lens is always wide open (set at f2) regardless of the fact that you may have set the aperture selection ring at f8.

This is because the lens, set at f2, will allow the most light through at this maximum aperture setting. This light is reflected by the camera's mirror up into the pentaprism that houses the viewfinder, thus giving the photographer the brightest image possible (in the viewfinder) while setting up the shot.

The pentaprism is the area on top of a 35mm digital (or film) SLR that houses the viewfinder.

When the photographer trips the shutter to take the shot, three things happen. Firstly the mirror springs up to allow the light to travel directly to the camera's focal plane, instead of being reflected to the viewfinder. This blocks the photographer's view through the viewfinder for a fraction of a second.

Secondly the aperture stops down (closes) to the f-stop you, or the camera in some automatic modes, have preset. In this example the aperture was preset the to f8.

Finally the shutter opens for a preset time (say 1/125th of a second) and the light, passing through the lens, is allowed to record on to the imaging sensor. Then the shutter closes, the aperture opens up to f2 again, and finally the mirror drops down allowing the photographer to see through the viewfinder again.

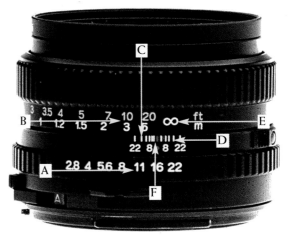

A Aperture selection ring with f-stops.
B Distance scale in feet (yellow) and meters (white).
C This line represents f16 (front), indicating the closest distance to the camera that will be in focus when the lens is set at f16.
D This line represents f16 (back), indicating the furthest distance from the camera that will be in focus when the lens is set at f16.
E Infinity symbol. In this case anything further than 30ft (9.7m).
F Depth of field indicator lines. The red line in the center represents the smallest f-stop number on this lens (f2.8) and it also doubles as the focus mark. The lines radiating to the left and right of the center line each represent the other f-stop numbers on this lens. The lines to the left of the center line indicate the distance closest to the camera, from the point of focus, that will be in focus. The lines to the right of the center line indicate the distance from the point of focus, to infinity, that will be in focus. The second red line, two to the right of the center line, not only represents f5.6 but also doubles as a focus mark when using infra-red film (which has a different point of focus).

The pentaprism of a 35mm camera

Depressing the depth of field preview button simply closes down the aperture to whatever f-stop you have preset, while keeping the mirror in place, so that you can still see through the lens. With the aperture stopped down to your preset f-stop you get a very good indication in the viewfinder of the depth of field.

There is a second way to determine the depth of field available when using a particular lens and f-stop.

Notice in the photograph (previous page) that, engraved on the lens barrel just above the aperture selection ring and below the distance scale, the f-stop numbers are repeated with line indicators.

If your lens is focused at 25ft (7.6m) as in the previous example, and set at f16 again, then all you need to do is find f16 on this secondary scale on the lens barrel.

To the left (on this secondary scale) you can see f16. If you follow its indicator line up to the distance scale you will see that it points to around 17ft (5.2m). On the right of this secondary scale you will find f16 again. Follow its indicator line and you will see that it is pointing to the infinity symbol (∞).

Therefore, although your lens is focused at 25ft (7.4m), your depth of field extends from 17ft (5.2m) out to infinity (∞). Neat eh?

Obviously if you change your f-stop from f16 you then find the guidelines applicable to your new f-stop selection.

It is rare for compact camera lenses or zoom lenses to have depth of field indicator lines and they are normally only found on individual lenses (not zoom), for example, a 50mm or a 200mm lens.

This brings up another point associated with depth of field called hyperfocal focusing.

Again, to take advantage of this a compact camera will normally not do the job—you will need a 35mm digital SLR.

Say you are about to take a shot of this beautiful valley stretching away before you. You have the aperture set at f16 and you are focused on infinity (∞).

You look on the lens' depth of field indicator scale and notice that it indicates that your depth of field stretches from 22ft (6.7m) to infinity (∞). Not too bad.

Lens settings before (TOP) and after (BOTTOM) hyperfocal focusing

Try this: reset your focus point to 22ft (6.7m) instead of infinity (∞). Now look at your depth of field indicator scale. All of a sudden you depth of field has extended and now runs from around 16ft (5m) to infinity (∞).

If in-focus foreground was important to your shot, you just picked up an extra 6ft (2m) of it.

There is another way to use this helpful feature. Say you are in a situation where photo opportunities develop quickly and don't give you much time to refocus.

Well, don't refocus. Simply leave the lens set on its hyperfocal focus setting. That way you know that everything from 16ft (5m) to infinity (∞) is in focus.

Sixteen feet is not a hard distance to judge by eye so that you should be able to position yourself easily to ensure that everything is in focus.

Simply adjust only the camera's shutter speed to allow for varying light conditions and shoot. Be careful, though, that the shutter speed doesn't become too slow and give you a problem with camera shake.

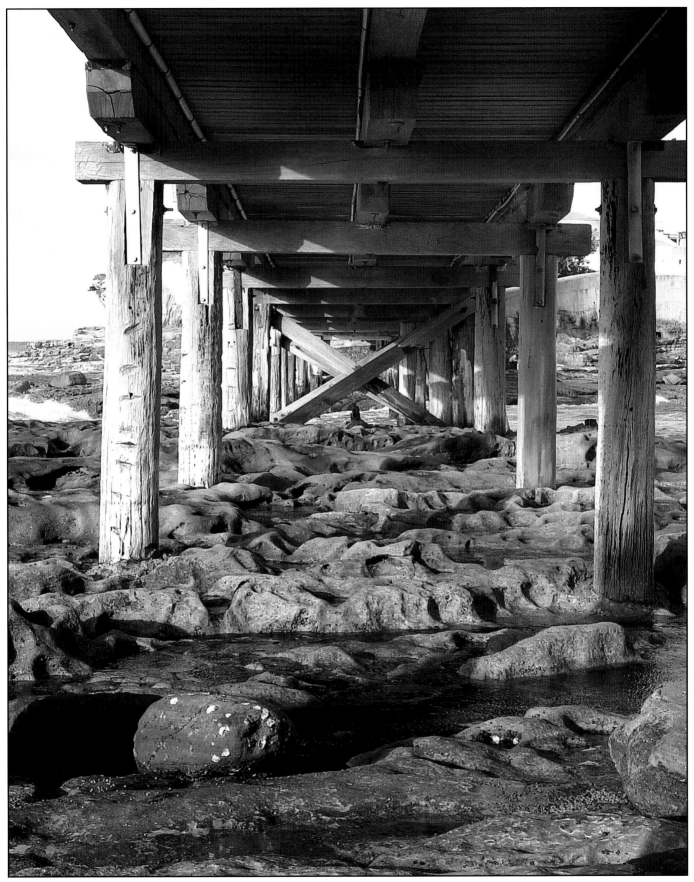

Under the bridge

Types of Lenses

There are so many lens types on the market it is difficult to know where to start.

But start we must, so here we go. I'll start with the easy one.

Digital Compact Camera Lenses

These cameras normally only have one of two types

Digital compact camera with zoom lens

of lenses. Some have a lens of fixed focal length normally between 35 and 40mm (35mm lens specification). That means the lens has no zoom capability and normally has a field of view that is similar to human eyesight.

While having a fixed focal length lens helps in keeping down the cost of the camera, unfortunately it also restricts your options in photography.

You have no zoom capability to get closer to the subject or to compress the perspective. You also, normally, do not have any control over aperture settings (the camera does this automatically) and therefore, have no control over depth of field.

The second type of lens that can come with compact cameras is a zoom lens.

A zoom lens is so called because you can zoom between variable focal lengths thus enlarging or reducing the image size. This gives the photographer much more scope when composing his shot.

With this type of lens the photographer has a range of focal lengths that start at a moderate wide-angle, move through to a normal lens configuration, and then expand up to a short-range telephoto, which is normally ideal for portraits.

Typically a zoom lens attached to a modern compact digital camera will have a focal length range from about 35mm (moderate wide-angle) through to 105mm (portrait or short telephoto). Again these are 35mm lens specifications.

As with the fixed focal length I spoke about earlier there will be no control over aperture settings, and therefore no control over depth of field.

A depth of field preview button will also not be an option, for with these types of cameras, you are viewing the scene directly through the camera's rangefinder window. For a depth of field preview button to be effective you need to be viewing your scene through the lens, as is the case with 35mm SLR digital and film cameras.

Digital 35mm SLR Camera Lenses

The 35mm digital SLR camera has so many varieties of lenses available that they write entire books on the subject.

I am going to keep it simpler than that (as I promised at the outset).

Over the following pages you will find the various types of lenses that are available for the 35mm digital SLR camera, together with a brief description of their general specifications and uses.

Before I get to that a few points need to be made.

Most camera makers (in the overall 35mm SLR market) produce a whole range of lenses specifically for their own cameras. These lenses will not normally fit another make of camera.

Therefore, when purchasing a lens for your particular 35mm digital SLR camera you are restricted to the lenses offered by your camera's manufacturer or, as an alternative, you could choose a lens from an independent lens maker that can be adapted to suit your particular camera.

Most professional photographers, and serious amateurs as well, seem to prefer to stick to lenses made by whichever manufacturer produced their camera body, as do I.

However, it must be said that some of the more specialized lenses from these manufacturers cost an arm and a leg.

You may well find that if you get to this situation that you are better to look at a similar lens from an independent lens maker.

In all likelihood it will be cheaper that the one from the camera manufacturer and do the same job for you.

There are a number of independent lens manufacturers with products on the market. To choose one particular brand over another, you should get some advice from your camera store retailer.

I will introduce the various types of lenses to you starting with the type that has the widest angle of view and then proceed through the range up to the narrowest angle of view.

Once that is done I will move on to zoom and speciality lenses.

Please remember that in this next section when referring to a 35mm SLR lens' focal length I will be talking about them in the context of a film camera. You must then apply the digital factor, as discussed at the start of this chapter, to the lens to determine its equivalent digital focal length.

16mm fisheye lens

The Fisheye Lens

The fisheye is an ultra wide-angle lens. Typically, it will have a focal length of between 6 and 16mm.

Where a normal wide-angle lens is produced in such a manner to ensure that vertical and horizontal lines in the subject are recorded on the film as vertical and horizontal lines, this is not the case with the fisheye lens.

With the fisheye lens straight lines are recorded as curves and the final image has the appearance of a convex mirror reflection.

Some fisheye lenses record a normal rectangular image while others record a circular image in the center of the frame.

Because of their limited use in photography, fisheye lenses are not normally a low-cost item.

Note: With digital 35mm SLR cameras fisheye lenses are not as effective as they are with traditional 35mm film cameras. You will still get the fisheye effect but not to the same degree as with traditional 35mm SLRs.

Typical fisheye effect (Warrewyk Williams)

Wide-Angle Lenses

The wide-angle lens includes focal lengths ranging from around 15mm through to 35mm. Unlike the fisheye lens, the wide-angle lens is corrected to ensure that vertical and horizontal line are recorded faithfully on your image.

One of the more useful lenses in the photographer's camera bag, its uses include landscape photography, group shots, and architectural shots.

28mm wide-angle lens

Kicking up your heels (Steve Hlavenka)

50mm standard lens (Maxwell Optical Industries)

The Normal (or Standard) Lens

The normal or standard lens usually is considered to be around the 40-50mm size.

This is because the 40-50mm lens's angle of view approximates that of the human eye.

Normal or standard lenses have many uses and, in addition, are usually amongst the cheapest lenses available for the 35mm SLR.

In addition to this they are quite often among the fastest lenses in the photographer's arsenal.

Prices vary depending on how wide you want to go but most manufacturers have a reasonably priced model around the 28mm mark, which is a very useful focal range.

Wide-angle lenses with focal lengths of less than 24mm tend to get a tad more expensive.

Although wide-angle lenses are corrected to ensure that vertical and horizontal lines are recorded faithfully on the image, this type of lens can be used to produce an image that appears distorted.

In the photo above, taken with a 24mm wide angle lens, the person on stilts looks distorted due to the close distance that the photographer used to take this shot combined with the great depth of field that the 24mm wide angle lens provided.

However, note that the lens accurately reproduces the vertical and horizontal aspects of this shot.

Restaurant on the left bank, Paris. Taken with a 50mm lens.

300mm telephoto lens

Bonita Point lighthouse, San Fransisco.
Taken with a 300mm telephoto lens.

The Short and Long Telephoto Lens

The short telephoto lens includes the lenses within the boundaries of 85mm up to 250mm; long telephoto lens range from around 300mm up to 1000mm.

Both of these groups have a multitude of uses including landscape photography, sports photography and wildlife photography.

In addition, a short telephoto lens of around 100mm is considered ideal by many photographers (myself included) for portrait photography.

These lenses have a restricted field of view; in fact, the longer they are, the more restricted the field of view becomes, which can be quite useful in certain situations.

They are not normally particularly fast lenses, with apertures starting at around f2.8. There are some long telephoto lenses that are quite fast but the cost of these models is quite horrifying. The not-so-fast models, however, are more reasonably priced.

If you are into landscape, portrait, wildlife, or sports photography, you should look at including one or more of these lenses in your camera bag.

The Zoom Lens

Zoom lenses are designed to have a variable focal length. For example, 24mm to 120mm, o, 80mm to 200mm.

The focal length is controlled by an extra control ring on the lens barrel, which when turned will vary the focal length. On some models, instead of turning this zoom control ring, you slide it either forward or backward.

These are very handy pieces of equipment, since you get two or three normal lenses in one lens.

Naturally they tend to cost more than the straight fixed focal length lens, but when you consider that they can take the place of two or three of these they are actually quite economical and well worth considering.

80–200mm zoom lens (Maxwell Optical Industries)

The Mirror Lens

The mirror lens is a specialized variant of the long telephoto lens. It has a number of advantages over the long telephoto lens and some disadvantages. It normally comes in focal lengths of 500mm or 1000mm.

Because of their unique design they are much shorter than the long telephoto lens that they are designed to replace (they are also fatter). They are also lighter than their equivalent long telephoto lens and this is quite a consideration if you are lugging around a camera and three or four lenses all day (unless you can talk your partner into carrying the equipment—fat chance in my case!).

More good news in regard to mirror lenses. They are cheaper than their comparable long telephoto counterpart.

Now the bad news. They have a fixed aperture, normally around f8.

This means that the only controls you have for correct exposure are the shutter speed and the ISO setting, which can limit you in certain situations. And you have no control over depth of field.

One other note regarding mirror lenses. They incorporate a rear-facing mirror that will produce donut-shaped rings around any highlights that are out of focus within your shot.

Having said all that, the mirror lens is a useful tool and should be considered as long as the photographer takes these limitations into account.

The Shift Lens

If you take a photograph of this interesting building from the pavement you may be in for a shock when your photograph is displayed.

When you look at the photo you will see that the building appears to be falling backward (see next page). Funny how you didn't notice this at the time of taking the photo.

The building is obviously not falling over! What has happened is that the position you took the photo from resulted in a situation that made the distance from your camera to the bottom of the building very much shorter than the distance from the camera to the top of the building (see illustration on next page).

Canon shift lens can both tilt and shift to correct perspective problems.

This considerable difference in the distances from the camera to the top and bottom of the building records on your image sensor and, there you are, the building is falling over.

To overcome this problem those clever little makers of lenses designed the shift lens.

Sydney Harbour Bridge: shot at 80mm (left), 120mm (center) and 200mm (right)

Apartment houses with perspective control (left) and no perspective control (right)

This is normally a 28mm or 35mm lens that has a special facility that allows the lens to be racked (shifted) or tilted, sometimes both.

Therefore you can stand in front of the building with the camera pointed vertically as normal.

Then rack the lens so that not only does your picture encompass the entire building but also the lines of the building no longer seem to converge at the top, which gives the appearance that the building is falling over.

This is a very useful piece of equipment if you are into architectural photography. Unfortunately it is not cheap so if you don't plan to photograph a whole lot of buildings, I'd probably forget it.

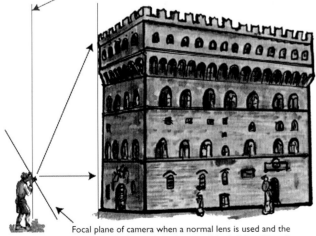

Focal plane of camera when a perspective control lens is used to photograph the building. Note the focal plane of the camera is now parallel to the building.

Focal plane of camera when a normal lens is used and the camera is tilted to include the top of the building. Note the focal plane of the camera is not parallel to the building.

The Macro Lens

Macro-photography is a term that covers photography of subjects either on a life-size scale (expressed as 1:1) or larger than life size, perhaps up to 10 times life size (1:10).

Subjects like wildflowers and insects make ideal macro subjects, as do a host of other items.

Canon 100mm macro lens

To photograph a subject at a ratio of 1:1 or larger the macro lens was developed and most 35mm SLR systems have at least one in their range. In addition there are a number of independent lens manufacturers who offer macro lenses, which can be adapted to suit most 35mm Digital SLR Cameras.

Some zoom lenses incorporate a macro facility as well and this can save the photographer considerable expense, as you effectively get two or three lenses for the price of one.

Some compact cameras do not have the ability to take photographs in a macro mode. Others, especially the more modern variants, have a macro mode program.

Embossing on a model canon at 1:1

Canon 100mm macro lens

Teleconverters (35mm SLR Cameras)

In addition to buying different lenses for your 35mm SLR you can also effective double your present lenses focal length by the use of a teleconvertor.

A teleconvertor fits between your lens and the camera body. Typically a teleconvertor might be classed as a two times (2X), which means that, when fitted, it will double the focal length of the lens attached.

The model in the photograph is a 2X unit.

Therefore if you fitted this teleconvertor onto a 200mm lens you will end up with a 400mm lens.

The downside to this is that because you are extending the distance that light has to travel through the lens, you will lose two f-stops. For example if your 200mm lens had a maximum aperture of f4, with a 2X teleconvertor attached, the maximum aperture would now be f8.

Remember that when discussing the focal length of a lens as we have just done we are talking in terms of 35mm film lens classification. For 35mm digital SLR cameras you need to apply the appropriate factor to calculate the equivalent digital focal length of the lens in question.

Summary

- Angle of view, or field of view, refers to the view that can be seen through the lens.
- Focal plane refers to the point where the lens focuses the image being viewed.
- The aperture controls the amount of light that passes through the lens. This is achieved with a series of settings known as f-stops. Each f-stop doubles (or halves) the light passing through the lens.
- High f-stop numbers mean less light and low f-stop numbers mean more light. Therefore f16 will allow less light to pass through the lens than will f5.6.
- Lack of focus in a photograph could be caused by a number of things including:
 1. Camera shake
 2. A shutter speed too slow for a moving subject
 3. Incorrect focusing
- Depth of field defines what is in focus both in front of and behind your point of focus.
- Depth of field is controlled by:
 1. The focal length of the lens used
 2. The aperture setting (f-stop) used
- The higher the f-stop (less light passing through the lens), the greater the depth of field.
- Longer focal length lenses have less depth of field.
- Depth of field is normally not controllable on compact cameras.
- Many 35mm SLR cameras have a depth of field preview facility that allows the photographer to view the depth of field before taking the shot.
- Some 35mm SLR lenses have depth of field indicator lines to assist in gauging depth of field.
- Fisheye lenses have an extra wide angle of view but produce a distorted image.
- Wide-angle lenses produce a nondistorted view with an angle of view greater than human sight.
- Normal or standard lenses produce an angle of view similar to human sight.
- Short, medium, and long telephoto lenses produce an angle of view that is narrower than human sight.
- A zoom lens combines different focal lengths.
- A mirror lens is a long telephoto lens that has a fixed aperture, due to its design.
- A shift lens can be adjusted to correct perspective problems, for instance, photographing tall buildings.
- A macro lens allows photography of small objects at life size (1:1) or larger.
- Teleconverters are an add-on that can increase the focal length of a lens. However, they decrease the maximum aperture available.

Matthew

Stand-alone flashgun

Flash Equipment

The Flashgun

The flashgun is a small portable light source that can deliver a brief burst of light that lasts for a fraction of a second. It should be noted that the light delivered by the flashgun is similar in color temperature to daylight, and therefore when using a flashgun you should have your digital camera's white balance control set for auto, daylight, or flash.

The flashgun is normally powered by batteries, whether disposable or rechargeable, but in some cases can be powered by normal household current via a transformer.

The flashgun connects to the camera (presuming it's not built-in) either via the camera hot-shoe, or alternatively, via a cable connected to the camera's coaxial socket.

SLR camera's hot-shoe and coaxial socket

The flashgun is one of the most useful tools that the photographer can possess.

Whether the flashgun is built into the camera or a separate stand-alone type, it can provide the photographer with a whole range of photographic options not otherwise available.

It is also true to say that the flashgun is one of the most misunderstood items of equipment that the average photographer possesses.

Some photographers expect far too much from this particular piece of equipment, while others underestimate its potential, and therefore fail to exploit it fully.

In both cases the faults are caused by photographers failing to understand the limitations of their equipment, or a lack of knowledge in regard to its correct use.

In this chapter we will endeavor to explain the correct use of the flashgun, and show you some other really useful functions it can perform for you when used correctly.

We will break of this chapter into subsections as follows:

* Flash Equipment
* Correct Exposure with a Flashgun
* Using the Flashgun
* Additional Flash Techniques

Cameras that have a built-in flash generally have little flexibility in their flash operation. The flash, simply due to design constraints, is mounted very close to the axis of the lens and generally has no facility to alter its direction of fire. In addition the flash that is built into a digital compact camera normally only has a range of approximately 10ft (3m) with the camera set at ISO 100 (although there are exceptions).

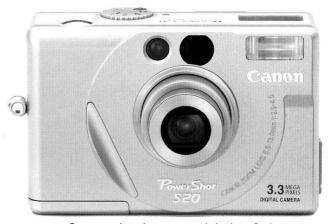

Compact digital camera with built-in flash

When you next watch a live performance, whether in person or on television, take note of all the people with their cameras flashing away merrily in the stadium.

Unfortunately, when they download or print their images they are going to find out the hard way the limitations, in terms of distance, of the built-in flash. Even those people with the more powerful stand-alone flashguns will probably be disappointed at the results they get (unless they are very close to the stage or are using a powerful flashgun combined with a high ISO setting).

Matthew on stage. This illustrates the problems faced when taking a shot with a flashgun where there is some distance between the camera and the subject. The flashgun was simply not powerful enough to illuminate the subject properly.

Stand-alone flashguns come in a variety of forms from the simplest and relatively inexpensive models, to the most powerful and complicated versions that, in some cases, can cost as much, if not more, than the camera itself.

Most have a built-in sensor that reads the light being reflected from the subject and cuts it off when the sensor judges the exposure to be correct. Others read the light being reflected from the image sensor to calculate the correct exposure.

Stand-alone flashguns designed to read the light being reflected from a camera's film plane are inappropriate for use with digital SLR cameras, unless they are specifically dedicated for digital cameras. These units are normally called dedicated flashguns.

Built-in sensor on a stand-alone flashgun

Canon Speedlite 550EX. A stand-alone flashgun that is configured to work properly with a digital SLR camera.

This is because these types of flashguns were designed to operate with film-based cameras, not digital. When used with digital cameras the imaging sensor acts much like a mirror and causes the flash to overexpose the image. Some camera makers are now bringing out digital versions of the dedicated flashgun that overcomes this problem.

So if you are going to purchase a stand-alone flashgun make sure that it is an appropriate model for your particular digital camera.

Dedicated flashguns (that suit digital cameras) normally have a zoom head that allows the user to tailor the angle of light being emitted from the flashgun to suit the lens being used at the time. The longer the focal length of the lens the narrower the angle of light being emitted from the flashgun. This is because, as you will remember from the chapter on lenses, the longer the lens focal length, the narrower the angle of view the lens presents to the camera.

Flashgun Controls (Compact Camera)

With a digital compact camera there can be a number of options for the built-in flash, depending on the particular camera model.

These settings can have different names depending on the camera involved but generally go something like this:

• Auto Flash: With this setting the flash will fire when the camera's on-board computer calculates that additional light is necessary.

• Flash Off: This control will turn the flash off under all circumstances.

• Flash On: This control activates the flash with each shot regardless of the external lighting conditions; it can be used for fill flash situations, which are discussed a little later.

• Slow Sync: With this setting the flash's timing is adjusted to a slower shutter speed than normal, reducing the chance that the background will be dark when shots are taken at night or in rooms with artificial lighting; the use of tripods is recommended when using this setting.

• Red-Eye Reduction: This setting usually involves the firing of pre-flashes to help reduce the red-eye effect (see red-eye effect later in this chapter).

You will need to check flash options available on

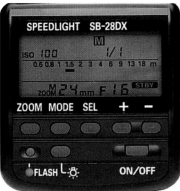

any digital compact camera you own, or contemplate purchasing, to ascertain the capabilities of the built-in flash.

Close-up view of the control panel on a dedicated flashgun. This flashgun displays quite a bit of information from the camera. It shows that the camera is using an ISO number of 100, a 24mm (wide angle) lens, that the flashgun is in manual mode (M), and that the distance scale is in meters. This type of flashgun is capable of quite a number of variations in modes. One of the most useful is TTL (through the lens), where the flash reads the light that will strike the imaging sensor and, based on the information it has received, tightly controls the duration of the flash to give the optimum exposure. When using a dedicated flashgun (in TTL mode), ensure that it is specifically designed to suit digital SLR cameras.

Not only does stand-alone flashgun have more controls that the photographer can utilize to control the light in any given shot, but also some stand-alone models have the ability to alter the direction of the light that they emit.

For instance, some models can tilt and swivel their flash heads so that, instead of the light being directed straight toward the subject, it can be aimed at the ceiling or the wall, and bounced back to the subject.

This technique of bouncing the light diffuses (softens) the light and can produce a much better result in comparison to a single light source, aimed directly at the subject. Bounce flash is discussed in more detail later in this chapter.

A dedicated flashgun in the tilt and swivel position. Notice that although the flash head has been swung to one side and raised so that it is in the bounce flash position, the flashgun's sensors are still pointed directly toward the subject. This is most important for achieving correct exposure.

Correct Exposure with a Flashgun

Before we get into the different types of flashguns and how to calculate exposure settings when using them, we had better establish a couple of relevant facts:

1. All flashguns have a guide number (GN), which reflects that particular flashgun's power (more about this a little later).

2. When a camera or flashgun manufacturer specifies a particular flash's power, this is usually calculated using at an ISO setting of 100.

3. A higher ISO number (such as 200) increases the effective range of the flash.

Although in this scenario you have doubled the ISO setting (ISO 100 up to ISO 200) this doesn't mean you have doubled the effective range of the flash.

As light travels it covers four times the area each time the distance doubles. For instance, light striking a subject at a distance of 6.5ft (2m) will decrease in intensity by a factor of 4 if that same subject is at a distance of 13ft (4m).

The upshot of all this is that increasing your camera's ISO setting by 100% does not double the effective range of the flash. In fact the effective range increases by around 50%. To double the effective range of a flash by using a faster ISO setting you need to increase it by a factor of 4—in our example ISO 100 would increase to ISO 400.

4. If increasing the effective range of your flash is not a priority but depth of field is, then using a higher ISO number (if your digital camera allows) will achieve this aim. By using a higher ISO number you can decrease the aperture you are using (higher f-stop) and increase the depth of field.

5. On 35mm digital SLR cameras the maximum shutter speed that can be used when engaging in flash photography will normally be 1/250 or 1/500 of a second.

Whatever the speed indicated, you can use it or any speed less than the one indicated. If, however, you try to use a faster speed, say 1/1000 of a second on a camera where the maximum flash synchronizing speed is 1/250 of a second, than you will probably find that the camera's shutter speed defaults back to 1/250 of a second.

This is because the camera knows that it has a flashgun mounted on it and that the maximum permissible shutter speed, in this case, is 1/250 of a second.

Most digital compact cameras have a combination mechanical and electronic shutter that, in certain circumstances, can adjust the camera's shutter speed to up to 1/300 of a second during flash photography.

However, as digital compact cameras are nearly always fully automatic, you most probably won't know what the shutter speed is during flash photography and will be unable to adjust it anyway.

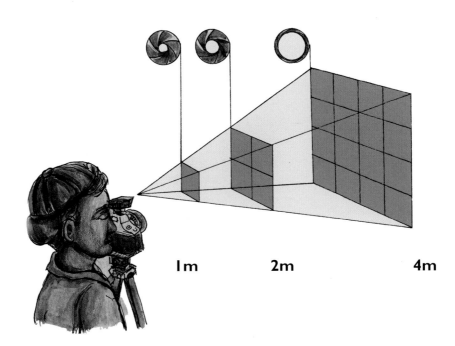

Inverse square law

1m 2m 4m

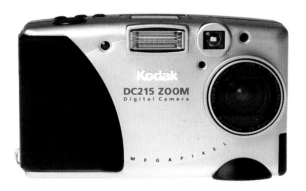

The Compact Camera with Built-in Flash

Because the vast bulk of these cameras are automatic I'm afraid that there is normally no way for you to vary the way the camera takes a flash photograph with just the built-in flash other than with the controls specified earlier in this chapter.

The comments I make further on in this chapter on multiple flash photography can be also utilized using a compact camera with a built-in flash, as are the comments on the use of reflectors.

But you need to keep in mind that the minimum and maximum apertures on a compact camera are somewhat restricted. Therefore you will need to ensure that the second flashgun is set at around the same power level as the built-in flash. Some experimenting may be called for here!

You should also do some test photographs to ensure that your camera and its built-in flash are performing correctly.

First you should read the camera manual and familiarize yourself with the camera and flash operation. You should also read the specifications, which you will normally find toward the back of the manual, and check the minimum and maximum range of the flash.

| Lens Size | Flash Range (ISO 100) |
|-----------|------------------------|
| 35mm | 27cm–3m (11in–10ft) |
| 70mm | 27cm–2m (11in–6.6ft) |

Specifications for a digital compact camera's built-in flash as taken from camera manual

As you can see from the specifications above, this built-in flash has a minimum range of 10.7 in (27 cm) and a maximum range 10ft (3m) when the camera's zoom lens is set to 35mm (wide-angle).

However, if you set the zoom lens to 70mm the effective range of the built-in flash changes to a minimum of 10.7 in (27 cm) and a maximum of 6.66 ft (2m).

The reason for the change as you vary the zoom's focal length is that compact cameras change their effective aperture size as the zoom lens changes its focal length. The longer the focal length, the smaller the aperture. Therefore as you extend the focal length of the lens you need more light.

Unfortunately, the built-in flash cannot produce any more light. The end result is that the effective range of your built-in flash is decreased.

Once you have sorted out the effective range of your built-in flash, take two photographs of your favorite person, indoors. Have the lens set at around 50mm and take the first photograph from about 10ft (3m). Next extend the lens to around 70mm and take the second photograph from the same position.

If the results look natural and the exposure is fine, good. If not, it may pay you to take the camera and the results to a good camera store and seek their advice.

The Stand-Alone Flashgun

There are just about as many varieties of stand-alond flashguns as there are cameras on the market.

These flashguns are manufactured by camera companies (specifically designed for their own cameras of course) and by independent manufacturers who ensure that their products can be adapted to suit nearly all the various camera types.

The controls on these different flashguns are all different and you should carefully study the instructions that are supplied with your flashgun. Remember my comments on dedicated (stand-alone) flashguns in regard to digital SLR cameras.

However, there is no reason that any flashgun that calculates it duration of flash by means of a sensor that reads the light being reflected from a subject would not work correctly with a digital camera (either compact or SLR).

When using such a flashgun with a compact digital camera, you should adjust the controls so that the flashgun's settings for aperture are not in excess of the camera's. Some tweaking may be necessary here to get the two units working correctly together.

Calculating Flash Exposure Manually

As mentioned previously in this chapter, each flashgun has a guide number (GN), which reflects the power capabilities of the flashgun. To calculate the exposure settings of a flashgun manually use the following formula (presuming a GN of 16).

1. Determine the flash to subject distance (in meters) by looking at the distance scale on your camera lens. Let's say it's 2 meters.

2. Divide the GN by this distance (16/2).

3. Take the result of this division and set the aperture to the closest f-stop, in this case f8 (16/2=8).

4. Ensure that your camera's shutter speed is set for flash photography.

5. Take the photograph.

Another example: let's say that the flashgun's GN is 24 and the camera lens indicated a flash to subject range of 4 meters—24/4 = 6. As there is no f6 on the lens you could set the aperture to f5.6 or just above if your lens allows partial settings.

Simple, isn't it? But remember always to work in meters (not feet) when using this formula. Also keep in mind that some manufacturers of flashguns are a tad optimistic when applying a GN to their products.

Tip

If you would prefer to work in feet, multiply the flashgun's GN by 3 and then use the formula substituting feet for meters.

In the first example the GN was 16. Using feet it becomes 48. The distance was 2 meters, which roughly translates into 6 feet. The GN (48) divided by the flash to subject distance (6ft) will give a result of 8 (48/6=8). Therefore the aperture setting would still be f8, the same as if you did the calculation in meters.

Guide number calculations normally presume that the flashgun is mounted on the camera so the flash-to-subject distance is the same as the camera to subject distance. If, however, you have the flashgun off the camera and the flash-to-subject distance is different from the camera-to-subject distance, you need to make some alterations to your calculations.

For example, let's look at the case of the camera being 2 meters from the subject and the flashgun, with a GN of 16, being only one meter from the subject.

If the flashgun was positioned with the camera 2 meters from the subject, you would use an aperture of f8. On the other hand, if the camera was positioned with the flashgun, using the formula, you would use an aperture setting of f16 (16/1=16).

But in this case the camera is not with the flashgun, but positioned 1 meter further back. The formula, when calculated from the camera position, indicates that you should use an aperture of f8. When calculated from the position of the flashgun, however, it indicates that you should use f16.

In this circumstance I would use an aperture setting of f11, since in this scenario the light has to travel 25% less distance than in the original example. To be safe I would also bracket two other shots 1/2 stop either side of f11.

If the flashgun were further back from the subject than the camera you would need to allow for the increased distance the light has to travel. For instance if the camera was still at a 2-meter distance from the subject but the flashgun was now 3 meters away, I would use an aperture of f5.6. Again I would bracket 1/2 stop either side.

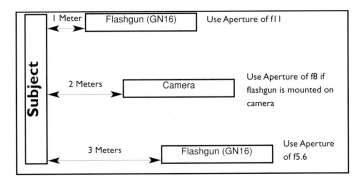

Using a Flashgun's Manual Calculator

Some flashguns will have an exposure calculator table similar to the one illustrated overleaf. To calculate flash exposure settings using this type of table:

1. Select the ISO you are using from the table. Note the ISO range is limited. Let's say it's 200.

2. Focus on your subject.

3. Check the distance scale on your camera's lens barrel to determine the distance to the subject. Let's say, for example, in this case it is 16 feet (5 meters).

4. Look up 16ft (5m) on the calculator table and run down the vertical column until you intersect with the horizontal column with ISO 200. As you can see, the point of intersection shows an f-stop of 5.6 and this is what you should set on your camera lens.

Exposure calculator on a relatively inexpensive flashgun

Using a Sensor Regulated Flashgun

As mentioned previously in this chapter, some flashguns have a built-in sensor that reads the light being reflected from the subject and cuts the light off when it judges the exposure to be correct.

Some more advanced models read the light that will strike the imaging sensor when coupled to the camera either via the camera's hot-shoe, or by means of a special cable that connects the flashgun to the hot-shoe. This is called through the lens (TTL) metering.

Normally you only need to do two things to achieve the correct flash exposure using these type of flashguns:

1. Set the ISO number the camera is using into the flashgun. You will most likely find that the ISO number is automatically picked up by the flashgun anyway.

2. Select an aperture setting using the aperture selection ring. As you turn this ring you will find that the distance lines on the flashgun's readout panel change. These distance lines indicate the subject-to-flash distance choices available to you. As long as you are within the distance indicated your image should be correctly exposed.

As you can see in the photograph above right, this flashgun has been programmed for an aperture setting of f5.6 and the ISO is set to 100. This gives the flashgun an operational range of just under 0.6 meters up to 4 meters (1.3ft–13.3ft).

When you take your shot the sensor will measure the light being reflected from the subject and cut it off when correct exposure has been achieved.

The flashgun will either regulate the flash duration via its sensor or, if it has TTL capability, via the exposure reading at the focal plane. Again make sure that the dedicated flashgun is suitable for digital cameras!

Dedicated flashguns can also have a number of other useful features. The model illustrated below has quite a number of useful features that include:

• Full tilt and swing of the flash head to allow any variety of bounce flash

• A zoom head that tailors the light output angle to suit a range of lenses with focal lengths between 24mm and 85mm

• Four program modes:

1. Manual: This allows the user to set the flashgun manually and also allows part strength flash for manual fill flash applications.

The broken black lines just below the distance scale indicate the effective minimum and maximum distance for this flashgun with the selected aperture

2. Automatic: Here the flashgun combines with the camera and acts in the same manner as an automatic flashgun with built-in sensor.

3. Strobe: This allows multiple flashes in a very short space of time.

4. TTL: Operating in this program mode the flashgun acts as an automatic flashgun but instead of using its own sensor to read (and control) light output it utilizes the camera's TTL metering function.

There are many other features in regard to this type of flashgun that we will not go into at this point. The instruction manual for the model illustrated runs to one hundred pages so it requires some study to operate properly. Having said that, this type of unit is, in my opinion, the best around if you do, or plan to do, a lot of flash photography.

Tip

This type of flash unit is very useful because it allows you to preset the exposure settings and then forget them and devote your time to composing and shooting your photographs.

You must remember, however, to stay within the distance guidelines defined by your aperture selection.

You should also ensure that, at all times, the sensor is pointing toward the subject, especially when using bounce or umbrella flash.

Using the Flashgun

In this section we will look at ways to improve the results you get from your flashgun. Flash gives the photographer independence from existing lighting conditions, distant subjects excepted, or alternatively can be used to augment them.

Flash also freezes subjects, thereby eliminating camera shake problems, and gives consistent color results.

Firstly we will identify some of the problems that can (and do) beset the poor beleaguered photographer with flash photography.

Red Eye

Problem The subject's eyes have a red glow.

Cause The flashgun is too close to the lens and has picked up the blood around the retina, at the back of the eyes. This normally occurs when the angle of the light, striking the subject and being reflected back to the camera, is 2.5 degrees or less.

Possible Solutions
(1) If possible move the flash off camera. (See Additional Flash Techniques later in this chapter.)
(2) Use bounce flash if your equipment allows.
(3) Have subjects look slightly away from the camera. They should look at a point slightly to the right of the photographer. This presumes that the flashgun is to the left of the photographer.
(4) Move closer to the subject. This increases the angle of the light from the flashgun to the subject and back to the camera.

Note: Some modern cameras with built-in flash, and stand-alone flashguns, have a red-eye reduction feature incorporated within their system. In some cases it is automatic, in others it needs to be activated. Sometimes they even work!

An example of the red eyed effect

Blank, Underexposed, or Overexposed Frame

Problem You either have no image at all (blank frame) or, alternatively, the image is either overexposed or underexposed.

Blank Frame

Cause The frame received no light. If your frame is totally blank there are a number possible causes:

1. You left the lens cap on.
2. The camera's shutter failed.
3. Wrong shutter speed was set.

The results from a blank frame

Possible Solutions
Did you leave the lens cap on? Have you checked you shutter speed setting? If this does not solve the problem, check battery strength and then take another shot. If it is still blank you should have the camera checked as soon as possible.

Underexposed/Overexposed Frame
The frame received too much or too little light.

Cause Here the probable cause is either incorrect camera settings, if the camera is in manual mode, or the flashgun's GN (guide number) is out a tad.

Possible Solutions Check the camera and flash settings and try another shot. If the next shot has the same problem you might want to try some shots that are either underexposes or overexposed by, say, one stop to check the accuracy of the flash's guide number.

Note: If your shots are overexposed make sure that you are not using a dedicated flashgun that is designed for film cameras.

Color Cast

Problem Your photograph has a distinct color cast.

Cause A color cast when using a flashgun usually indicates that you used bounce flash techniques and reflected the light off a surface, such as a ceiling, that was colored rather than white.

Possible Solution If you use bounce flash techniques make sure that the surface you are bouncing off is white. If the surface is other than white, say cream, then the light from the flashgun will pick up the color and transpose it into your photograph. Bounce flash techniques are discussed later in this chapter.

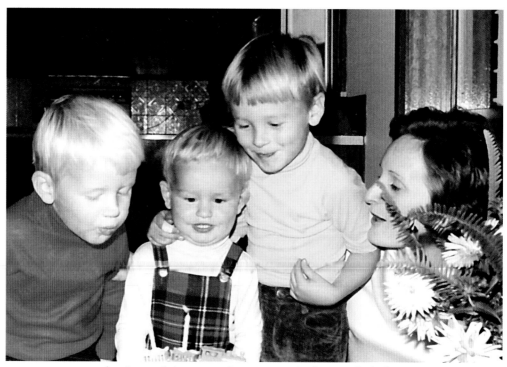

A yellow wall throws a color cast over this bounce flash shot

Hot Spot

Problem You have a bright white hot spot of light that spoils your photograph. In addition you might also find that the photograph is over-exposed.

Cause Light from the flashgun has been reflected back from some bright surface such as glass or polished metal.

Possible Solution First keep a good lookout for this type of situation. Even eyeglasses can be a problem. If the situation cannot be avoided take the shot at an angle to the reflective material involved, not directly in front of it.

Hot spot caused by the flash reflecting from the glass in the picture on the wall

Additional Flash Techniques

Cameras with Built-in Flash

While having a built-in flash is extremely convenient, it is also very limiting in terms of the quality of the images you can produce.

A single flash, mounted either above or near the lens, will produce a photograph that is flat and unnatural looking. In addition strong shadows will be cast on any background, which will detract from the image. There are, however, a couple of things you can try to improve your images.

First, when taking flash photographs, if possible, keep away from walls that are directly behind the subject.

Portrait shot using a single flash. The subject was kept well awat from the wall to eliminate the strong shadows that would result from the flashgun had she been positioned closer.

Second, you could tape a piece of opaque tissue paper across the front of the flash. This will have the effect of diffusing the light that is being emitted from the flash and give a softer light, which will improve your photo. This technique also applies to stand-alone flashguns, although in their case purpose-made diffusers are available.

When you diffuse light you also lessen its strength, so the effective range of your flash will be reduced. If your flashgun has a sensor this should not be a problem provided you are not at the edge of your flashgun's range before using the diffuser. If your flashgun does not have a sensor, then in these circumstances I would open up the aperture (lower f-stop number) by at least 1 1/2 f-stops. You may need to do some experimenting to obtain the right result.

Cameras with a Stand-Alone Flashgun

35mm SLR camera with dedicated flashgun mounted on a bracket and connected via cable to the camera's hot-shoe

Where your flashgun is a stand-alone type that can be mounted, either on the camera's hot-shoe or away from the camera entirely, your options for improving your flash photography improve substantially.

First I should start out by saying that if you mount the flashgun on the camera hot-shoe and point it directly at the subject, you will achieve the same dull flattening effect that we spoke about earlier, in regard to built-in flashes.

So don't mount the flashgun in the hot-shoe unless you are using bounce flash. Bounce flash will be discussed in the next section of this chapter.

However, as the flashgun is not fixed and simply needs to be connected to the camera by a flash sync cord, you have a number of options.

For starters you could purchase a flash bracket and mount the flash as shown in the photograph above. Taking the flashgun to the side of the camera has a number of benefits.

You severely reduce the possibility of the red-eye effect. You also start to model the face somewhat, as the light is striking one side of the face more strongly than the other.

Another option is to have the flash connected to the camera by a long sync cord and position it further away from the camera.

By taking the flashgun to the side you will produce stronger shadows behind your subject.

You may want to soften these shadows a little unless you want a particularly dramatic effect. By softening the shadows you will model the face, producing more of a 3D effect. But you only have one flashgun. So what do you use to direct some light on to the dark side of the face?

A simple and cheap solution is to build a reflector. It should take about two minutes.

Simply get a piece of cardboard about two feet by three feet. Then get some aluminum foil (the type used in the kitchen), and cover the cardboard with it. You could staple it on, or use tape. For the best result it helps if you crumple the foil up before attaching it to the cardboard.

Position the makeshift reflector as shown in the diagram and now take the same three shots as previously. As you can see the reflector has bounced some light back to the dark side of the face and lightened the shadows. The modeling of the face has been improved as well.

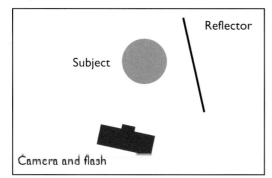

There you have it, an effective two-light system at a cost of pennies. Experiment with this idea and you'll be surprised at the results you can achieve.

Another way to model the face in this one-flashgun situation is to position the subject close to a window with reasonably strong light pouring through to the shadowed side of the face. The photograph opposite shows the results achieved by this method.

Light streaming through the window has helped illuminate the shadowed side of the subject's face.

Bounce Flash

Bounce flash is a technique where you simply point the flashgun, either at a ceiling or wall, and bounce the light off the surface, toward your subject.

You may recall, earlier in this chapter, that some flashguns have the ability to swivel and raise the flash head. It is these types that are normally used for bounce flash.

By using this technique you soften the light, and again help model the face to produce a more interesting and lifelike image.

A few points about bounce flash follow.

• This technique is not possible using cameras with a built-in flash, at least not unless you have an extra flashgun. More about that in the next section.

• It does not matter if you mount the flashgun on the hot-shoe.

Left: A portrait shot using a single flashgun. Note the lack of depth in the photograph and the heavy shadows.
Right: The same portrait using a single flashgun and a reflector. Note here how the shadows have been dramatically reduced and the background has been effectively illuminated. Color rendition is also much improved.

• You must ensure that if your flashgun has a light sensor it is always pointing toward the subject.

• If you bounce the light off any surface that is not white your photograph will pick up a color cast (black-and-white mode excepted, of course).

• If your flashgun does not have a light sensor then you should allow 2-3 extra f-stops in your exposure calculations to allow for the extra distance the light has to travel.

• When directing the angle of bounce ensure that the flashgun is aimed at a point, either on the ceiling or wall, that is no more than one-third of the distance between you and your subject.

• If you bounce off a wall you will create reasonably dark shadows on the side opposite the flashgun—consider the makeshift reflector again.

Bounce flash using a white wall as reflector

Bounce flash using a white ceiling as reflector

Umbrella Flash and Reflectors

Both of these methods are useful for improving light when using a single flashgun.

Each of the techniques will diffuse the light and help improve the modeling of the subject.

You must again ensure that the flashgun's light sensor is pointed toward the subject at all times to ensure correct exposure.

Multiple Flash Photography

The use of two or more flashguns can significantly improve the quality of flash photography and give studio-like results.

There are so many combinations that can be put together that books have been written about this subject alone. Try getting a copy of a book specializing in flash techniques and start experimenting. You should enjoy yourself.

You might also want to go to photographic exhibitions and see how other photographers handle flash. You will be surprised at what ideas you can pick up.

Fill Flash

Strange as it may seem, bright sunny days can be some of the best times to use your flash. You could, for instance, want to take a photo of your son with the local park in the background. Unfortunately, the best position for the shot puts the your son in a shaded spot, which will result in shadows on his face.

If you expose for the background, the shadows on the face will be prominent, which does not make for an attractive photo. Your spouse may have a few words to say about your photographic ability! If you expose for the shadows on the face, the background will be burnt out, another unattractive option.

Use your flashgun! Let's say that the exposure for the background (the brightest part of the scene) was f11. Set the flashgun up so that it will require an aperture of f8 and take the photo.

This setup correctly exposes your son's face and lightly overexposes the background, while still retaining all the detail. Alternatively, you could match your flashgun with the background reading of f11. Try different combinations and see what pleases you best.

The same technique can be used indoors when you wish to show details outside as well. Determine the exposure required for outside the room. Set the flashgun for 1 or 2 f-stops less and take the photo. Again, experiment to determine the best balance.

Balancing indoor flash with outside light

Heavily shaded position with fill flash (top) and without (bottom)

Slow Shutter Speeds with a Flash

One of the problems with flash photography when using a single flashgun is that although the flashgun will correctly illuminate the subject, the background stays dark and most detail is lost.

On a compact digital camera you may have a flash function called slow sync, mentioned earlier in this chapter.

This setting will use a much slower shutter speed when taking a flash photograph, which not only correctly exposes the main subject but also allows background detail to appear.

If you are using a stand-alone flash with a digital 35mm SLR camera you can achieve the same effect by setting the camera's shutter to a lower speed than is normally used with flash.

The photograph on the left was taken with a digital SLR camera at a shutter speed of 1/500th of a second, while the shot on the right was taken using a shutter speed of 0.5 of a second. The background detail and color rendition has improved significantly with the slower shutter speed and looks more natural. A tripod was used to eliminate camera shake at the slower shutter speed.

Useful Accessories

Kingston Town, Norfolk Island, South Pacific

A well-stocked camera store

Walk into any well-stocked camera store anywhere in the world and you will be confronted by literally thousands of pieces of photographic equipment and accessories.

For the casual photographer it is probably fair to say that most of these items will not be needed.

However, there are a number of accessories that will come in handy, and these are the ones that we will concentrate on in this chapter.

This in no way implies that the accessories not covered in this chapter are not useful; they are simply not essential, unless you are going to take your photography a little more seriously than the average person does.

Also you will remember that at the beginning of this book we promised to keep things as simple as possible, and a discussion on the many thousands of accessories available would not be of help in this regard.

The accessories outlined in this chapter can be regarded as the basics you should consider purchasing to assist you in producing better images, and also in taking care of your precious equipment.

As well as accessories for your camera we will also need to look at the storage side of the equation for the digital photographer. So there is a separate section in this chapter that deals with storing your digital images, both in the field and at home.

We will start with accessories that help you either take care of your digital photographic equipment, or make it easier to carry it around.

Iomega Click Drive with optional CompactFlash card adaptor. One of the many ways to store digital images.

Accessories for the Digital Camera

Camera Straps

Just about every digital camera sold is supplied with a camera strap of some kind. However, some cameras can be quite heavy (especially some digital 35mm SLRs), so to make it easier on yourself, you might want to consider investing in a wider camera strap that will distribute the weight more evenly.

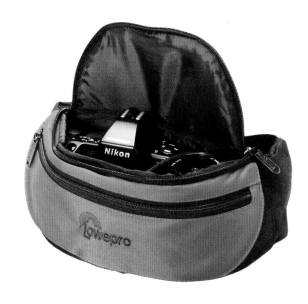

Medium-sized gadget bag

An accessory camera strap

Camera Cases

Camera cases are useful items that will help protect your camera from the elements, as well as dust and accidental scratching and bumps.

Just about all digital 35mm compact cameras come with a case, but in the case of digital 35mm SLR cameras they are often an optional item.

In addition, the camera cases that the camera makers supply usually fit around the body of the camera, with a hood that fits over the lens.

This can be a nuisance when you wish to use the camera quickly, so you might want to look at a gadget bag, instead of a camera case in this instance.

Gadget Bags

Gadget bags are the preferred option of the serious digital photographer, for not only will they protect your camera from the elements, they allow you, depending on size, to carry all the accessories and extra bits and pieces that invariably accumulate over the years.

Gadget bags come in a variety of sizes and styles, including the type that is carried on the shoulder and the backpack style. Either way they simplify carrying your photographic equipment and help protect it at the same time.

If you do opt for a gadget bag, make sure that it is easily accessible, as you may find yourself in the situation of wanting to get at your camera quickly.

Lens Hoods

Lens hoods fit on the front of the lens and perform two useful functions.

1. If you accidentally bump your camera into some object, it is the lens hood that absorbs the impact, not the front lens element or lens body. Thus the lens hood helps protect your valuable lens.

2. The lens hood also helps shield the lens from stray light. Therefore the lens only receives light reflected from the general direction of the subject being photographed. This assists in preventing sun flares appearing in your photograph.

Unfortunately, it is difficult to find compact cameras that accept lens hoods but just about all lenses that are made for digital 35mm SLR cameras accept them.

Lens with hood fitted

Photographic Cleaning Accessories

There are a number of useful products to assist you in keeping your equipment in tip-top shape, including the following items.

Cleaning Cloth

Specially made for photographic use, these useful cloths are good for removing dust from glass surfaces such as lens elements and viewfinder windows and are also good for wiping down camera and lens bodies. These cloths can also be used to clean the LCD monitor. Alternatively chamois leather can be used for this purpose.

Cleaning cloth for photographic use

Lens Tissue

When your lens get dirt or, worse, fingerprints on its glass elements use *only* lens tissue in conjunction with a photographic lens cleaning solution to remove them. *Do not* use handkerchiefs or normal tissues for this purpose.

Lens Cleaning Solution

Specially made for photographic use, you should only use this type of product to clean the glass surfaces of your camera and lenses. Use in conjunction with lens tissue as discussed above. Do not use solutions designed for eyeglasses because they are unsuitable for optical lenses.

Some of these lenses have the lens hood already built in, while others have a screw thread at the front, on the inside of the lens barrel, that will accept them.

If you purchase a lens hood for a lens, be sure that it is the correct one for the angle of view of the lens. Attaching an incorrect lens hood to a lens could produce a darkening at the corners (called vignetting) due to the lens hood being the incorrect size for the angle of view of the lens.

It is far better to have a separate lens hood for each lens you possess.

Some lens hoods are made from rubber while others are made from metal or plastic. The rubber variety absorbs impacts (if you are unfortunate enough to bump your camera into something) much better than the metal or plastic varieties.

Lens tissue and cleaning solution

Hand-operated blower brush

Blower Brush
A similar purpose to cleaning cloth in that the blower brush is designed to remove dust from glass surfaces, except that it is assisted by the puff of air obtained by squeezing the pump. Also useful for removing dust from the inside of camera bodies.

Pressurized Air
There are a number of these products on the market and they are also very useful for removing dust from cameras and lenses. However, be warned that you must follow the instructions on how to hold the can, which will usually instruct you to be sure that at all times you hold the can upright. Failure to do so may damage your valuable photographic equipment!

Pressurized air for photographic use

Other Accessories
Tripods
One of the most common problems with photographs is image blur due to camera shake. As discussed elsewhere in this book, camera shake can occur when the shutter speed is set on a slow speed.

A tripod helps alleviate the problem of camera shake by giving you a solid platform on which to mount your camera.

Some tripods have the facility to extend their support legs out a considerable distance more than normal. This brings the camera much closer to the ground for that unusual angle of view.

Alternatively, if you want to take your photograph from ground level, some tripods have the ability to reverse their center post so the camera can be positioned very close to the ground.

As shown below, tripods come in many sizes, from the small tabletop model to the large varieties that look like they could support a tank. As a general rule I find that the models with the tubular legs give better support than those models with the channel variety. Either way it is much better to have a tripod and help avoid camera shake than to be without.

The other interesting thing about using a tripod is that it tends to make you a little bit more deliberate in composing your shots. No a bad thing at all.

Large and small tripods

Cable Release

Unfortunately, the use of a tripod does not always solve all camera shake problems. For instance, a heavy digital 35mm SLR with a long telephoto lens can still produce camera shake, especially when the tripod is extended to its maximum height.

In these circumstances the pressure of your finger pushing down on the shutter release can be enough to induce camera shake.

A cable release can fix this problem. Cable releases come in a number of different models, from mechanical—which are very inexpensive and connect to cameras via a screw thread—through electronic models. Although the mechanical cable release is normally the most inexpensive type to purchase, digital cameras released to date (that I have seen) will only take the more expensive electronic models.

Elecronic cable release for the Nikon digital camera

However, this is a very worthwhile accessory and should not be overlooked by the serious photographer. Unfortunately, most compact cameras do not have the facility to allow the use of cable releases.

Tip

If your digital camera does not allow the use of a cable release, or alternatively you don't have one, you can use your camera's in-built self-timer to avoid camera shake.

Providing that your intended image is stationary you can simply set the camera up and activate the self-timing mechanism. Most digital cameras with built-in self-timers allow a ten-second interval before the shutter is released. This is enough time for any camera shake, induced by the pressure of your finger on the shutter release, to settle down.

If you're using a 35mm SLR you might consider using the mirror lockup facility, if it is incorporated within your model—useful in reducing camera shake.

A selection of photographic filters

Photographic Filters

They are literally hundreds of different filters that are available for use in photography. Because we promised to keep this book as simple as possible we are only going to cover a few filters that are really a must-have in your photographic kit.

Unfortunately most compact cameras do not have the facility to fit filters to their lenses, while 35mm SLR cameras invariably have the facility to fit filters to their lenses.

In addition to providing useful photographic effects a filter also protects the front element of your lens. Better that a relatively cheap filter is damaged than the much more expensive front lens element.

Some filters require some degree of exposure compensation to allow for the fact that they reduce the amount of light available to pass through the lens.

If your camera has in-built metering, exposure compensation will be automatically calculated. If, however, you are using a hand-held meter you must allow for the filter factor in your calculations. Check the instructions that come with the filter you are using to find the degree of compensation needed.

We will just be covering five of the hundreds of filters available.

Bare Island, Sydney Australia

The Ultraviolet and Skylight Filters

The ultraviolet (UV) filter is used in film photography for filtering out ultraviolet radiation, which gives the distant sky a mistlike appearance, especially

UV Filter

on hazy days, and when shooting a perspective with distant views. The skylight filter is also useful in reducing the effects of ultraviolet radiation in your photography with film.

However, you are not using film in digital photography, but rather imaging sensors, which are not susceptable to ultraviolet light. Still, either of these filters is useful in protecting your front lens element, which is why they still rate a mention here.

Skylight Filter

The ultraviolet and skylight filter requires no exposure compensation.

The Polarizing Filter

This is one of the most useful items a photographer can have in the gadget bag. Like the two previous filters (the skylight and ultraviolet filters), the polarizing filter also helps to penetrate haze and darken the sky. It also

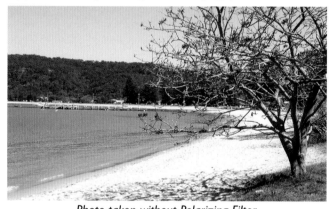

Polarizing Filter

can remove reflections, especially from glass, water, and other reflective surfaces. In addition, it has the effect of enriching the color of many surfaces, including foliage and skin.

The polarizing filter acts in a similar fashion to Polaroid™ sunglasses. Light traveling in one particular directional plane is blocked. The filter rotates in its holder, thus enabling light coming from a particular direction to be blocked depending on which way the filter is rotated.

Unlike the two previous filters, the polarizing filter does require exposure compensation. Normally the filter is rated at 2.5, which means that exposure compensation of one and one-third stops is required. If you are using a 35mm SLR with through-the-lens metering, this exposure compensation is automatically calculated. If, however, you are using a hand-held light meter you must make the exposure adjustment manually.

Tips

1. On the rotating outer ring of the polarizing filter you will normally find an index mark. You can achieve maximum effect by rotating this mark to point directly at the main light source, be it the sun or artificial light source.

2. Reflections that emanate from metallic surfaces cannot be eliminated by the use of a polarizing filter. This includes any mirror that has metal-leaf backing.

3. If you wish to photograph the sky and show it at its deepest blue, make sure that the sun is at a 90-degree angle to an imaginary line between your subject and yourself.

4. If you wish to use a polarizing filter to eliminate reflections, you need to ensure that your camera is at a similar angle of view to the reflections, as the light source. For instance, if the light source is the sun and it is creating reflections in a shop window, and the sun is positioned at an angle of approximately 40 degrees to the window, your camera should also be at a similar angle on the opposite side (see diagram next page).

Photo taken without Polarizing Filter

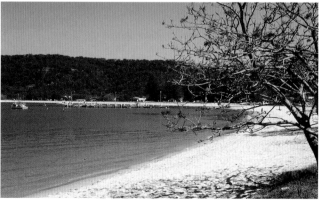

Photo taken with Polarizing Filter

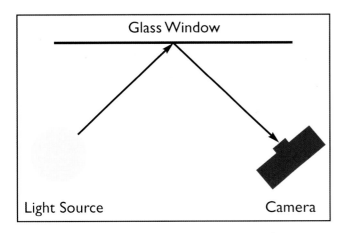

Color Correction Filters

With traditional film cameras special filters (80A or 80B) are sometimes necessary to correct color cast problems that occur when using film rated for daylight with tungsten lights or film rated for tungsten light in daylight.

With digital cameras these filters are unnecessary as the camera will have a white balance (WB) control that should be able to allow for different types of light (daylight, tungsten, fluorescent, and so on).

Flash Slave Units

Flash slave units are designed to trigger a flashgun automatically when a second flashgun is fired.

A small cell in the slave unit senses the first flash firing and automatically triggers the second flash, to which it is attached, in synchronization.

This device, which is used in multiple flash photography, can be quite inexpensive, and is extremely useful.

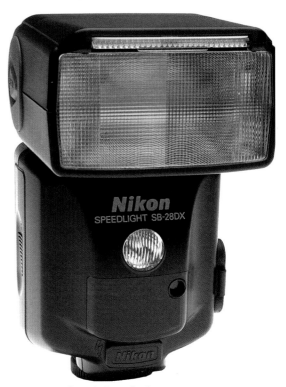

Stand-alone flashgun

Flashguns

Most modern digital compact cameras have a built-in flash. These days quite a few digital 35mm SLRs also have a built-in flash.

If, however, your camera does not come with a built-in flash then you will need to consider purchasing a separate flashgun.

Even if your camera does have a built-in flash you may wish to consider the purchase of a separate flashgun for multiple flash photography as discussed in Chapter 4, "Flash for the Digital Camera."

Combined with a slave unit, as discussed above, multiple flash photography can give superior results in comparison to a single flash source mounted on the camera.

There are literally hundreds of different varieties of flashguns on the market. Selecting the right model for your needs can take a little bit of research.

As discussed in Chapter 4, having a slightly more powerful second flashgun can be quite useful in a multitude of situations.

A small flash slave unit

Various portable image media cards and disks

Digital Storage Accessories

If you are using compressed images (JPEG files) then your storage requirements will not be as critical, since you will be able to fit many more images on the portable storage card within your digital camera. However, be aware that using the JPEG format results in some loss of image data compared to an uncompressed format such as TIFF.

Having said that, digital photographers who take their images in an uncompressed mode such as TIFF soon discover the limitations of the on-board storage facilities of the digital camera, as an average TIFF file for, say, the Nikon D1 is 7.5 megabytes. So if you have a 96-megabyte CompactFlash card in the camera you will only get 12 shots before the CompactFlash card is full.

What are you to do? Rush home, download the images onto your computer, then return to take more shots? I don't think so! You need to look at the portable image storage options available to you at the present time.

The most obvious answer to storing images is to buy whatever extra storage cards your digital camera uses: CompactFlash, SmartMedia, PC Cards, Memory Sticks, or Floppy Disks.

This will give you the extra storage capacity you need. Fill up one card, stick, or disk and then simply insert a new one in the camera, and keep shooting.

However, this can be expensive, or cumbersome, depending on the type of storage card your digital camera uses. So let's us look at some alternatives.

Iomega has a nifty little portable drive for the computer called the Click Drive. This very useful device will allow you to download images from the camera's CompactFlash card or PC card and then reuse them to take more images. It is battery powered, so it will go with you anywhere.

One word of warning: Click Disks have a maximum storage of 40 megabytes, so if you try and download something bigger—say a 96-megabyte CompactFlash card—you are going to be severely disappointed. There is no facility for downloading individual files from your portable storage card onto the Click Disk.

An alternative if you have a laptop computer is to take it with you and download your images as you go. I'm not suggesting you carry it around with you but if you are on a serious pho-tographic expedition then you must plan for storage.

Iomega Click Drive

Laptop computer

Leave the laptop in your hotel room or car (hidden from view and protected from heat, of course) and download at night or when you run out of storage space. Just take enough portable storage media to last for the intended shooting time, with a bit left over for safety.

Now that we're onto the subject, what happens when you do download your images onto your computer's hard disk? Sooner or later your hard disk will be full. What then?

Most camera manufacturers usually supply storage solutions with their products; however, these inevitably require the purchase of special cards that need to be installed on the computer. Fortunately there are a couple of useful third-party accessories that can help in this regard.

Now, 7.5 megabytes per image does not sound like all that much, but if you start taking a lot of images (as I would hope you would) and accumulate, say, a thousand images, then you are looking at over 7.5 gigabytes (7500 megabytes) of storage on your hard disk.

And that's without resampling! Let's say that you resample some of the images to increase their hard copy size, to print out.

As an example, let's say that you wish to double the size of an image that is currently 7.5 megabytes.

Okay, I hear you say, that means the file size doubles to 15 megabytes; what's the big deal?

Wrong! I hate to be the bearer of ill tidings but the file size will increase by a factor of four to just over 30 megabytes!

Start getting a few of these on your hard disk and watch what happens to your available free disk space!

Now let's look at the computer itself, loading your images onto the hard drive and then storing them for the long term.

Most digital cameras come with some means of loading the digital image onto the computer's hard drive but, as stated earlier, this often involves the purchase and installation of special cards for the computer.

There are a couple of accessories that can be of help here, thus avoiding the purchase of such cards.

CompactFlash card reader

The first is a CompactFlash card reader, which when attached to the computer simply becomes another drive like the CD-Rom or floppy disk drive.

CompactFlash card adapter

With this device you simply insert the CompactFlash card and transfer the images from the card to the hard drive. Simple and painless.

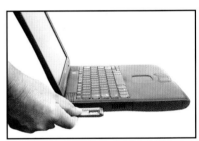

Inserting a CompactFlash card adapter into a laptop PCMCIA slot

Another way to transfer image files from a CompactFlash card to a computer is the Picture Card Adapter shown above.

Floppy disk adapter

With this device you simply insert the CompactFlash card into the adapter and then the adapter into a PCMCIA slot that can usually be found on a laptop and transfer the images to the hard disk. Again very simple.

Inserting floppy disk adapter into a computer's floppy disk drive

An easy way to transfer the images from your SmartMedia card to your hard disk is to use a floppy disk adapter.

This device looks like a normal 1.4 megabyte floppy disk (see photo on previous page) but has a slot which takes the SmartMedia card. You then place the adapter into your computer's floppy disk drive and transfer the images to the hard disk. Easy, painless, and inexpensive.

Now we should discuss the storage of your precious images. Obviously you can just store them on the hard drive. The problem with this is, first, you will find out that you may soon start to run out of space on the hard drive as your image bank increases.

Of course you can always get a bigger-capacity hard disk or a new computer for that matter but, to my mind, this is a bit extreme.

Second and more important, have you ever had a hard disk crash and then lost all your data? Not a pretty sight.

Imagine having hundreds of your precious photographs on hard disk and then having them totally wiped out in the blink of an eye—with no chance of retrieval! It is the same as if a fire swept through your house and destroyed all the contents.

If you have ever seen anyone who has had the misfortune of having their house burn down and lost all their possessions, you will know that the loss of family photographs is most keenly felt, simply because photographs, unlike most other possessions, can normally never be replaced.

Anyone who has anything to do with computers (and knows what they are doing) will always tell you to back up your files at least once a week, but preferably daily.

This is because computer hard disks are known to crash occasionally (?) for a variety of reasons.

So it is important to back up your image files and preferably store them in a different location in case of fire.

There are a number of ways to do this, which we will discuss now.

Firstly you could store the files on a separate disk, such as Iomega Zip or Jazz drives. With sizes starting at 100 megabytes up to 2 gigabytes these devices can hold a significant number of images.

However, be aware that these disks are magnetic, with the attendant risk that the files stored on them can be accidentally erased if placed in the presence of a strong magnetic field. They need to be carefully stored. There is also the question of their long-term life (archival life is the term used). Any recording done on magnetic tape, which is what we are talking about, will degrade over the long term.

A far better approach to long-term storage of images is to use CDs. If you don't have a CD burner you will find that your local photo lab will most likely provide this service, at a reasonable price.

If you do have a CD burner then you can do the job yourself. Please be aware that there are two types of CD burners available on the market.

The first is called CD-R. CD-R stands for CD recordable. What this means is that you can record your images onto the CD up to its maximum capacity of 650 megabytes. The image files cannot be erased and are stored permanently. CD-R disks have an archival life of around 100 years.

The second type of CD burner is called a CD-RW. In this case the RW stands for rewriteable. This means that not only can you record your images onto the CD but you can also erase them and record different files. The CD-RW disks have an archival life of around 30 years. Please note that CD-RW burners will also record on to CD-R disks.

Also many older computers with a CD drive cannot read a CD-RW disk. To read this type of disk you must have a multiread CD drive, which is generally found on new computers but not normally on older models.

Given the archival life difference between CD-R and CD-RW I tend to favor storing my images on CD-R disks. But I use a CD-RW burner. That way I get the long archival life of CD-R disks for my images and use CD-RW disks for other storage and backup tasks where long archival life is not an issue.

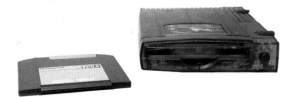

Iomega 100MB disk drive with disk

CD-R burner and disk

Troubleshooting and Maintenance

Steel Shades, Sydney Australia

This chapter looks at how to handle, maintain, and care for your valuable digital photographic equipment.

But before we get into all of that we should have a look at one important point that could save you considerable heartache, not to mention expense.

Please remember that when using your camera's controls at no time should you force anything! All your camera controls should adjust smoothly and easily.

Your camera is a precision instrument and if one of the controls will not adjust then either it is not meant to adjust (at least in the current circumstances), or else something is broken. Trying to force the issue could make matters considerably worse.

You should make sure that you are thoroughly familiar with all the camera controls and their functions. Many modern cameras, especially 35mm SLRs, have safety locks that will not allow adjustments unless the safety lock is disengaged.

But please remember—don't force anything!

Camera Shake

One of the most common photographic problems that can cause a photograph to be less than satisfactory is camera shake.

The normal cause of camera shake is usually either:

1. Holding the camera incorrectly
2. Using a slow shutter speed without properly bracing the camera
3. A combination of both

Shaky camera

Holding the camera correctly

The photographs below demonstrate the correct way to hold a compact digital camera or digital 35mm SLR.

Please note that the photographers' elbows are tucked into their bodies, giving extra stability. Also the photographers' feet are spread apart (one in front of the other) for extra stability.

The correct way to hold a camera. Note that when holding the compact camera the hands are kept well away from the camera's sensors. With the 35mm SLR camera the photographer places his left hand under the camera's lens to ensure steadiness.

A Few Useful Tips for Preventing Camera Shake

Photographing in the prone position

Using a flat surface to steady the camera

Lying flat allows all the weight to be taken on both elbows. A camera bag (or similar) under the camera's lens provides additional support.

Camera bean bag

Here the camera is given additional support by the photographer bracing himself, and the camera, against a convenient tree trunk, but any flat surface will do the trick. When using this technique, place the camera's base plate on the tree trunk, or similar useful object, and hold firmly to the surface.

You could purchase one of these small bean bags on which it is ideal to place the camera, thus avoiding camera shake.

Kneeling allows the photographer to brace the elbow on the raised knee, which provides extra support.

The best way to ensure the elimination of camera shake is the use of a tripod and cable release, as shown here. Mount the camera on the tripod firmly, but do not overtighten the tripod mounting screw, as this can cause damage to the camera's base plate. When shooting. use the cable release to trip the shutter. If you do not have a cable release, and the situation allows, you can use the camera's self-timer to trip the shutter. Both the timer and the cable can prevent camera shake caused by the pressure of your finger on the shutter button.

Camera on tripod

Photographer in kneeling position

Using Slow Shutter Speeds

As a general rule you should take precautions against camera shake whenever you are using a shutter speed of 1/60 of a second or less. For more specific rules regarding shutter speeds, see the section on focus in Chapter 3, "Lenses for the Digital Camera."

With 35mm SLR digital cameras this will be no problem as you will easily be able to tell what shutter speed the camera is using and either adjust the shutter speed or take other precautions against camera shake.

With a compact digital camera this is not the case. Some digital compact cameras give no indication of the shutter speed being used in any particular situation. However, some do have a slow shutter speed warning light that will illuminate in these situations.

So you should give serious thought to using any of the camera-steadying techniques described previously in any situation that involves low light, such as shadows or indoor photography, where supplementary flash lighting is not employed.

Shutter Problems

So you get your photographs back from your recent holiday and to your horror the beautiful shots you took look like this (above left) instead of like this (below). What happened?

Unless you left the lens cap on the chances are you may have a problem with the shutter on your digital camera.

North Parade Bridge, Bath, UK

Where traditional film cameras have a shutter that normally consists of some type of blade or curtain arrangement that opens to allow the light to strike the film, digital cameras are a tad different.

Digital cameras have an imaging sensor that records the image. The shutter is replaced by a simple timing device that simply turns the imaging sensor on and off for the required amount of time.

Therefore if you are having problems with your digital camera's shutter the only thing you can do is to take it to the nearest qualified camera repair facility as soon as possible.

Under no circumstances should you try to rectify the problem yourself!

Battery Failure

One of the basic truths in life is that if something is going to go wrong, it will always do so at the most inopportune time.

A small selection of the many different batteries that are used to power photographic equipment

Battery failure—or worse, leakage—is one of those things.

You haven't used the camera for months, and you drag it out of the drawer to take the photo of Aunty May, who just happens to be visiting, and when you turn the camera on, what happens? Absolutely nothing, zip. Dead as the proverbial dodo.

Not to be defeated by a stupid machine, you replace the batteries with a new set that you had for just such an emergency (please note here that you should always replace all batteries at the same time if your camera uses more than one).

Now one of two things could happen:

1. You have outwitted the stupid machine and fixed the problem.

2. The stupid machine appears to have outwitted you because it still will not function.

Drat! Aunty May will be less than impressed.

If this happens, first check that you have installed the fresh batteries with the + and − polarities correctly aligned. The polarity alignment will normally be embossed in the battery chamber somewhere.

If the camera still will not function, remove the batteries and have a close look at the battery contacts in the camera's battery compartment. Do they look bright and shiny, or do they have a greenish or copperish tinge?

If they do have a green or copperish tinge than you have probably suffered some battery leakage that has fouled your contacts, preventing the current flowing through the camera's electrical circuits. If this is the case you could try giving the contacts a scrape with a small screwdriver blade or some similar implement to clean them—but do so very very carefully!

This may get you out of trouble in the short term but you should have the camera checked and cleaned by a suitable repair facility as soon as possible.

All digital cameras rely on batteries for power and they can chew the power up at a rapid rate! However, many models use specialized battery packs (always rechargeable) that are not available at the corner store.

Therefore it is mandatory to ensure that when leaving on a photography expedition with a digital camera, you carry at least two sets of batteries with you.

Also remember that if you are not going to use the camera for some time it is a very good idea to get into the habit of removing the batteries and storing them separately.

A specialized power pack for a digital 35mm SLR camera

Batteries and Cold Weather

Batteries can drain very quickly in cold weather. If you are using your camera in these types of conditions make sure you have spares handy and, if possible, keep your camera and the spare batteries in a pocket or close to your body (perhaps under your jacket) when not using them. Your body heat will help prevent battery drainage.

Checklist

1. Always carry spare batteries.

2. Remove batteries from your camera (or flashgun and other equipment for that matter) when you will not be using the equipment for some time, and store them separately.

3. If your equipment uses more than one battery (for example, two penlight batteries), always replace both at the same time.

Using your Camera in the Rain

You're in San Francisco and you come across Macarthur Park. All of a sudden you remember the words from the song. "Macarthur Park is melting in the rain. . . ."

And guess what? It's raining.

You know that you still have the album somewhere at home, so you decide to take a photograph to show the kids, and perhaps help them understand what the '60s and '70s were all about (good luck!).

But it's raining, and water and your digital camera shouldn't mix, should they? No, as a matter of fact, a digital camera together with water in any form is not a recommended combination.

However, you still want the photo, in the misguided belief that it will help your kids understand their parents. So, to protect your valuable piece of optical and electrical equipment, you need to improvise.

First get yourself a clear plastic bag, large enough to hold the camera.

Next place the camera inside it and, using a rubber band, secure the opening of the plastic bag around the lens so that only the end of the lens is protruding. It would also be a big help if your lens had a lens hood to keep the rain away from the front lens element.

Protecting your camera in the rain (and snow or dust)

Now make a small opening in the plastic bag so that you can see through the viewfinder to focus and compose your shot. If your camera is a digital compact you will also need to make another hole at the front to enable you to see properly.

Also your camera may have sensors at the front to make exposure calculations, or focus. You would need to make holes in the plastic bag to accommodate these sensors. Use another rubber band around the camera body to secure the holes you've made in place with the various sensors and so on.

Next, focus and compose your shot and then take it, making sure your exposure settings are correct.

Finally, get your camera out of the rain as soon as possible, remove its improvised raincoat immediately, and wipe off any water droplets that may adhere. Use only lens tissues on any glass that needs to be dried.

I would recommend the same procedure if you also get the urge to take photographs in falling snow, dust storms, or sandstorms.

Good luck with the kids!

Camera Straps

Nearly all cameras come supplied with a strap. At the very least they all have provision to attach a strap. One of the most horrible sounds in the world is the sound of a camera hitting the ground (nearly always cement or rock) after it has slipped out of your hands. Please use the strap and make sure it goes around your neck, not over your shoulder. This will stop it slipping from your shoulder and make it much more difficult for any snatch-and-grab thief to steal. If the strap is a thin one and the camera is heavy, you might want to look at investing in a wider strap to spread the weight. All camera stores usually have a good selection of straps.

Camera cleaning materials (above); pressurized air can (below)

Cleaning Your Camera and Lenses

The items shown above are the *only* cleaning materials you should let near your valuable digital camera equipment. In regard to the pressurized air, however, please use this product with extreme caution. If you release the air while the can is being held at an angle, you run the very real risk that some or all of the propellant will escape and cause damage to your equipment.

Also be aware that some propellants can cause frostbite if allowed to touch human skin. Be very cautious and make sure you carefully read the instructions on the can.

Do not apply any cleaning agent to the camera! Simply wipe the camera body with a soft cloth and remove any dust or lint with a blower brush or very carefully with compressed air.

Don't leave your photographic equipment in areas of high heat or humidity for long periods of time. This is not what is known as best practice!

If there is high humidity in your area, store your equipment with some packets of silica gel pellets to absorb the moisture in the air. You will find that most cameras are supplied with these gel pellets—keep them. If not, your local camera store should have them. Replaced them about every twelve months.

Tree frog (Izzy Perko)

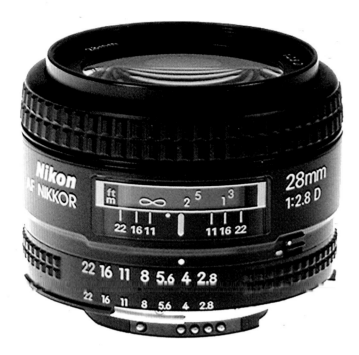

28mm SLR wide angle lens (Maxwell Optical Industries)

Now let's talk about glass.

The glass in your camera's lens is its eyes on the world. Eyes need to be kept clean.

To keep your lens elements clean—front and back in the case of digital 35mm SLR cameras and normally only front in the case of digital compact cameras—do the following:

1. Always use a front lens cap when the camera is not in use. Many digital compact cameras have an automatic lens cap that activates when the camera is switched off. Digital 35mm SLR camera lenses will normally be supplied with both front and rear lens caps. Use them!

2. If your lens allows (and most digital compact cameras don't), use a skylight, or UV, filter on the lens at all times. That way it will be the filter that gets dirty, not your front lens element (see Filters in Chapter 5, "Useful Accessories"). As well as being easier to clean, the filter will take any initial impact if you bump your lens against anything (much better that the filter gets damaged than your front lens element. Much less expensive as well).

3. Again, if your lens allows, use a lens hood. Lens hoods (see Lens Hoods in Chapter 5, "Useful Accessories") not only protect the lens from extraneous light and dust but if you happen to bump any part of the camera against any *solid* object, the lens hood is the best option.

4. When any glass on your camera equipment (lens elements, viewfinder glass, filters, and so on) gets dirty, use only a proper photographic lens-cleaning solution, together with lens-cleaning tissues to clean it. You can also use a lens cloth and a lens blower brush to remove dust and lint. Please don't use anything else! These items are inexpensive, and available at any camera store outlet.

5. Digital cameras have LCD screens at the rear of the camera. Unfortunately, they are always in position to rub against your face when you are taking photographs. The upshot of this is that the LCD screen is quite often covered in streaks resulting from contact from your face. To clean the LCD screen use a soft, moist chamois.

Lens Tissue and Cleaner for camera lenses

Image Editing and Printing

Flower-sellers, Sydney, Australia - Izzy Perko

Now that we have covered the camera equipment side of the digital photography equation, we need to turn our attention to the output side.

As the object of taking a photograph is to capture a moment in time and then revisit it in the years ahead, we will look at how we can do this, and examine the equipment required.

The most obvious way for you to display your photographs is on a computer.

A computer monitor displaying a digital image

A computer can store your digital images, and at a touch of a button they will be on the screen in living color.

You can compress the images in JPEG format and then e-mail them to friends or business colleagues around the world in a matter of moments. You can also place them on a web site for the entire world to see. Many people create wallpaper or screen savers for their computers with their images.

All of these things are wonderful and a great boon to the digital photographer; however, most people will also want to have hard copies (prints) of their work.

Let's face it—a computer monitor is probably not going to look all that good mounted on your living room wall even if it is displaying your latest photographic masterpiece! It will certainly not fit in your wallet.

So the chances are that you will need to print out some of your images over the years and display them in some manner. The easiest way to do this is to take them to your local photo lab and have them printed.

A typical photo lab

These days most photo labs will accept digital images from a variety of storage sources and print them for you. For instance, you could supply the images on CD-ROM, Zip Disk, Floppy Disk, SmartMedia card, CompactFlash card, or the like. Just check with your photo lab to make sure they can accept your images on the storage media you plan to use. That is the easy way to get hard copy prints of your images.

A more interesting and satisfying way is to print them yourself with your own printer. It's almost certain that if you are into digital photography, you possess a computer, and if you have a computer then you will surely have a printer.

Now there a quite a few different types of computer printers on the market so we had better

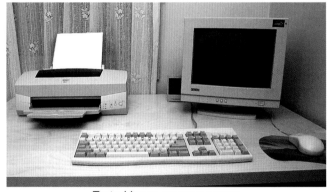

Typical home computer setup

start by identifying them and commenting on their suitability for printing color or black-and-white prints of your images.

Now, don't worry. I am not going to bore you to death with all of the different technologies that make these different printers work. I don't understand much of it myself, so I'm hardly in a position to explain it all to you!

Printers

We will simply identify the different types of printers and then look more closely at the types that are suitable for digital image printing at home.

Dot Matrix Printers

These printers are now superseded in the market-place, which for our purposes is fine, as they were not suitable for printing images anyway.

Dye Sublimation Printers

These printers can produce precise photographic images of high quality. Advertising bureaus and graphic artists mainly use them. Having said that, they are extremely expensive both to purchase and to operate and generally are not considered practical for the home user.

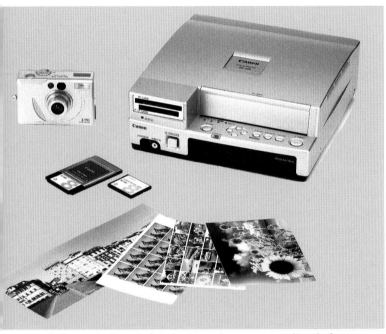

A Canon dedicated digital printer that can print directly from the camera in a variety of sizes

Dedicated Digital Camera Printers

A number of camera manufacturers also supply dedicated digital camera printers. These devices do not require connection to a computer and work normally from direct transfer of images from PC, SmartMedia, or CompactFlash cards.

These printers will print approximately postcard-sized prints (at least one will print in the panorama format) and work on the excellent dye sublimation method discussed previously.

They are not cheap and seem to cost around the same price as a good-quality inkjet printer. Likewise their consumables are also not at the cheap end of the price scale, in comparison to inkjet printers.

The question to be asked when looking at these products is "Is it good value, compared to an inkjet printer?" The inkjet printer will do a good job of printing your images (with the option of much larger prints) and, of course, the ability to print other documents (word processing, spreadsheets, and so on) that the computer may generate. Inkjet printers are covered on the following page.

Laser Printers

Laser printers are capable of printing fine black-and-white images. Color laser printers are also capable of printing both black-and-white and color images of high quality. Their consumables (paper, ink, and toner) are more cost effective than you would initially think, being a tad cheaper than inkjet printers when compared on a per page basis.

Unfortunately, the down side is their initial purchase cost, which for color laser printers is quite high. The servicing costs for color laser printers can also be high. If you want a color laser printer that can print bigger

Epson laser printer

than 8 1/2 X 11 inches, then the purchase cost rockets upward to dizzying heights.

The conclusion here is that although they are lovely machines, capable of producing great images, the cost is unrealistic for the home user.

Thermal Wax Printers

These printers produce high-quality images and are also used by graphic artists and advertising bureaus. Unfortunately, the cost to produce these images (in consumables) is quite high and they are easily subject to damage by heat and scratching. Definitely not suitable for the home user.

Inkjet Printers

This is the most common type of printer used to print digital images by home users. When used with specially treated papers they produce high-quality images that can rival traditional photographic printing.

Epson inkjet printer

Models abound from various manufacturers that can print from postcard-sized prints, up to large prints that can just about cover a wall. It will all depend on your needs, and the size of your bank balance!

However, in the main they are comparatively inexpensive compared to other printing technologies, although the cost of consumables needs to be looked at closely before making a purchase of one of these machines.

As well as images, these printers are also very good for printing text and graphics.

There are currently two different technologies used in inkjet printers. The difference between the two is in the manner that they actually deliver the ink onto the paper.

Now I know I promised not to bore you to death with the different technologies surrounding digital printers, but in this case I need to make an exception. Sorry, but it is important for you to understand the differences between these two different types of inkjet printers.

The first type of inkjet printer is commonly known as the bubble-jet printer. This type of printer works by heating up the ink in the printer head and then squirting it on to the paper.

With this system the print head forms part of the ink cartridge and is replaced when you load new ink cartridges into the printer. Therefore the costs to run this type of printer are higher than the second variant, which we will look at in a moment.

In addition to the print head issue, the inks used in bubble-jet printers seem to be susceptible to moisture. Keep water well away from your prints!

Canon bubble-jet printer

Also if the bubble-jet printer does not have an automatic built-in drying function, it can take a little while for the ink to dry. Therefore, some care needs to be taken when handling prints fresh from the printer.

However, given these considerations, bubble-jet printers can produce fine results for the digital photographer.

The second technology involved with inkjet printers is called the piezoelectric method. Instead of heating the ink the printer has a crystal in the print head that, when an electric current is passed through it, flexes and pushes the ink out through the nozzle onto the paper.

The result of this is that the ink is dry by the time the print emerges from the printer so there are no worries in immediately handling the print.

Secondly, the print heads are designed to last the life of the printer and do not have to be replaced each time you change ink cartridges. This makes your consumables more cost-effective.

The inks used by this type of printer

An inkjet printer that doesn't heat the ink

are dye-based (more on inks a little later) and therefore not as susceptible to smudging by moisture.

Either of these two types of printers can give excellent results for the digital photographer, and they are relatively inexpensive. Even the most basic models will normally be able to handle 8 1/2 X 11-inch prints.

For not too much more of your hard-earned cash you can get inkjet printers that will go to 11 X 17 inches—big enough to make quite a splash on your living room wall!

The best results will be gained by using the specially developed photographic papers designed for these printers and you may need to experiment a little to find what gives the most pleasing results in your case, as there are quite a few options available.

However, these papers are a good deal more expensive than normal paper. Therefore, it can be a good idea to print out a draft copy on normal paper first to proof the image before loading the expensive variety.

Archival Life Inks

Inkjet printers, both the bubble-jet and the piezo-electric type all use inks, either water- or dye-based that, to date, have had a problem.

This problem is archival life. Archival life simply refers to how long the finished print can be exposed to light before it starts to fade.

You see, all the inks mentioned earlier are susceptible to ultra violet (UV) light.

So how long your print will last will depend on a number of factors:

1. What type of ink was used
2. What type of paper it was printed on
3. How the print is displayed

The way the image is displayed is the most important factor here, although ink type and paper used contribute to the image degradation process.

For instance, if the print is to be kept in a photo album it will most probably last for years. If, however, you are going to put the photograph in a frame, it's a different matter.

In these circumstances the print may last a year or two (depending on how exposed to the light it is) or it may start to fade in a matter of weeks. As a matter of fact, if you put it near a window that receives strong light you may detect fading within days, in some cases.

What are you to do? What's the point of having the digital camera, computer and printer if the results can literally fade before your eyes?

Good question, but there are a number of options.

First, you can always reprint the image relatively cheaply provided you have saved the image. Just replace the image when the fading becomes noticeable.

Second, if the image is really important, you could have a photo lab print it for you. Photographic prints should last around 25 years in normal lighting conditions.

Third, Epson has recently announced a new range of digital inkjet printers that use specially formulated inks that will last up to 130 years without noticeable fading (in indoor lighting, framed behind glass).

If you want to stick your photo out in the sun (and I can't think why you would want to), the nonfade time is down to three years, but this is still much better that the old option that would see fading within days.

The Epson Photo Stylus 2000P model shown below is the first of these models to be released for home use. It is at the high end of affordability for a home printer (big surprise!) but, in its defense, it will print both roll paper and up to Super B-size paper (13 X 19 inches).

Epson Photo Stylus 2000P printer

It's the first printer designed for the home user that I know of that allows the use of roll paper. This will allow users to print some pretty impressive images if they wish.

As far as price is concerned I'm sure that Canon and Hewlett Packard will not let Epson have the running to themselves in this market for very long, and when they release comparable models, the prices should fall.

Consumable costs are not known at this point but I would expect that they will be slightly higher than current products.

A print that has faded over time

Image Editing

Image editing is the digital photographer's darkroom.

With traditional photography the film is developed and then printed onto photographic paper.

During both film development and printing in a darkroom, there are quite a number of techniques that experienced photographers use to enhance the final outcome.

For instance, you can perform what is known as pushing and pulling film. This means that you either deliberately overdevelop (push) or underdevelop (pull) the film.

You can also do the same to prints. When printing your photographs you can dodge or burn specific areas of the image. Dodging is where you hold back exposure to a certain part of the print that may be overexposed. Burning is where you overexpose part of the print that may be under-exposed.

Now I don't want to get into a whole lecture here about the various darkroom techniques available to manipulate film (and prints for that matter), rather only point out they are available, and used quite often by experienced darkroom operators to improve their final results.

The good news is that the same techniques (more in fact) are available to the digital photographer. The computer software programs that deliver all of these magical tools are called image-editing or image-manipulation programs.

Using one of these programs, the digital photographer has the advantage of seeing the results instantly on the screen. If these results aren't what was desired, the changes can be dumped (some or all) and the process may be started again—*provided the original image is saved.*

There are many image-editing or manipulation programs on the market. Many digital camera manufacturers provide at least a basic version of one program or another with the camera to get you started. Quite often that program will be Adobe PhotoDeluxe®, which is a reasonably close relative of Adobe Photoshop®—the leading professional-level image editor.

Now I don't intend to try and teach you how to use one of these programs in this book. That's impossible, given the space I can devote to this particular topic.

Adobe Photoshop® image-editing software

Rather, what I intend to do is to give you an overview of the more important tools available in these programs and the functions that they can perform.

To fully utilize the power of programs such as Adobe Photoshop, you need to devote some serious time to studying the manuals that come with the program you are using.

Also there are some excellent books that are totally devoted to teaching you the power these programs can put in your hands. I would recommend you consider investing in one of these publications.

I will use Adobe Photoshop as my example, first because that is the program I use, and second because, as far as I am concerned, it is the most powerful program on the market.

If you are using a different program you may find that some of the tools and commands have different names but they should be easy for you to identify.

Before you start, however, you should look at calibrating your computer monitor.

Calibrating a monitor involves adjusting how it displays an image on its screen.

Most monitors come with some form of calibration program for you to achieve this task. Some professional image-editing applications also provide help in this area. If you have neither it may pay you to talk to your friendly computer dealer and seek their advice. So let's begin and have a look at the wonderful world of image editing.

Hong Kong incense seller

Opening Images

You need to open an image within an image-editing program before you can play with it.

To do this is very easy. Simply go to the File command (at the top of the screen) and choose Open. A dialogue box like the one below will appear on the screen and you then need to tell it where you have placed the image you wish to open.

Opening a file in Photoshop®

There is also a universal Open command shortcut that you can use to achieve the same result: press Control + O on a PC or ⬤ + O on a Mac.

Some notes:

1. Digital cameras often use a proprietary file format to store images on their storage media that image-editing programs can't read. If this is the case you need to read your digital camera manual, which should give you the information needed to convert the camera's files into a standard format that the image-editing program can read.

2. Image-editing programs use a prodigious amount of computer memory (RAM). If your computer balks at opening the program and basically says, "Excuse me, you want to do what?" you may need to close down all other programs that are open to free up enough RAM to get the program up and running. Alternatively, you can always purchase more RAM for your system.

3. Some image-editing programs, including Adobe Photoshop, also use hard disk space as well as RAM when processing images. If you are using a program that operates in this manner you will need at least the same amount of free hard disk space as RAM to allow the program work to work properly. If this is not the case, chances are you will get a message that says your scratch disk is full. If this occurs you need to dump some unwanted files and free up the necessary hard disk space.

4. Some digital cameras can connect directly to a computer to download images into an image-editing program using what is known as a TWAIN driver. You should check your camera manual to see if this feature is available with your camera.

5. Always have a copy saved of the original file before beginning the image manipulation process. You can then go back to the start and begin again if things go wrong.

6. Photoshop can open images that have been saved in most of the file formats available. Some image-editing programs will convert the file being opened into a specific format such as PDD and open a copy in that format. This is normally because the programs can process images faster in these formats. If this happens, don't save the image in the same name and format as the original. Again this allows you to always revert to the original file if you mess things up.

7. When you open the image from the camera or the camera's storage media it should open as an RGB (Red/Green/Blue) image.

The File/Open dialogue box in Photoshop®

Saving an Image

As mentioned in the previous section, as soon as you load an image you should save it.

You should also save it often along the way as you are working on it, because computers can suffer many dire fates during the image-editing process and unless you save your work along the way it is all lost forever and you need to start again. By the way, unless you saved the original image as discussed earlier, starting again will be impossible. Ignore this piece of advice at your peril!

The commands for saving an image are also pretty common in image-editing programs.

Again simply click on the File command and choose Save As (not Save).

The reason for not using the Save command is that it is a good idea to give the image a different name than the one that you loaded in. Clicking on Save As gives you the option of renaming the file to distinguish it from the original.

As stated earlier, you can then always call up the original file if things go wrong.

Once you have renamed the file and saved it you can then use the Save command to save changes along the way.

There is also a universal Save command. Ctrl + S on a PC and ⌘ + S on the Mac. However, please use these only after saving the image under a different file name, otherwise they will save the file to the original file name and extension.

Always, if possible, save the image to the hard drive rather to a floppy or Zip disk. This is simply because your computer can work much faster from the hard drive as opposed to removable storage media.

Select File/Save As the first time you save an image in Photoshop®

The Undo and Redo Commands

Normally under the Edit command you will find a command called Undo. This command allows you to Undo your most recent command in case you don't like the results. Redo allows you to reapply the command if, after undoing it, you change your mind.

History Pallet

Normally this command will only allow you to cancel the last change to your file or reapply it, if you subsequently happen to change your mind.

Some image-editing programs (including Photoshop) offer the facility for multiple undos. This is quite often found under a heading called History which, in Photoshop, is found on one of the pallets on the desktop. If it doesn't show on the desktop it can normally be called up by clicking on the Window command, and then clicking Show History. Read the software manuals on how to use the History Pallet.

Show History command

Okay, before we continue with image-editing commands let's just review two of the rules for success.

1. Right at the start make a copy of your image using another file name. Use this copy for image-editing purposes.

2. As you edit the image, save your work along the way. You can also use Layers to do this (discussed in a moment), but Layers will not protect your work from a computer crash. So, for safety purposes still save you work along the way, even when using Layers.

Now you have your raw image file on the screen and you have saved a copy in a different name to work on. By the way, when you save a file with the Save As command, that is the file you will be working on from that point.

Orientation

When your image file comes up on the screen it might happen to be upside down, back to front, or any other of a number of orientations that are not correct.

Image/rotate command

Panic not! This is simple to fix. In Photoshop, go to the Image command and click on it (the function I am about to describe could be given different names in other image-editing programs).

Go down to a sub-command called Rotate Canvas and click on it. Up pops a whole range of options that will allow you to manipulate how the image is presented on the screen.

You could click on any of the following:

• 180°: rotates the image 180°
• 90° CW: rotates the image 90° clockwise
• 90° CCW: rotates the image 90° counterclockwise
• Arbitrary: allows you to type in the degree and direction of rotation
• Flip Vertical: flips the image vertically
• Flip Horizontal: flips the command horizontally

Simple, isn't it? Try out all the variations with an image and see what they do. Remember that using the Undo command will revert the image to its original state.

From this point on, the order that people do various things to their images varies. In my case I would now go to the Levels command, which we will get to in a moment.

Just before this, however, I would create a new layer for my image and do subsequent adjustments in the new layer.

Layers

Layers is a method of working on an image and keeping the original there to compare with at all times. Using layers enables you to make alterations that can be compared to the original image, or another layer, and dumped if incorrect.

The layer function can be found residing in a pallet on the desktop. If it does not show on your desktop go to the Photoshop Window command and click on it.

A dropdown menu will pop up on the screen. Go down to Show Layers and click on it. The layers pallet should now show up on the desktop.

Look at the layer pallet and you will see the following:

1. A representation of an eye
2. A drawing of a paintbrush
3. A thumbnail (small image) of the image being worked on
4. The word "Background," which will be highlighted

At the bottom of the pallet are three small icons. Place your cursor on the word "Background" and drag it down to the second icon from the left. Now you will see a new line form above, which is the same as its parent except that it will say, "Background Copy." This line will now be highlighted. Congratulations, you have just created a new layer!

The layers palette

This Background Copy layer is a direct copy of the original Background layer. That is, until you start manipulating it. Then it becomes different from its parent. You can make multiple layers if you wish. Each successive layer will be named Background Copy 2, Background Copy 3, and so on.

To change the layer you are working on simply click on it and it will be highlighted. The highlighted layer is the only layer to be affected by any changes you make. Make alterations only to the last layer created.

The layers palette after a new layer has been created

This now brings up a very useful function of layers. Let's say that you have made a change to your image in the Background Copy layer, but you're not sure how the changes you have made compare to the original.

Simple, remember the representation of the eye in the layers pallet? If you look at the Background Copy layer you will see that the eye is showing, as it is on the background line as well.

Click on the eye on the Background Copy layer. This turns the layer off and brings up the original background image on the screen. Switching it on again shows the effect of the changes you have made in the Background Copy layer. Neat, isn't it?

If the changes are not to your satisfaction you can undo them and start again or drag the Background Copy layer to the trash can at the bottom of the pallet and dump it. You then make a new layer and start again.

You can make a new copy layer for each change you make, if you wish. This protects all changes you have made to that point and you only put at risk the latest alteration to your image.

Please note that the layer function will not protect you from a computer crash. If the computer goes belly up you will lose all work in all layers! You still need to save as you go. By the way, when you are working with layers you will only be able to save your work as a PSD file until you "flatten" the image, which combines all the layers back to one.

To "flatten" the image click on the Layer command and select Flatten Image from the dropdown menu. Leave this for last, when you have finished making any changes, and are totally satisfied with the image.

Image Levels

The levels command is used to set the tonal range of your image.

It may go by other names in other image-editing applications. Many do not have it, in which case its functions have to be undertaken using the basic brightness and contrast controls, which, frankly, are not as good, due to their lack of control in midtones—something we will get to soon.

To access the levels command, first click on the Image command. A dropdown box will appear and you should select Adjust.

A second dropdown box appears, which will give you a number of options, two of which apply to levels. The first is Levels and the second is Auto Levels.

Levels command

With Auto Levels the program automatically sets the levels of tonal range in your image based on what it perceives to be the correct setting. I must admit to not liking this option and prefer to use the manual levels command.

So select Levels and up will pop a dialogue box that looks a tad complex (shown overleaf). Don't panic! It's not as complicated as it looks.

The part of the dialogue box that looks like a chart (it is a chart, by the way) is called a histogram. A histogram maps out the brightness range of your image. The darkest pixels are plotted to the left of the graph, while the lightest pixels are plotted to the right. Very interesting (yawn) I hear you say, but how does this help me improve the look of my image?

Well, a properly exposed image will normally have a brightness range that stretches right across the histogram. Mind you, if you took a photograph of an object that was totally gray on a gray background this would not apply, but with a typical image that includes shadows and bright highlights (black through to white), the brightness range could be expected to occupy the major part of the histogram.

The levels dialogue box

Adjusting the slider in the histogram

Now although this image has dark shadows and bright highlights, it isn't showing up in the histogram as expected. This could be because we either under-exposed or overexposed the image.

The histogram exposes the flaws in the brightness range and the Levels command gives us the tools to help correct the situation.

Let's say the shadows are not as dark as we would wish. Click on the little box that says Preview so that a checkmark (√) shows. This allows us to preview the changes we are about to make.

Take the mouse pointer and place it on the black solid triangle at the extreme left (called a slider) directly below the histogram, not the one further down under Output Levels.

With the mouse button down, move the slider to the right slowly and you will see the shadows change. Move it gently and stop when you judge the shadows in your image to be correct.

Perhaps this image also has a problem with high-lights. Repeat the process with them. Take the mouse pointer and place it on the slider at the extreme right. Again press the mouse button and move the slider to the left until the highlights look correct.

That leaves the midtones, which are controlled by the slider in the middle. Normally the midtones will also need adjusting after the shadows and highlights have been altered.

Place the mouse pointer on the center slider and move it to the left to adjust the midtones. It is more likely that moving this slider to the left, rather than to the right, will correct any midtone problem, but try it both ways and judge for yourself.

Once you are satisfied click on OK to save the changes. Remember, the changes will be saved in the Background Copy layer if it is highlighted and the Background layer will remain unchanged.

Now go back to the layers pallet and toggle between the two layers (by switching the eye next to Background Copy on and off). This will clearly demonstrate the effects of the changes you have made.

There is a better way of setting the black-and-white points in this command (which is really what the Levels command does) by using the eye-droppers in the dialogue box.

You should read the Photoshop manual (or the manual from your own particular image-editing application) to learn more about this function.

There are also a number of other options with the Levels command that can be employed. Again read the manuals or a good book on Photoshop (or your own image-editing application) to learn more.

By the way, some digital cameras (compact and 35mm SLRs) have a histogram function built in. This shows you the brightness range of your shot and can be an invaluable tool in judging the exposure for a particular shot.

If your image-editing application does not have a Levels command then you will need to use the Brightness/Contrast command to try and achieve the same function.

In Photoshop click on Image and select Adjust. Then select Brightness/Contrast and a dialogue box similar to the one below pops up on the screen.

Image/Adjust/Brightness/Contrast command

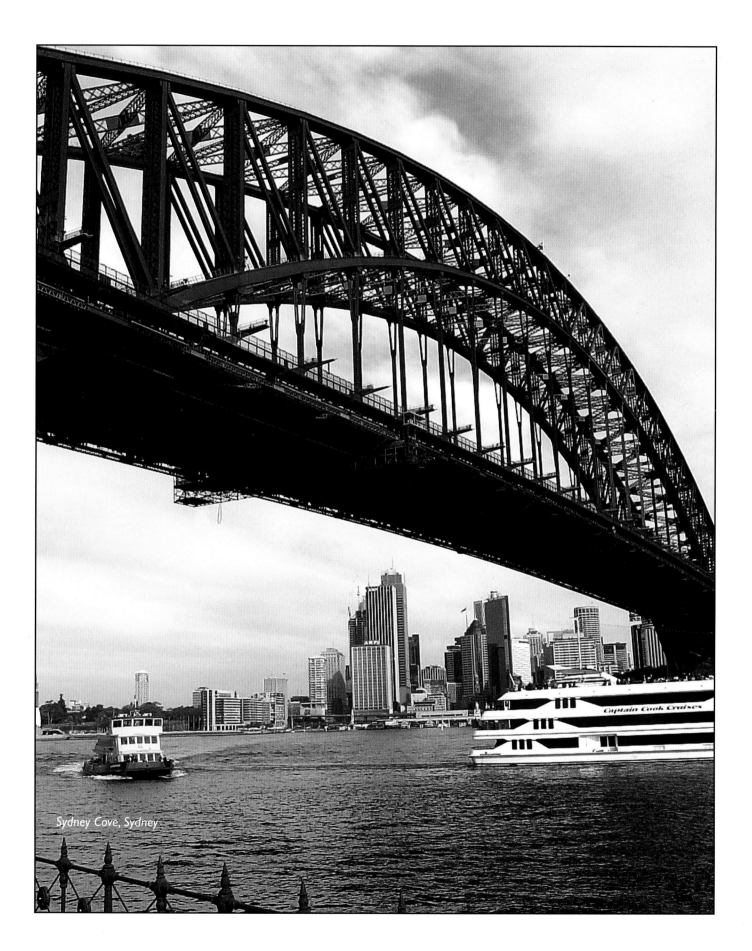

Sydney Cove, Sydney.

Again by placing a checkmark (√) in the preview box, you will be able to see the changes you are making before committing to them. Don't forget that you can always use Undo to cancel changes and if really desperate you can always dump the Background Copy layer and start again.

Both the Brightness and Contrast controls have sliders. By placing your mouse pointer on their sliders and holding down the mouse button you will be able to move them left or right.

Moving the sliders to the right will increase brightness or contrast and, conversely, moving them to the left decreases them.

However, these controls work globally. That is they affect all pixels in the image equally, which is different from the Levels command.

If, for instance, your image was uniformly dark, it will work well. Sliding the Brightness control to the right should improve the image for you.

What if the image is not uniformly dark? In the Levels command you can alter the shadows, midtones, and highlights separately. With Brightness/Contrast all areas of the image are affected by the changes you make.

You might, for instance, have an image that is correctly exposed except for the sky, which is under-exposed.

Using Brightness/Contrast here will affect the entire image and might well correct the under-exposed sky, but will put the remainder of the image out of kilter. What to do?

Fortunately, Photoshop and other image-editing applications have various selection tools that will be discussed later in this chapter.

A selection tool allows you to select a certain part of the image and only apply changes to this area. Therefore in the scenario described above you would use one of these tools to select the sky and apply Brightness/Contrast alterations to this area only.

It's not as easy as Levels, but it will work fine.

By the way, you will notice that many of the dialogue boxes discussed have number indicators that change as you adjust the various sliders. It is possible to click in the area where the number is displayed, then type in a number, instead of moving the slider. Personally, I rarely do this because I prefer to see the gradual change that adjusting the slider makes on the screen.

Curves

The Curves command is similar to Levels in that it allows adjustment in the tonal range of the image.

However, where Levels makes adjustments in the shadows, midtones, and highlights, Curves works more like a fine tuning tool, allowing adjustment at any point along the tonal scale.

Image/Adjust/Curves command

To access the Curves command, click on Image and select Adjust from the dropdown menu. Find Curves in this menu and click on it. The following dialogue box will appear.

The Curves dialogue box

Uh-oh, I hear you say. Another funny looking graph thing! Have some faith, people—you must have survived Levels to get this far and Curves is just as easy to understand.

Keep in mind that with RGB (Red/Green/Blue) images, pure black is represented by the number zero (0) and pure white is represented by the number two hundred fifty-five (255).

Using the Curves command you can adjust the tonal range between 0 and 255.

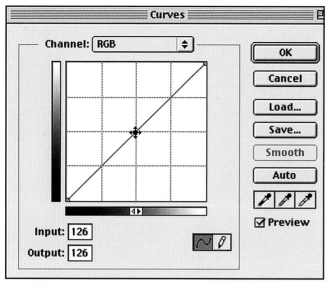

Placing an adjustment dot in the Curves dialogue box

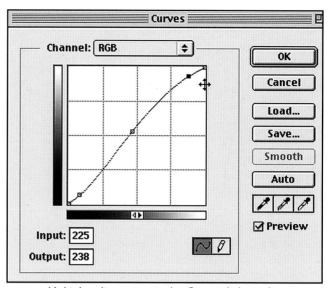

Multiple adjustments in the Curves dialogue box

If you place the mouse pointer anywhere on the diagonal line and click, you will see a dot appear on the line. With the mouse pointer on the dot, hold down the mouse button and drag it either up or down and watch the effect on your image. Having fun, are we?

Now let's stop having fun and get a tad more serious for a moment. The very bottom point on the line in the graph represents the darkest point in your image. Likewise the highest point represents the brightest point and the middle point represents the midtones. If you click on the very center of the line and drag it upward slightly you will see the midtones get darker. Likewise if you drag it downward they will get lighter.

Place the dot higher than the mid point on the line and then drag it up or down and you will affect the highlights. Place the dot lower down the line (from the mid point) and you start to affect the shadows.

Curves is a very useful tool for fine-tuning the way an image presents. You can use multiple dots and affect various parts of the image.

I would suggest that you start to experiment with this command and see what it can do for your images. Remember you can always cancel out of Curves or use the undo command if you don't like the results.

Saturation

Is your image looking dull and washed out a tad? The Saturation command can come to the rescue. This command is used to pump more color into images that may look a little washed out. It is accessed by clicking on Image, then Adjust (familiar?). Next select Hue/Saturation from the dropdown menu.

You are confronted with three selection sliders: Hue, Saturation, and Lightness. We are going to concentrate on Saturation. Look up Hue and Lightness in the manuals for a detailed explanation. However, don't confuse lightness with brightness; they are entirely different.

Call it up. Moving the slider to the right increases the color saturation of the image. Moving the slider to the left decreases the color saturation. Easy.

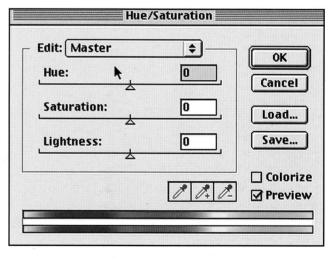

Saturation dialogue box

Color Balance

Sometimes your images have a color cast. They may be a bit red or green or blue.

This can sometimes be caused by the camera you are using, which may have a slight color preference. Sometimes it's a result of scanning when film has been digitized.

Click on Image and again select Adjust (we've been here before, haven't we?).

Select Color Balance from the dropdown menu and the dialogue box appears on screen (below).

As you can see you have three controls with sliders labeled Cyan /Red, Magenta/Green, Yellow/Blue.

You also have three check boxes that allow you to select between Shadows, Midtones, and Highlights. A preview check box is also there.

Let's say your image has a slight green color cast. Place your mouse pointer on the slider below the Magenta/Green line and, while holding down the mouse button, start dragging it toward the left, away from green.

If you have checked the preview button with a checkmark (√), you will see the color change as you drag the slider across.

Take it easy and use small increments to judge the effects. Click OK when you are satisfied.

Notice that you can work in the Shadows, Midtones, and Highlights by checking the appropriate box.

Be aware that when you do make a change it again is global and will affect the entire image.

To affect only part of the image you need to select the appropriate area only. We'll get to how to do this in a moment.

There is another way in Photoshop (and other image-editing applications) to look at an image and see what difference various color changes will make.

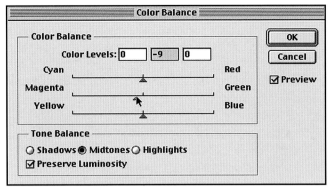

Adjusting Color Balance

It's called Variations. To access it click your mouse pointer on Image and then select Adjust. From the dropdown menu that appears select Variations.

Variations is a more visual way of adjusting color within your image and is used with images that don't require precise color adjustments.

When you open the Variations

Selecting variations

dialogue box the first thing you notice is that you have twelve thumbnails of your image. At the top are two thumbnails labeled Original and Current Pick. When you first open the dialogue box these two thumbnails are the same. However, as you make changes, the Current Pick thumbnail will alter to reflect the changes you have made.

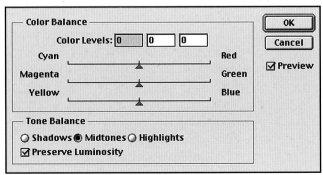

The Color Balance dialogue box

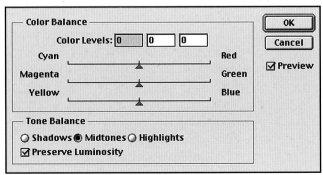

The Variations dialogue box

Below these two thumbnails are two other sections of the dialogue box.

Here there are seven more thumbnails labeled as follows: More Green, More Yellow, More Cyan, Current Pick, More Red, More Blue, and More Magenta. It is in this area that you make any color alterations.

To the right are three further thumbnails labeled Lighter, Current Pick, and Darker. Here you can adjust the brightness of the image. The two extra Current Pick thumbnails are repeats of the one at the top for convenience.

To add a color to an image click on the appropriate thumbnail. For instance, if you feel the image needs more yellow click on the More Yellow thumbnail. If you wish to subtract a color, click on the opposite thumbnail. In the above example you clicked on More Yellow. If you wish to subtract Yellow you would click on More Green.

If you wish to lighten the image you would click on Lighter and clicking on Darker has the opposite effect. I think you get the idea by now.

Unsharp Mask

Unsharp Mask is designed to sharpen the edges of the image.

Rather an odd name for a tool that is sitting under the heading of image sharpening commands, wouldn't you say?

Nevertheless, Unsharp Mask is an extremely useful tool in the image-editing process.

Digital images can have a tendency to look soft or slightly out of focus. Photoshop offers a number of tools to help correct this problem. In this book we are only going to look at one: the Unsharp Mask command.

Selecting Unsharp Mask

You should consult the manuals of your image-editing application to see what other tools are available in this area.

To access Unsharp Mask, click on Filter, from the dropdown menu click on Sharpen, and finally click on Unsharp Mask.

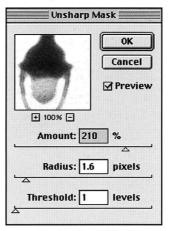

The Unsharp Mask dialogue box

This dialogue box opens. The thumbnail in the top left-hand corner is a part image of your photo on the screen. The scale of the thumbnail can be altered by clicking on the + and − controls directly under the thumbnail itself. Moving the mouse pointer over the main image can alter the area showing in the thumbnail.

When you do this the mouse pointer forms a square. Place the square over the area of the image you want represented in the image and click your mouse button. Hey presto! There it is.

Now you have three slider controls that are labeled Amount (%), Radius (in pixels), and Threshold (in levels). You also have a Preview check box. The Amount control will determine the amount of sharpening that is applied to your image. For high-resolution printed images Adobe recommends between 150% and 200%. You need to experiment to see what will give the best result with individual images.

The Radius control determines how many pixels neighboring the edge will be affected by the sharpening. Here, for a high-resolution image, Adobe recommends a Radius factor of between 1 and 2 pixels.

The Threshold command helps Photoshop determine what is an edge within your image. If you have it set at zero, Unsharp Mask will affect all the pixels within the image. You need to experiment here but try a range of between 2 and 20.

If you make an alteration with the Unsharp Mask command and place your mouse pointer over the thumbnail and click it, the thumbnail will toggle between the alteration and the original image. This is a very handy way to determine the changes you are making before hitting the OK button.

No image-editing application can correct a badly out of focus image, but it may help a bit.

The Magic Wand

Previously in this chapter, I have mentioned that most of the commands we have discussed will perform their tasks in a global manner. That is, they will affect the entire image.

The Magic Wand options palette

To affect only part of an image we need to identify the area concerned and define it with a selection tool.

Photoshop and other image-editing applications have a number of different selection tools that you can utilize. Due to space constraints I am only going to discuss one of the selection tools that Photoshop offers to the digital photographer.

This tool is called the Magic Wand, and what a handy little tool it is.

The Magic Wand is accessed from the main tool pallet, which should be in the top left part of the screen. If it isn't there, go to the Window menu at the top of the screen and click on Show Tools.

Now click on this icon:

When you do this your mouse pointer turns into a Magic Wand and a Magic Wand Options pallet should appear on the screen. If you don't see this, go to the Window menu and click on Show Options.

Tool palette

Now let us say that you want to select the sky in your image as it is underexposed and could do with some tweaking. Have at look at the Magic Wand Options pallet and you should see a Tolerance check box with a number in it. Click in the check box and type in the number 32. Now take your Magic Wand pointer, place it over the sky, and click.

There should be a dotted line encompassing the sky part of your image. This dotted line is known as a marquee or mask. Now you can apply the necessary tool to improve the appearance of just the sky. Whatever you do will only affect the area encompassed by the marquee. The remainder of the image is untouched.

Sometimes the Tolerance setting needs to be adjusted, normally down, to affect just the area you want to work on. If that is so just type a lower number in the check box and try again.

Alternatively if your Magic Wand got most of the sky, but missed a portion simply hold down the Shift key and click the Magic Wand over the area that was missed. That should pick up the part that was missed and add it to the marquee.

A marquee defining the selection

The Magic Wand, like many Photoshop Tools, may need some practice, but you will soon get the hang of it. By the way, if you select an area of your image with the Magic Wand and then click on the Select command at the top, a dropdown menu appears. Select Inverse by clicking on it. Now when you make any alterations the areas outside, not inside, the marquee will be affected. This can be very helpful with some images where you find it difficult to select particular areas.

Selecting inverse

Cropping

Now let us look at cropping an image in Photoshop using the Rectangular Marquee tool and the Crop tool (also selection tools). Some images need cropping (the cutting out of extraneous parts) to help improve their composition.

In Photoshop place your mouse pointer over this icon and click.

Place the mouse pointer on the image at the point you wish to be the top left hand corner of the image.

Depress the mouse button and drag diagonally down and to the right until you reach the point that you wish to be the bottom right hand corner of the image.

Rectangular marquee defining section of a photograph

Release the mouse button and a marquee will form defining the new borders of your image.

If it is as you wish, go to the Image command at the top of the screen and click on it. From the dropdown menu click Crop and the unwanted

| Image | Layer | Select |
|---|---|---|
| Mode | | ▶ |
| Adjust | | ▶ |
| Duplicate... | | |
| Apply Image... | | |
| Calculations... | | |
| Image Size... | | |
| Canvas Size... | | |
| Crop 🔍 | | |
| Rotate Canvas | | ▶ |
| Histogram... | | |
| Trap... | | |
| Extract... | ⌥⌘X | |

Selecting Crop

portion of the image (outside the marquee) will be removed. If you have made a mistake don't worry. Simply go up to Edit and click. Now click on Undo Crop and your original image is restored.

If you hold down the mouse button while the mouse pointer is within the marquee you can reposition the marquee by dragging it. However, there is a better way to do this.

Additional marquee and cropping tools

Instead of selecting the Rectangular Marquee Tool as we did a moment ago, place the mouse pointer on the same Icon and while holding down the mouse button drag to the right. Up will pop five different icons.

Select the one at the end (right).

Place your mouse pointer on the image and drag (down and to the right) to form your marquee. Release the mouse button and a marquee forms. Notice that the marquee has little boxes on each corner and also in the middle of each line.

Place your mouse pointer over one of these boxes and directional arrows show. These indicate that you can resize the line selected. Press the mouse button and move the mouse up or down.

Crop marquee with directional boxes (handles)

See what happens the line moves to the new position. Refine your marquee using this technique until you have got the new image size just right.

Then when satisfied press Return (Mac) or Enter (PC) and the image will crop to the new size. Again you can use undo to return to the original image.

Finally

Although we have examined but a small selection of Photoshop's full repetoire, it's a good start, and will get you well along the way to mastering these clever programs.

Remember, read the manuals that came with your own application and, if possible, get a good book on explaining its specific functions. Have fun!

Scanning

Not all digital photography involves the use of digital cameras. Most people still have film cameras and a whole heap of prints and slides that they have taken over past years that they may like to digitize and put on their computer.

The way to do this is to scan the image into the computer. The following can be scanned (depending on your scanning equipment):

• Negatives (both color and black and white)

A film transparency that can be digitized by scanning

• Slides or transparencies (both color and black and white)

• Photographic prints or any other form of hard copy

There are basically three types of scanners on the market.

Flatbed Scanner

The first is known as a flatbed scanner and these machines can range in price from quite economical up to reasonably expensive,

These scanners will scan just about anything, normally up to 8 1/2 X 11 inches.

The only limitation you might find is the degree that they can enlarge your scan. This could be limited depending upon the model involved. But check this point out before committing to one of these scanners.

Some flatbed scanners have trays that hold multiple images such as slides and negatives. This allows multiple scanning, which can be a great time saver.

Above: A flatbed scanner

Film Scanners

Film scanners will only normally scan 35mm negatives or slides. However, they are a useful tool but can be a tad expensive for the good ones.

A film scanner

If I am going to shell out for a scanner I'd probably go for a good-quality flatbed scanner that has a better range in relation to the types of media (film, prints, printed pages, and so on) it can accommodate.

Drum Scanners

The creme de la creme of scanners, these wonderful machines can scan just about anything and do it with ease.

Unfortunately, you will need a pretty hefty wallet to afford one. They are normally not small and can take up a significant amount of room. Usually they are not found in the home enthusiast's digital darkroom.

Scanners all come with some sort of software to make them run. This software could include things like a histogram function, which can be adjusted before you actually scan the image.

Things to look for when purchasing a digital scanner include:

• The dpi rate that the scanner works at—the higher the better

• The density rate the scanner delivers Again the higher the better, but look for one that has a density rate of 3+.

Scanners normally come with their own manuals, which should be studied closely. Also scanners, to date, are SCSI devices so you may need a SCSI card to hook it up to your computer (if using a PC).

A drum scanner

The Correct Exposure

Snowgums, Kiandra, NSW, Australia

So you have read your camera manual and the chapters in this book on equipment from front to back and, better yet, understood the information contained therein.

Out into the big wide world you go and take some shots. Then you come home, download you images onto your computer, and you find that while 80% of your photographs are fine, the remaining 20% look like either photo 1 below (underexposed) or photo 3 (overexposed). What went wrong?

To work this out we had better start by revisiting the controls that the camera uses to determine exposure.

Bare Island, Sydney, Australia. Photo 1: underexposed (top); Photo 2: correct exposure (middle); Photo 3: over-exposed (bottom)

Exposure Controls

There are three controls that effect exposure calculations: aperture, shutter, and ISO setting.

Aperture

As you will remember from previous chapters the aperture controls the amount of light that, once reflected from your subject, is allowed to pass through the lens, and be recorded on the imaging sensor.

Lens aperture

This is achieved by altering the size of the aperture from a small opening (high f-stop number - less light allowed to pass) to a large opening (low f-stop number - more light allowed to pass). Remember also that the sizes of the openings in the aperture are called f-stops. Each f-stop represents either a doubling or a halving of the amount of light that is allowed to pass through the lens and strike the sensor.

Therefore a lens with its aperture set at f22 will let in half as much light as one that is set at f16. Conversely, a lens set at an aperture of f8 will let in twice as much light as one that is set at f11.

Also remember that the aperture size selected controls the depth of field within the image. You will recall that depth of field is what is in focus within your image, both in front of and behind your point of focus.

The smaller the aperture (high f-stop number), the greater the depth of field. The larger the aperture (low f-stop number), the less the depth of field.

Shutter

The camera's shutter is the control that determines the time period that the light coming through the lens (controlled by the aperture), is allowed to strike the imaging sensor.

The time that the light is allowed to strike the imaging sensor is typically quite short, probably averaging at around 1/125 of a second. However, times of between 1/16,000 of a second to perhaps 10 seconds or longer for a time exposure are also possible, depending upon the camera equipment and the ISO setting being employed at the time, as well as, of course, the lighting conditions.

Shutter speed dial. Digital cameras normally have this control set up in a different format (see The Camera)

As with the aperture, each shutter time setting represents either a doubling, or a halving, of the time the light is allowed to strike the film. So therefore a shutter speed of 1/250 of a second will allow the light to strike the imaging sensor for half as much time as a setting of 1/125 of a second.

Where the aperture setting controls depth of field, the shutter setting can affect movement. If you wish to freeze movement, a shutter speed of 1/60 of a second (with a standard lens of around 50mm) or higher is recommended. If, however, you wish to show movement in your image, than a shutter speed of 1/30 of a second or lower would be required.

Remember also that camera shake, which will result in blurred images, can result from using a slow shutter speed, without the benefit of some additional support for the camera, such as a tripod.

A handy rule to avoid camera shake when hand-holding a camera is to use a shutter speed about equal to the focal length of your lens or higher.

Therefore, if you are using a 150mm lens (without a tripod or additional support), and you wish to avoid camera shake, you should use a shutter speed of 1/125 of a second, or higher (1/250 of a second would be better).

ISO Setting

The ISO setting you use in the camera (presuming you can set it and it's not fixed) is another control, as far as determining exposure is concerned.

ISO dial. Digital Cameras normally have this control set up in a different format (see The Camera)

Remember that the higher the ISO setting, the more receptive the imaging sensor is to light, and therefore less light is needed to form the image.

As discussed in a previous chapter, the higher the ISO setting, the greater the attendant risk of producing computer noise within your images.

ISO settings are also similar to both the aperture and shutter, in that a doubling of the ISO setting means that you need half as much light to expose your image correctly, given the same lighting conditions.

Halving your ISO setting (for example, set at ISO 100 instead of ISO 200) will mean that you need twice as much light to correctly expose your image, again given the same lighting conditions.

Combining the Exposure Controls

To obtain the correct exposure for your image you, or your automatic camera, must combine the three exposure controls, so that the correct amount of light strikes the imaging sensor, for the correct amount of time.

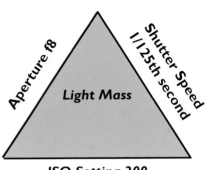

ISO Setting 200

Aperture and shutter speeds are variable and, with some digital cameras, so is the ISO setting. With other digital cameras the ISO setting is fixed.

Let us consider that the three exposure controls are each represented by three separate lines that, when combined, form a triangle. The line that represents the ISO setting will be nominated as the base line as, for this particular exercise, we will consider it not to be variable.

We will call the green area formed within the triangle the light mass, which is really a combination of the amount of light allowed to pass through the lens by the aperture, and the amount of time the shutter allows that light to strike the imaging sensor. This combination is sometimes referred to as the exposure value, or EV.

Both of these factors (aperture size and shutter speed) are influenced by the ISO setting, which we will consider constant for our purposes.

For this exercise we will say that the ISO setting is 200. Having turned our camera on we will also say that the camera's meter has come up with an aperture of f8, together with a shutter speed of 1/125 of a second, as the correct exposure combination, which is represented by the triangle above.

We know that on some cameras we can adjust both the aperture and shutter speed. We also know that if we change the aperture from, say, f8 to f5.6, this action will have the effect of doubling the amount of light passing through the lens.

This extra light means that, by changing the aperture setting to f5.6 without making some adjustment to the shutter timing, we will over-expose our image.

So we need to halve the time the light is allowed to strike the film to bring the equation back into balance. To halve the shutter timing we will need to change it from 1/125 of a second to 1/250 of a second. Now our triangle will look like this.

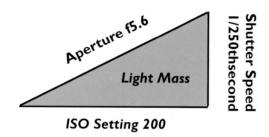

ISO Setting 200

The shape of the triangle has changed somewhat but the light mass remains the same, and will still correctly expose the image.

There are many changes you could make to this equation and arrive at the same exposure value (EV). The table below illustrates this fact.

| Aperture Setting | Shutter Speed | ISO No. | Comment |
|---|---|---|---|
| f8 | 1/125 | 200 | Original recommendation from camera's meter |

Below are some of the possible variations to the camera's meter recommendation that will also give the same exposure value (EV). In addition, I have added comments on the differences these changes would make to the image.

Higher f numbers

| Aperture Setting | Shutter Speed | ISO No. | Comment |
|---|---|---|---|
| f11 | 1/60 | 200 | Increased depth of field. Possible camera shake depending on lens used. |
| f16 | 1/30 | 200 | Greater depth of field. Definite possibility of camera shake if hand-held. |
| f22 | 1/15 | 200 | Even greater depth of field. Must use tripod or some other support to avoid camera shake. |
| f32 | 1/8 | 200 | Yet greater depth of field. Must use tripod or some other support to avoid camera shake. |

Lower f numbers

| Aperture Setting | Shutter Speed | ISO No. | Comment |
|---|---|---|---|
| f5.6 | 1/250 | 200 | Decreased depth of field. This shutter speed and above will also freeze any movement. Precise focusing of lens will be critical. |
| f4 | 1/500 | 200 | Further decrease in depth of field. Focusing even more critical. |
| f2 | 1/1000 | 200 | Almost no depth of field. Focus carefully! |

As you can see there are a number of combinations of f-numbers and shutter speeds that will give you the same exposure value (EV) as the original combination of f8 at 125th second.

You may wish to use these combinations to increase the depth of field, or decrease it. You may want to freeze motion, or blur it, by using one of these settings in this hypothetical scenario, but whichever combination you choose, the exposure value (EV) will be the same.

The same relationships between aperture settings, shutter speeds, and ISO settings demonstrated here applies to all the possible combinations of exposure readings that your camera's meter will give you.

Just remember that if you decide to increase the aperture by one f-stop (say from f11 to f8) then you will need to decrease the shutter speed by one stop, to retain your original exposure value.

Now that you should have a good idea about the tied relationships between aperture, shutter speeds, and ISO numbers in photography, let us get back to the 20% of your photos that did not turn out so well.

When your camera's meter reads a scene, what does it "think" it is seeing?

Remember in most scenes you will find the full spectrum of color from white to jet-black and everything in between. The meter must have a standard reference point to help it determine the correct exposure value (EV).

Well, it does. Camera meters (digital and film varieties) and hand-held light meters are set according to a reference point. This reference point is based on light values that are reflected from a card colored 18% gray.

Eighteen percent gray, I hear you cry! Why this particular reference point?

Well it so happens that a card colored 18% gray has the same reflective ability as the average skin tone. As people are often the subject of photographs, it makes sense to tie the meters' reference point to this particular value.

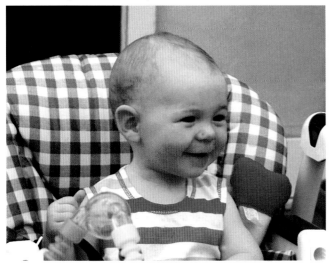

Sophie's skin has a reflective value equivalent to an 18% gray card. Not all human skin however, equates to 18% reflectivity.

A useful tip to remember is that the following objects also have a reflectance value close to 18% gray:

1. Grass (the type you mow!), not dark green, more the green/yellow varieties

2. Most lighter green tree leaves or plant foliage

3. Some, but not all, tree trunks

4. Older cured cement and concrete (very useful)

5. Aged, unpainted, timber

6. Red/brown bricks including pavers

7. Dry tree leaves

I will show you how to use some of these other 18% gray reflectors a little later.

Road sign, Snowy Mountains, Australia.
Correctly exposed (above) and underexposed (below).

Let's look at a subject that could be exposed incorrectly as it could easily fool the camera's meter.

The photograph above was correctly exposed. However, using an exposure based on the camera's meter (center-weighted) would have resulted in the photograph coming out like the one to the right.

So why was the camera's meter giving an incorrect reading?

Well you remember that the camera uses 18% gray as a reference point. Take a good look at these two photographs.

You will observe that some 90% of the photograph consists of snow! As you will realize, snow does not have the same reflective ability as 18% gray but will, in fact, reflect much more light than the 18% gray reference point.

The camera's meter is set not for a scene that comprises 90% snow, but rather for one that is 18% gray, so it gives an exposure setting to suit.

Similarly, in the two photographs below, the dark background can easily fool the camera's meter, resulting in an incorrect exposure.

Umbella man, Florence, Italy (Izzy Perko)
Correctly exposed (top) and overexposed (bottom)

Again the camera's meter has been fooled into "thinking" that it is seeing a subject that has an overall reflectance equivalent to 18% gray.

It would be helpful at this point to look at how digital cameras' meters work, and the types of metering modes they employ.

Basically there are four main types of meters built into digital cameras.

Overall Meter Reading System

The camera with an overall meter will look at the scene and give a reading for the overall brightness of that scene. It will not take into account that you have a large portion of your image filled with snow, which most certainly does not have a reflectance level equal to 18% gray.

Therefore this type of meter is the one that is most likely to give you an inaccurate exposure reading if you have a significant amount of light or dark subject matter in your image. This type of metering system may be found on some entry-level digital compact cameras.

Center-Weighted Metering System

Cameras with center-weighted meters give more prominence to the readings produced at the center of the viewfinder. This type of metering system is often found in some digital compact and 35mm SLR cameras and, in general, is more reliable than the overall metering system.

However, the center-weighted metering system can still be fooled and care needs to be taken.

Another version of center-weighted metering is called bottom-weighted metering. While being similar to center-weighted metering, it takes more of the bottom half of the image into account, thus helping eliminate mistakes arising from taking too much notice of the sky. Unfortunately, in the earlier example there was no sky—just snow, snow, and more snow. Therefore reading the bottom-weighted meter in this situation would also be inaccurate.

Spot Metering System

Some cameras have a metering system that reads only a very small part of the scene (between one and five percent). This allows for much greater accuracy in reading the brightness of a scene, provided, however, that the reading is taken from a suitable subject with a reflectance value equal to 18% gray.

Matrix Metering

Matrix or multi-segment metering is a newer method of evaluating a scene for exposure calculations. Found on quite a few digital cameras it is much more accurate than the other methods.

Matrix metering not only reads the overall light values, but also takes into account the brightness and contrast range of the scene being photographed.

Some cameras with matrix metering also take into account the colors in a scene when determining exposure requirements.

Once this data is collected the matrix metering system will then compare the collected data to a data bank of thousands of images stored in its memory chips to produce the optimum exposure value for the scene being photographed.

However, even with matrix metering, when confronted with a scene such as the example I would bracket the shot just to be sure.

One other method of metering does deserve a mention, however: incident light metering.

Light meters, found in compact and 35mm SLR cameras (both film and digital) measure the light that is being reflected from the subject.

Incident light metering is accomplished with a hand-held light meter that measures the light falling on a subject (rather than being reflected from it) and, after making adjustments, gives a reading.

An advanced light meter capable of reading light in both reflective and incidence modes

It is very important that you understand what type of metering system your camera, or light meter, uses. Check your manual, and if that does not tell you, talk to the retailer who sold you the camera.

The four metering systems discussed here represent the bulk of metering options found in cameras today. There are other methods but they are, in the main, variations of these methods. Let us now revisit these four metering methods.

Overall Metering

This method of metering is the most easily fooled as the meter presumes that everything it is measuring has a reflectance value of 18% gray. This is not the Einstein of the exposure meter world!

Therefore, when you point a camera with one of these meters at a subject such as that illustrated below, the meter reads the light from the sky and from the water, and says to itself that this scene has a reflectance value equal to 18% gray.

Lake Illawarra, NSW, Australia

Now since a bright blue sky obviously has a much greater reflectance value than 18% gray and likewise for bright sparkling water, it is obvious that the meter is going to give an incorrect reading.

In these circumstances the meter will give you a reading that, if followed. will underexpose your photograph.

Perisher Valley, NSW, Australia

In the second photo (above) the meter can, again, presume the white background is 18% gray, read the situation incorrectly, and give you a reading that will underexpose the shot. If the scene were dark the reverse could happen and the meter could give you a reading that would overexpose your photograph.

There are a number of things that you can do to prevent these mistakes in exposure control.

1. Some cameras have a control called exposure lock. This allows you to point the camera and its meter at a particular part of the scene with a reflectance value equal to 18% gray; take a reading, which is frozen when the exposure lock control is held in; recompose the shot for the view you want; and fire away.

In the photo of Lake Illawarra (previous page), I took a reading that only covered the timber of the jetty (which as you can see is not that far from 18% gray), activated the exposure lock, recomposed my shot to include the sky and water, and shot the scene.

In the photograph of the snow, I brought the camera up close to the gray rock in the foreground and took a reading. I then activated my camera's exposure lock control, which held the reading from the rock, stepped back, recomposed the shot, and took the photo.

By the way, if your camera does not have an exposure lock control but does allow manual settings, you can do the same thing.

Simply either move closer to the main subject so that it fills the viewfinder or point the camera at some other part of the scene that has a reflectance value close to 18% gray, take the reading and set the aperture and shutter accordingly, recompose, and shoot.

Be careful that if you do move close to the subject to take a reading, you don't block the light, and also make sure that what you are reading with your camera's meter has a reflectance value close to 18% gray.

The list of objects that have a reflectance value of around 18% gray that is printed on page 125 should be of some help.

2. If your camera has the facility to be set manually you could use an incident light meter, which will read the light that is falling on your subject rather than being reflected from it, and will make the necessary calculation and presto, correct exposure. This is a wonderful invention, although some of the more sophisticated models can be a little expensive. However, some models are reasonably priced, or you could try looking for a second-hand one at a reasonable price.

Center-Weighted Metering

Center weighted metering, which is found in many modern cameras, is more accurate than overall metering, but can still be fooled.

As you can see in the two photos below, the first has been correctly exposed, but the second is about one f-stop out.

In taking the second shot, the center-weighted meter was again fooled by the water and sky into giving an incorrect exposure setting.

In the first shot I took a reading from the reeds toward the bottom right hand corner of the shot, held it by activating the exposure lock control, recomposed the view to what I wanted, and took the shot.

Bird in reeds.
Correct exposure (above) and underexposed (below).

If you have a camera with an exposure lock control, you can do the same thing. All you need to do is find an area that has similar reflectance properties to the 18% gray card, take your reading and hold it by activating the exposure lock control, recompose your shot, and fire away.

If you do not have exposure lock control but can set your camera manually, you can do exactly the same thing. Again the incident light meter could be used in this situation. The comments regarding center-weighted metering also apply to bottom-weighted metering.

Matrix Metering

Matrix metering should give good exposure results around 95% of the time, but even matrix metering can be fooled.

What you need to do here is closely study the images where matrix metering has been fooled and then work out what adjustments will be needed in your exposure calculations when you encounter these situations.

Spot Metering

Spot metering, along with incident light metering, is my favorite method of calculating exposure. You will remember that a spot meter can read the light being reflected from a very small part of the scene, normall, between 1% and 5% of the area.

With spot metering you simply need to identify an area of your scene that is close to the reflectance value of the 18% gray card, take your reading and hold it with the exposure lock control, recompose if necessary, and shoot.

Remember, there is a list of common objects that have a similar reflectance value to the 18% gray card on page 125.

In the photograph below there are a number of areas that have a reflectance value approximately equal to 18% gray.

The first is the cement tower, not where it is shadowed, labeled 1 in the photograph.

The second area that equates 18% gray is the beige tower that abuts the cement tower and also the same structure at the rear of the photo. These areas are labeled 2 in the photo.

Third, the end section of the conveyor belt structure that sits directly on top of the silos is also very close to 18% gray. It is labeled 3 in the photo.

A spot meter reading from any of these areas would give quite an acceptable exposure.

Note that in this instance I did not mention taking a reading from the grass in the foreground of the shot. This was because the grass happened to be exceptionally dry. In order for grass to give a reading close to 18% gray, it needs to be of the green/yellow variety.

It's also a pretty safe bet that if your camera has a spot metering facility that it will also have an exposure lock control, but unfortunately there are exceptions.

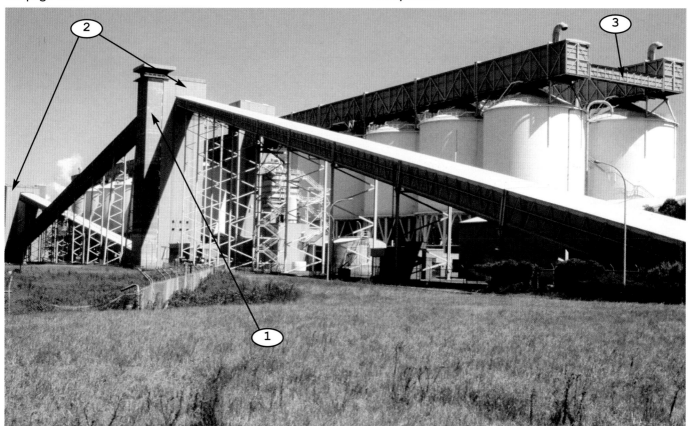

Grain silos, Port Kembla, Australia. Areas labeled have reflectance values equivalent to an 18% gray card.

Bracketing

Some photographic lighting situations are very tricky, as we have already discussed. To avoid missing that once-in-a-lifetime shot, when you are unsure of the correct exposure settings you can bracket the shot.

These days some of the more advanced digital cameras have an automatic bracketing feature.

Bracketing is a photographic technique that produces a number of exposures of the same scene, exposed not only at the meter's indicated settings, but also both underexposed and overexposed (according to the meter readings).

For instance, let's say that the scene you are about to photograph is a tricky lighting situation. Your camera's meter indicates that you should expose the scene at f8 for 1/250 of a second, but you're not quite sure.

To bracket this shot you would first shoot at the indicated settings (f8 for 1/250 of a second).

Next you would do two more shots, the first at f11 and the second at f16, both for 1/250 of a second. Alternatively, you could retain the aperture setting of f8 and change the shutter speed to 1/500 of a second, shoot, and take the next shot at 1/1000 of a second.

Either way the first shot (f11 or 1/500 of a second) will underexpose the image by one stop according to your meter recommendations. The second shot (f16 or 1/1000 of a second) will underexpose by two stops.

Now you take two more shots but this time you overexpose your images in comparison to your meter recommendations.

The first shot would either be taken at f5.6 for 1/250 of a second or f8 for 1/125 of a second. Number two in the overexposure sequence would be taken either at f4 for 1/250 of a second or f8 at 1/60 of a second.

The first option in the overexpose sequence (f5.6 for 1/250 of a second or f8 for 1/125 of a second) will overexpose by one stop in comparison with the meter recommendation. The second option (f4 for 1/250 of a second or f8 at 1/60 of a second) would overexpose by two stops.

By the way, when considering whether to change aperture or shutter settings in a bracketing situation, I would always go for shutter speeds and retain my depth of field, unless camera shake or movement is a consideration.

Note also that you do not have to bracket in full f-stops. If you are slightly unsure of the correct exposure setting, you might be better served by bracketing in half f-stops.

There are a number of controls on your camera that you can utilize to bracket a particular shot. However, not all cameras will have all these controls.

The shutter speed dial can be used for bracketing. Simply adjust the dial one or two stops up or down from the meter's recommendation.

Watch out for camera shake or subject movement if your shutter speed goes below 1/60 of a second.

Adjustments to aperture settings can also be used for bracketing.

Aperture selection ring controls

Simply open up the aperture (let more light in, lower f-stop numbers) or close it down (let less light in, higher f-stop numbers) one or two stops. Watch depth of field changes as you make these adjustments.

Many modern digital compact cameras have a backlight or snow mode setting. Usually when invoked it will compensate for the brighter reflections that snow and water give, which will usually fool your camera's meter.

This is helpful for bright subjects but unfortunately it is useless for subjects with a dark background.

Exposure Latitude

Exposure latitude refers to an imaging sensor's ability to produce an acceptable image, despite either being underexposed or overexposed.

In other words, let's say your camera's meter determined that the correct exposure for a particular image is a shutter speed of 1/125 of a second at an aperture setting of f8.

With color negative film the exposure latitude is considered to be five stops, with color slide film it is even less at three stops.

So what is the exposure latitude of a CCD or CMOS imaging sensor?

Good question, but I'm afraid there is no one answer.

Imaging sensors definitely have greater exposure latitude than color negative film, probably by at least one extra stop, perhaps a bit more.

However, it seems to depend on the individual sensor, so at this point in time, the only hard and fast rule I can give you in regard to exposure latitude of imaging sensors is that they should have about six stops of exposure latitude, which gives you two and a half stops leeway from the correct exposure setting.

If you study the aperture scale you can see that the correct exposure setting for the aperture is f8, but that the green band covers an area starting at f2.5 and finishing at f16.5.

So the latitude of the imaging sensor in this case covers an aperture range between f2.5 and f16.5. six full aperture stops.

A similar six-stop range applies to the shutter speed range.

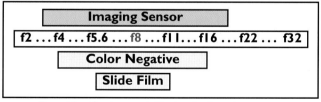

Example of exposure latitudes for imaging sensor, color negative film, and slide film

In the illustration of this meter reading shown in the scales above you can see that the aperturesettings indicated by the camera's meter, f8 is indicated in red.

The above graph show that your exposure calculations can be out by up to two and a half stops aperture (or shutter speed, or combination of both) and still get a usable result. Please remember that the combination of aperture and shutter speed cannot be out more than two and a half stops.

This does *not* mean that you would get an acceptable result if you shot this scene at a f2.5 aperture setting for 1/15 of a second.

As the correct setting was f8 at 1/125 of a second, shooting it at f2.5 and 1/15 of a second means that your exposure is 6 stops out.

When I say that an imaging sensor has a exposure latitude of 6 stops I do not mean that you can be 6 stops out and get an acceptable result.

Rather, it means that if you either underexpose or overexpose the shot, you can be up to two and a half stops either side of the correct setting and still get an acceptable result.

Two and a half stops either side of the correct setting equals a six-stop range. For instance, if you refer to the aperture scale, you can see that in the example shown, two and a half stops underexposed plus two and a half stops overexposed plus the correct aperture setting equals six stops.

Therefore if you shot this image at f5.6 (aperture one stop overexposed) and a shutter speed of 1/60 of a second (shutter one stop overexposed), you should still get an acceptable result because the combined exposure is only two stops out.

So the maximum you can be out in exposure calculations with imaging sensors is two and a half stops underexposed or two and a half stops overexposed.

A final word on exposure latitude. When I say that if you either overexpose or underexpose your image within its exposure latitude range you should get an acceptable result, that's correct. However, depending on whether you underexpose or overexpose, you will lose detail in either the highlight areas of your image, or alternatively in the shadow areas.

Much better to correctly expose your image in the first place.

Finally

Sometimes you can be photographing a scene and cannot find anything handy that comes close to the reflectance value of 18% gray.

As mentioned in Chapter 5, "Useful Accessories," those nice Kodak people produce a gray card, which is available from most camera stores.

Consider investing in one and keep it in your camera bag. They are very handy.

Canowrinda Dawn, NSW Australia

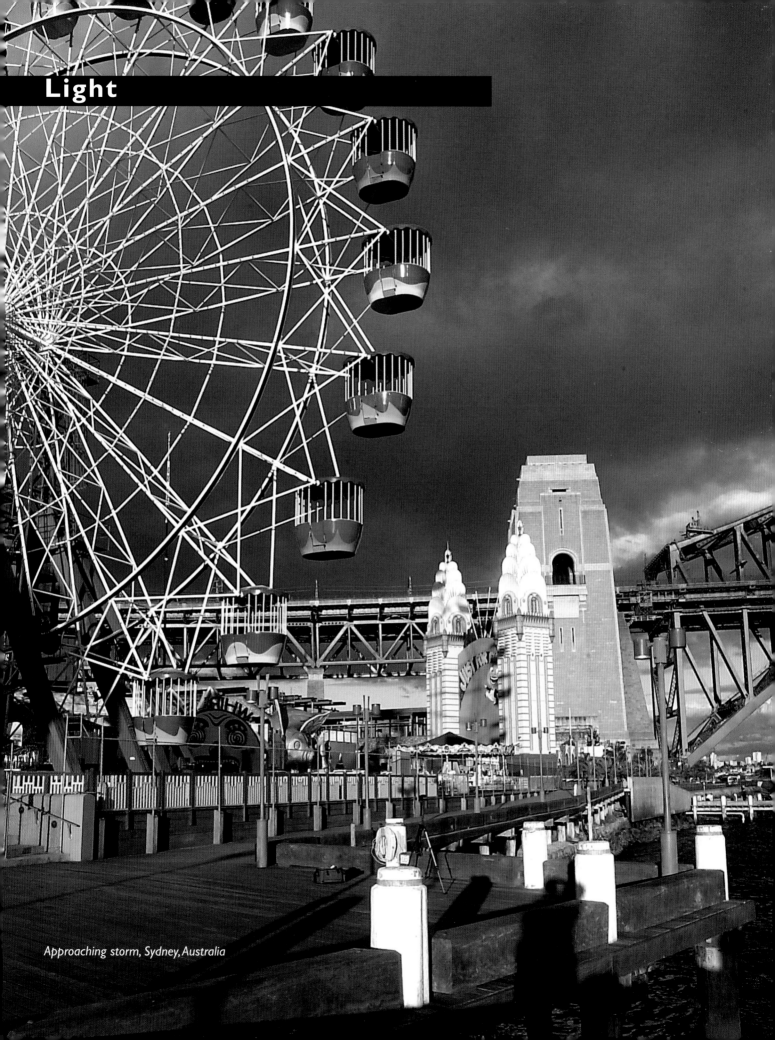

Light

Approaching storm, Sydney, Australia

Light is the essence of photography. Without it you have no photograph. Misuse it and you will have an unsatisfactory result. Use it wisely and the possibilities are endless.

Light is the most important tool in the photographer's kit bag. Like any tool it needs to be used correctly to produce the desired result.

The most constant source of light for the photographer is the sun.

However, sunlight varies significantly depending on a number of factors, either singularly or in combination.

These factors need to be taken into account by the thoughtful photographer.

In this chapter we will examine these factors in some detail.

The Direction of Light

When evaluating a scene that you propose to photograph, you need to consider the position of the sun and how the light, coming from that direction, will affect your photograph.

To demonstrate how the time of day can affect an image, the photographs on the opposite page were all taken on the same day, from the same position, but at different times.

The bridge, which is the subject of the photographs, runs in a north south direction. The camera was positioned on the western side of the bridge.

As you can see from the photographs, the position of the sun can dramatically effect an image.

It should be noted here that we started this series of shots by shooting into the sun. This was because our position dictated that the camera pointed east.

Try picking a favorite scene and photographing it at different times of the day as we have done below. You will be amazed at the differences as the day marches on and it will teach you quite a lot about light and how to use it.

Weather Conditions and Light
Overcast Days

Overcast days can be a boon to the photographer because they make things so much easier.

All that cloud up there in the sky diffuses the light and gives a nice soft effect to your photographs. Shadows are reduced or eliminated nearly completely.

This type of lighting is especially considerate of people being photographed because the light softens the image and can accentuate colors.

As you can see in the photograph of the Paris street corner, shadows, which would have been produced had the day been cloudless, are eliminated and the diffused light nicely models the entire scene.

Another nice bonus from overcast days is the fact that your camera's light meter is going to have an easier time in calculating correct exposure settings. You see the light is so diffused that no special conditions, as far as exposure settings are concerned, should be necessary. Light will be evenly spread out over the entire scene so you won't have to concern yourself with highlights or shadows so much.

In addition, the contrast range of a scene is compressed on cloudy days, which can also be a great advantage.

Street corner, Ile de lla Cité, Paris

6 A.M.

The sun is just starting to rise above the eastern horizon. The city and the bridge are silhouettes and the water takes on an amber shade from the early morning light. Note the long shadows on the water which result from shooting directly into the light.

10 A.M.

The sun has moved higher, and the water and the sky have taken on the traditional blue hue that you would expect. Note that the city and the bridge are now reasonably defined but the aspects facing the camera are still in shadow. Also notice that the trees are still reasonably ill-defined at this time.

Noon

At first glance this shot seems similar to the one taken at 10 A.M.; however, a closer inspection will reveal a number of subtle changes. The sun has risen overhead and the water has paled somewhat. The city and the bridge have lost most of their shadows, with the result that they are better defined. The definition of the trees is also much improved.

3 P.M.

It was the start of winter when this series was photographed and the sun was behind my left shoulder. Now the city, bridge and trees are all well defined by the light. Instead of shadows on the water we have reflections. The sky is considerably less blue and the water has taken on a blue/silver hue

6 P.M.

The sun was just dipping below the western horizon when this last shot was taken. The sky, and as a consequence the water, have taken on an almost purple tone. The trees have become ill defined once more but there is still quite a bit of detail as far as the city and bridge are concerned. This is partly due to the natural light available and also the lights of the city buildings and roads.

ABOVE LEFT: Anzac Bridge, Sydney, Australia - various times

Bright, Cloudless Days

When the sun is burning in the sky and there is not a cloud to be seen, light is very different than on overcast days, as discussed previously.

For a start, colors will be harsher, shadows will be much more pronounced, and, depending on the position of the sun, they may detract from your image.

Photographing people in such conditions, especially when the sun is high in the sky, can produce very distracting shadows around the eyes, as shown in the photograph below.

Contrast range will be extended, which may be beyond the exposure latitude of your imaging sensor. In this case you will have to make a decision (with exposure settings) as to whether you lose highlights or shadow detail.

Depending on the subject, this strong, directional and harsh light can be either a blessing or a curse.

As you can see in the photograph below, it can produce very unflattering shadows on people's faces, especially when the sun is high in the sky.

On the other hand, this type of lighting can be used for good effect as shown in the photograph of the Painted Desert (bottom of page), where it emphasizes the stark nature of the land.

If you read between the lines of the preceding two sections of this chapter, you will glean that the quality of light in your photograph can contribute a great deal in helping to set the mood of your image. Try it out.

One final note about working with light on bright, cloudless days. If you are looking to soften your images of people, try finding a large shaded area, for example, under a grove of trees. This should help soften the light and reduce the harsh shadows.

The Four Seasons
Summer

Light in summer is normally bright and harsh. As mentioned previously, it can be very uncomplimentary to photographic subjects due to the strong shadows produced.

Color can be quite strong in this light but can also be obscured by the glare produced in these conditions.

Early morning or evening can provide better conditions for photography or, alternatively, a shady setting can improve a shot presuming you do not want the intense effect produced by strong sunlight.

In the first photograph sun is directly behind, resulting in a large, distracting shadow in the middle of the image. In the second image the photographer moved to eliminate the shadow, resulting in a much better image.

Notice also that the foreground is in focus. The photographer used a small f-stop number to give a large depth of field. The small rocks that occupy the foreground of the shot tell the story of the harsh nature of the land.

Judy

Painted Desert, South Australia (Owen Wilson)

Autumn and Spring

Nature comes to the photographer's assistance in these two seasons with a vengeance.

In spring the sun is climbing higher in the sky without the harshness of summer's intense light.

In autumn the days are shorter but the light can be clear and crisp. In both cases nature is at its loveliest, providing the photographer with superb material to create beautiful images.

The colors of New England in the photograph below show very clearly that autumn is here and winter is just around the corner. The mist, hanging over the small village in the valley, reinforces the fact that cold times are ahead. Notice also how the mist softens the image, which helps accentuate the vivid colors of the foliage.

Another example of the softening and mood-setting effect of these seasons is the photograph of the bridge in Bath, England. Notice how the colors in the foreground are enhanced, while the mist on the hill sets the scene, as far as the season is concerned. You might also notice that there is still reasonable detail on the terrace houses that are blanketed by the mist.

Winter

Winter light can be as stark and severe as the season itself. However, you should look at it closely because it can reveal extremely delicate hues of color. Often you will find very overcast skies that do diffuse the light very effectively.

Snow can fool the camera's exposure, so care should be taken in this regard. At the same time snow can be used as a very effective backdrop for the subject of your image.

In the photograph below of the fallen tree and creek, shot in the middle of winter, you might at first think that the image is almost totally devoid of color.

However, a closer inspection reveals subtle shades in the tree bark, the creek bed, and the snow itself.

New England (TOP) and Bath, England (BOTTOM)

Snow gums, Australia (Izzy Perko)

Taking Photographs at Night

Taking photographs at night brings its own special set of problems and rewards. Exposures are going to be long (unless you are using a very high ISO setting) so a tripod is mandatory to avoid camera shake.

The shot of the hot air balloon flying overhead (opposite page) was taken before dawn from the backyard of a guesthouse.

At the time I did not have my tripod with me. The exposure was about two seconds and I had to brace myself against a verandah column to avoid camera shake (see Chapter 6, "Troubleshooting and Maintenance"). I was lucky that the balloon was firing off its burners at the time as this highlighted it nicely.

The photograph of the city skyline was shot just after the sun had dipped below the horizon. The camera's meter indicated that at f8 the correct shutter speed was 2 seconds. The photographer shot the scene at this shutter speed and then took additional shots at 4 seconds, 8 seconds, 15 seconds, and 30 seconds. Naturally a tripod was used to steady the camera.

All the shots yielded acceptable images but the one shot for 8 seconds (below) was judged the best.

Shooting at night during an electrical storm can produce spectacular results as shown below.

To achieve this result the photographer mounted the camera on a tripod and stopped the aperture down to f22.

He then used a cable release with the shutter set at B. The B setting keeps the shutter open as long as the shutter release is depressed. The cable release was used to stop camera shake caused by the pressure of the finger on the shutter.

The shutter was tripped for thirty seconds and two lightning flashes were captured as a result.

Please remember that lightning loves metal objects that are attached to the ground, so take good care to protect yourself if you are attempting a shot like this.

Sydney night view (Izzy Perko)

Lightning over Sydney (Izzy Perko)

ABOVE: Painted
Desert, South
Australia (Owen
Wilson)

BELOW: Balloon
at night,
Canowindra,
NSW, Australia

Impalas, Kenya (Tina Jaworski)

Photographing in Low Light

Photographing in low light can present similar problems to photographing at night.

Unless you are using a high ISO setting you may need to either use a tripod or somehow brace the camera to avoid camera shake. Having said that, there are some wonderful moody images that can be created shooting in low light.

The lack of light and the mist just reinforce the eerie feeling Stonehenge can present to its visitors. The same shot in bright sunlight would not have the same presence as the one below.

Light as an Illuminator of Detail

The way in which light strikes the subject makes a huge difference to the quality of the resultant photograph. In the beautiful shot of a herd of African Impalas (above), the photographer caught the intricate details of the animals in their natural environment. It was late afternoon and the sun was very low on the horizon.

Due to the low angle of the sun and the surrounding foliage, the light was greatly diffused. Note the lack of significant shadows in the shot. The diffused light washed over the herd and highlighted the animals in a dramatic way.

In the simple shot below of a harborside rockpool, the sun was low in the afternoon sky. Consequently the light skipped across the surface of the rockpool. Notice how the shape of the various rocks is clearly outlined by light and shadow. Where the surrounding rocks are not too high, the water takes on a silver hue and the bottom of the rockpool is clearly visible.

Stonehenge, England

Rock pool, Parsley Bay, NSW, Australia

Balloon firing up, Canowindra, NSW, Australia

Light as a Mood Setter

Here is another shot from the Painted Desert (right). However, this one was taken just after sunrise before the sun got too high in the sky.

Note how the intense foreground shadows give the image an eerie feel. The tops of the small mounds in the foreground that have caught the light accentuate this mood.

The second photograph was taken in the very early morning at a hot air balloon festival. In this case the shot was directly into the sun, but partly protected by a recently inflated balloon.

The sunlight, streaming between the balloons, picks up the dust of the fairground that was being used as the launch site. The long shadows of the people give you the message that it was very early morning, as does the position of the sun. Note that there is still quite a bit of detail in the shot, despite shooting into the sun.

Mixed Light Sources

Different light sources affect a camera's imaging sensor in different ways. Mixed lighting sources are normally best handled by having the camera's white balance control set to auto or daylight.

For instance, in the shot (previous page) of the balloon being fired up, the main light sources were the balloon's burner and sunlight.

As you can see the resulting shot looks quite natural, with no distinct color casts evident.

In the two images to the right, we have two distinctly different lighting situations.

The first (the freighter at dock) is illuminated by both tungsten and fluorescent lighting.

As you can see, the tungsten lights give off an amber cast and the fluorescent lights emanate a distinct green cast.

This shot was taken with daylight-rated film and then scanned into the computer. The results from a digital camera with the white balance set to auto or daylight would have been the same. Given the industrial surrounds, the resulting image looks quite natural.

The second shot was of a dockside crane illuminated only by tungsten lights. Also shot on daylight-rated film and scanned, there is an amber cast in the shot but, as the crane itself is yellow, it looks quite natural. Again the same result would have been achieved with a digital camera's white balance set to auto or daylight.

The Painted Desert, South Australia (Owen Wilson)
Dawn, Canowindra, NSW, Australia
Freighter at dock, Port Kembla, NSW, Australia
Dockside crane, Port Kembla, NSW, Australia

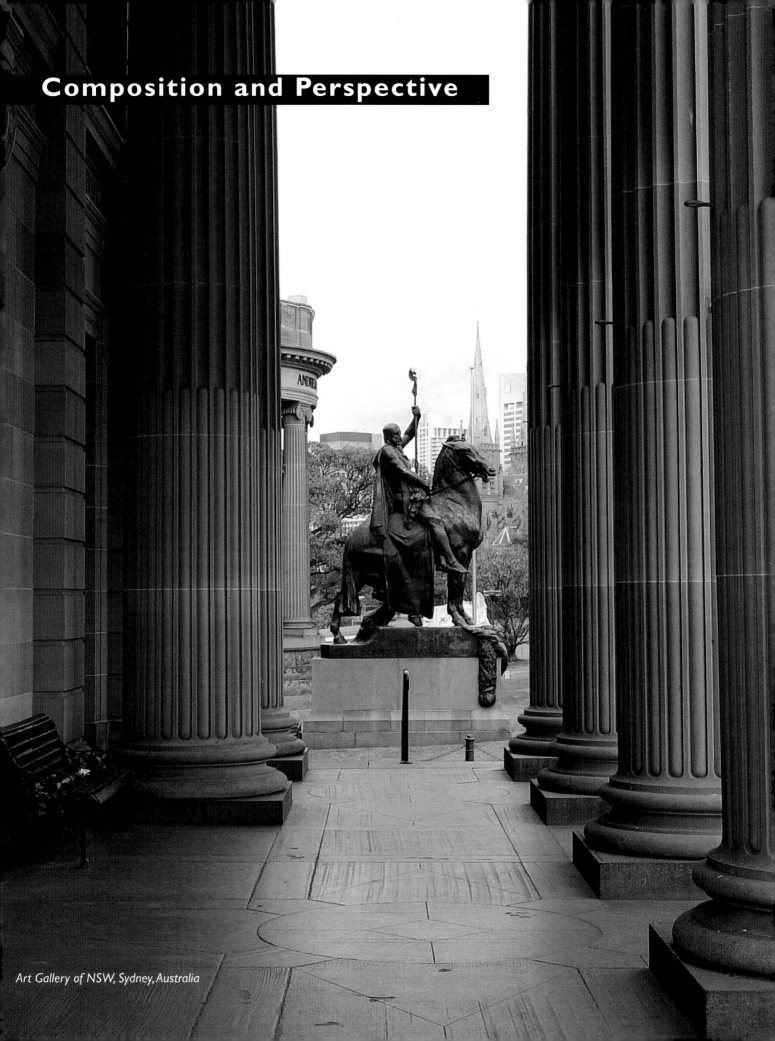

Composition and Perspective

Art Gallery of NSW, Sydney, Australia

A really great photograph is produced with a combination of skills.

First, there is subject selection—an artistic skill that, as discussed earlier in this book, can be developed. This first step is very important, as you need to visualize the final image in your mind.

Second, there is the technical and mechanical side, which covers the selection and correct use of equipment to produce the desired result. Selecting camera settings is another technical facet of the process. Here you need the skills in ISO selection and exposure calculations to produce the result you imagined.

Composition deals with how you will place the various elements of your photograph in the final image and is certainly an artistic skill. Perspective deals with how you view the composition.

In reality these skills form part of the first step, for not only do you need to select a subject, but you also need to be able to visualize how your final photograph will look. Composition and perspective form a great part of this equation.

Framing Your Image

The impact of some images can be greatly enhanced if you compose them in such a way that the main subject is "framed." There are many ways to frame an image using the natural surrounds in the vicinity of your main subject. In this example. the ancient portal of the Colosseum neatly frames the Arch of Constantine. Not only does the main subject of the photograph get neatly isolated or framed, the shape of the portal also compliments the antiquity of the Arch.

RIGHT: Arch of Constantine, Rome :
OPPOSITE PAGE: with shed and pole removed
FAR RIGHT: Loch Aird Gorge, Victoria, Australia

Another advantage in this case is that the frame neatly covers the traffic and restoration equipment that surrounded the Arch at the time of shooting. Unfortunately, the Roman authorities did not think it a good idea for me to cut down the street light and demolish the builder's shed that remain in the shot. Most unreasonable of them!

However, there is more than one way to skin a cat. Using a computer and an image manipulation program, in this case Adobe Photoshop®, I was able to remove the offending shed and light pole without offending anyone (see photo, page 145).

While we are in Rome, let us look at another example of framing. In this case it is the Colosseum, which is right beside the Arch of Constantine. At least I didn't have to walk far for this example.

The Colosseum's natural oval shape makes a perfect frame for this shot of its interior.

Colosseum Rome

Another example of a subject providing its own frame is this shot of a small inlet on the south coast of Victoria, Australia. Here the natural shape of the inlet frames itself neatly. The eye is led first to the inlet itself, and then to the Great Southern Ocean beyond.

Central Park, New York

Some Other Examples of Framing

The trees in the park frame this image of New York's Central Park. The footpath leads the eyes directly to the center of interest in the image and then to the overpass and city buildings beyond.

This shot not only utilizes framing techniques, but also uses the foreground to take the viewer's eye to the main point of interest.

In the image of a lighthouse, two blocks of a man-made sea wall frame the stark white structure.

A Final Word on Framing

Framing will not always suit every image that comes into view through your viewfinder, but it will certainly suit some, and can add a powerful impact to your image. Like all things in life, use it wisely.

Wollongong Lighthouse, NSW, Australia

Composition

Composition addresses how you place the various elements of your image in the final photograph.

The selection of the various elements that will comprise your photograph is an important factor in composing your image.

Color, when used creatively, also enhances the composition of a photograph. Unfortunately, color, if not used wisely, can destroy the impact of an image just as easily.

Most people tend to place the center of interest smack bang in the middle of the photograph, as shown below.

Unfortunately this can be rather boring (but not always!). If you look at the diagram below you will see that it is divided, both vertically and horizontally, into thirds.

You will also notice that where the lines intersect, large dots have been placed.

The previous photograph places the subject at a position that is in the center of the four dots, as represented in the diagram.

Shooting the same scene four more times, each time placing the subject at approximately the same position in the frame, as represented by each of the dots in the diagram, gives the results below.

Ultimately, what works best in any given situation is subject to personal taste. Experiment and you will be surprised at what you can achieve.

Different placement of the bandstand within the picture frame

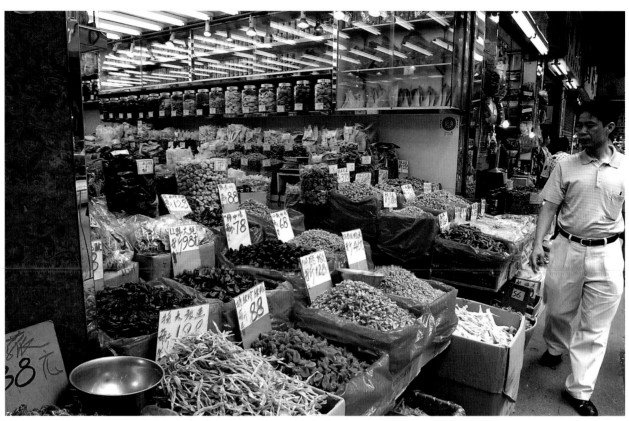

Cropping

Cropping is the removal of parts of an image, with the aim of improving the overall effect.

In the photograph above there is a considerable amount of fluorescent lighting at the top of the image plus a large chunk of wall at the left that the image can do without. The photograph to the right shows this cropped out to produce a tighter, and hopefully better, image.

Look at your own images and see if cropping might improve the result. Use a few pieces of white paper and place them over your photo to form new borders. Adjust them to see how different combinations look, and see if the result is more pleasing to the eye.

If you have a computer and photo scanner you can do this electronically. Photo processors are only too happy to produce a new print for you from a computer file, or you can do it yourself if you have the necessary equipment.

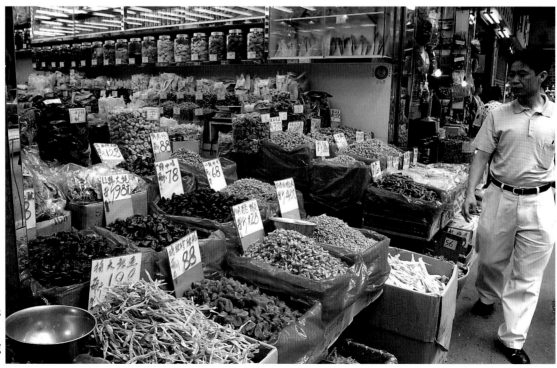

Landscape or Portrait

As you will have noticed, the viewfinder of your camera is not square but rectangular.

Therefore, when you take a shot, you have two choices about the format of the image.

These choices are normally called either landscape or portrait modes. Some people, however, prefer to call them horizontal (landscape) mode or vertical (portrait) modes.

Put simply, landscape mode is when the longest side of your rectangular viewfinder is parallel to the horizon. Portrait mode is the opposite, when the shortest side of your viewfinder is parallel to the horizon.

As the two images to the right clearly show, some photographs lend themselves to portrait mode.

Given the height of the buildings on the right of the photo, landscape mode just did not suit this composition.

To best determine if you should take a shot in landscape or portrait mode, simply view the scene through your camera's viewfinder in both modes and select the most appropriate view.

On the next page there are more images where the subject matter easily determines the best mode to be used.

Boston Harbor—portrait and landscape

TOP LEFT: *Country stream, Sofala, NSW, Australia*
TOP RIGHT: *USS Constitution, Boston Harbor*
BOTTOM LEFT: *Sleeping sentry, Musée Jacquemart-André, Paris*
BOTTOM RIGHT: *Monet's Garden, Givney, France*

War graves, northern France (Izzy Perko)

The lighthouse (Izzy Perko)

Selective Use of Color

Color can be very important in the composition of an image, and since over 90% of photographs are taken in color, it is important to look at color in some detail. Color can make or break an image. It can set the mood; it can turn the viewer on or, alas, turn the viewer off.

Some photographs have a very high degree of color saturation while others are nearly monochromic in their lack of color. The image of the Allied War Graves Cemetery tells a very definite story. With the sun being so low on the horizon, casting a distinctive orange hue over the entire image, the mood is appropriately somber and reflects the stupidity and senseless waste of war.

This is a good example not only of how color can set the mood, but also how sometimes a very simple image can say much more than one that is full of detail.

The image of the lighthouse is even simpler. The unusual angle, combined with the red roof at the base and the dramatic sky (achieved by using a polarizing filter), all combine to form a dramatic and interesting image.

Another way to use color in photography is shown quite clearly in the two photographs overleaf. The brightness of the Dublin Street busker's clothes and instrument is nicely captured in this tight shot. The gray stone column behind the subject serves as an effective neutral backdrop.

Steve Hlavenka's shot of Crowea Exalata is an interesting use of color, framing, and composition. The brightness of the flowers jumps out at you immediately. The blacked-out background effectively frames the subject, and the placement of the flower along the diagonal of the image completes the photo.

LEFT: *Cowea Ezalata (Steve Hlavenka)*

BELOW: *Dublin street busker (Izzy Perko)*

Leading Lines

Leading lines are features within your image that will draw the viewer's eyes to the main point of interest within your photograph.

In the example above the red carpet draws the eyes to the pyramid structure that is the Louvre's main entrance.

In the shot below, the zigzag pattern of the grass leads the eyes to the various statues and then on to the left wing of the Louvre.

ABOVE: The Louvre, Paris BELOW: Tuileries Gardens, Paris

ABOVE: A country gentleman (Izzy Perko)
BELOW: The Trocadero from the Eiffel Tower, Paris

Looking Up—Looking Down

Most people tend to take their photographs from eye level. However, some very interesting images can be taken from very different perspectives.

Take, for instance, the image above of the country gentleman. Izzy Perko took the shot from below and this perspective gives an unusual twist to what otherwise could have been just another photograph. By shooting upward, the sky and clouds fill the frame and leave you with only the face to focus on. In addition, the placement of the subject within the frame draws the viewer's eyes to the center of interest.

Height can also make images more interesting. The image to the right takes this to extremes since it was shot from the observation deck of the Eiffel Tower.

The height gives the photographer a grand view, and the opportunity to compose an interesting image.

The bridge in the foreground leads the viewer into the image (leading lines) and the brighter light toward the rear adds to the overall effect.

The swan

Foreground and Background

Both the foreground and background can be used to help improve the look of your photographs.

In the shot of the swan (above), the exposure was made so that the shadows behind the bird would black out, thus helping to frame the shot.

The shot was taken after the bird had ducked its head underwater and thus created the foreground ripples that help lead the viewer's eyes to the center of interest.

In the two photographs to the right, the image is improved, in my opinion, by tightening up and bringing the rocky outcrops into the foreground.

Overleaf, the background adds to the image of the old, beautiful railway station clock. The railway station has now been converted into one of Paris's best museums and the clock dominates the entrance and exit doors.

The lighted walkways behind the clock, with their shadowy figures and extensive ironwork, add substantially to the interest of this image.

Again overleaf, in the image of Arundel Castle, the grass that now covers the old moat, and the shape of the terrain, lead the eyes to the drawbridge and the castle walls. Again the foreground has been used to help improve the image.

I suppose the point I am trying to get across to you is that both the foreground and background can add interest to your main subject.

You should not only concentrate on your main subject, but also look at the foreground and background to see if they may assist in improving your image.

Two of the Twelve Apostles, Great Southern Ocean, Australia

This means that you should move around and look at your subject from many different vantage points. In addition, you could try lenses of different focal lengths to see what effect they will have on your image.

After a while you will find that you will get a feeling for this and, to some extent, it will be nearly automatic. When this occurs, however, don't get complacent. If you keep trying new approaches you will be surprised at the results that you can achieve.

ABOVE: Old railway clock, Paris

BELOW: Arundle Castle, United Kingdom

An Example

You will have noticed a few pictures of the Louvre in this book. Well, aside from being a beautiful building set in ideal surroundings, it is also huge. To take a photograph that shows all of the facets of this structure in one image would be difficult.

The following photographs were taken to show that by moving around and trying different approaches, you can get some very interesting images that hopefully you will treasure for years to come.

I could go on for quite some time with this but I think you must be getting my message by now.

The more you look at a scene, the more you can see. You should try an exercise like this yourself.

Find a spot that appeals to you and photograph the dickens out of it. Try every different angle and viewpoint. Take the same shots at different times of day (dawn and dusk are interesting).

The images you will capture should surprise you. And, more importantly, you will be teaching yourself how to view a scene, and how to extract great images from it.

Photograph 3 (ABOVE)

A similar shot to photo 2, but taken with a shorter focal length lens, resulting in less park, less garden, and less structural detail.

Photograph 1 (BELOW)

It is nearly impossible to capture the entire structure of the Louvre in one photo and show any detail. So I decided that the first shot would concentrate on one section of the building, concentrating on the magnificent construction. The resultant image is, however, rather boring. Back to the drawing board!

Photograph 2 (RIGHT)

A longer focal length lens results in plenty of detail in this shot of the east wing. It is nicely framed by a tree and even includes some of the gardens. A lot better.

Photograph 4 (RIGHT)
This image is framed within the arch. At least it is interesting and it clearly shows the entrance pyramid and the surrounding fountains. Not enough detail on the building, though.

Photograph 5 (BELOW)
Now for something different. The Louvre is fronted by the Tuileries gardens, which are very beautiful and full of interesting statues. Time to bring the surrounds more into the picture.

Photograph 6 (RIGHT)
Another variation on the same theme. Pretty gardens in the foreground, interesting statues midway, and the glorious building in the background.

Glossary

Aliasing
See Jaggies

Aperture
An opening or hole within a lens that restricts the quantity of light that is allowed to pass through the lens and strike the film or imaging sensor. The size of the opening or hole can in some cases be varied by a device known as an iris diaphragm, which is controlled by a rotating ring on the outside of the lens. The quantity of light allowed to pass is measured by a system known as f-stops (see f-stops). The aperture is one of the three exposure controls that will determine the correct exposure setting of your photograph. It will also help determine what is in focus in your photograph and what is out of focus (see Depth of Field).

Aperture Priority
See Mode.

Available Light or Ambient Light
A general term meaning the amount of light that is naturally within a scene without any supplemental illumination such as flashguns or photographic lights.

Artifact
A digital defect such as noise or an unwanted pattern that can be caused either by an image capture or processing problem.

Backlighting
Either natural or artificial light that is coming toward the camera from the subject.

Bit
The basic unit of digital information Eight bits equals one byte. Bit stands for binary digit.

Bracketing
A technique that consists of shooting the same scene at different exposure levels in an effort to get the most accurate exposure result.

B Setting
A shutter setting that, when used, will allow the shutter to remain open for as long as the shutter release button is depressed. It is normally used in time-exposure photography.

Burst Mode
A setting on digital cameras that allows the capture of a number of images in quick succession without the time delay of downloading onto the camera's storage media.

Byte
See bit.

CCD
Stands for Charged Coupled Device, one of two types of image-sensor computer chips.

Cloning
A process in Image Manipulation Applications that allows a part of the image to be copied onto another image or another part of the same image.

Closing Down
A photographic term used to describe the adjustment of an aperture to allow less light to pass through (higher f-stop). The opposite of opening up.

CMOS
Stands for Complementary Metal-Oxide Semiconductor and is the second type of image-sensor computer chip.

CMYK
Printing color model used to mix inks to produce colors. Stands for Cyan, Magenta, Yellow, and Black.

Color Cast
A overall bias toward one particular color in a color photograph or slide.

Color Correction
Refers to the adjustment of an end color result by the altering of the primary colors (Red/Green/Blue or Cyan/Magenta/Yellow/Black).

Color Temperature
A scale (expressed in degrees Kelvin) that measures the color content of various light sources. Different light sources have a differing color content, which can produce a color cast over a photograph. For instance, imaging sensors or film rated for daylight (5600 degrees Kelvin) but used indoors (3400 degrees Kelvin) without flash will produce a red/orange cast unless a color correction filter is used or White Balance (WB) can be adjusted (digital).

CompactFlash
A removable memory card for digital cameras to store image files. A smaller version of the PC Card.

Computer Noise
Sometimes simply called noise. Refers to defects in a digital image that can resemble grain in normal film photography. It can be caused by too little light during exposure or, alternatively, a defect in the electrical signal during the image-capture process.

Dedicated Flash
A flash designed for a specific camera or range of cameras that links, via contacts normally found in the camera's hot-shoe, directly into the camera's circuitry for transfer of information between camera and flash.

Depth of Field
Refers to the distance both in front of and behind a subject, that has an acceptable degree of sharpness (appears to be in focus) at any one setting of focus and aperture. As a general rule, the depth of field will extend one third in front of the point of focus and two thirds behind. Depth of field is improved when a lens uses a smaller aperture setting (higher f stop—see f stops). A shorter focal length (see focal length) lens has a better depth of field than does a longer focal length lens. For instance, a wide-angle lens (say 24mm) has better depth of field than a telephoto lens (say 200mm).

Diaphragm
See Aperture

Diffuser
An attachment or substance (for instance, petroleum jelly) that causes light passing through it to divert from its original path and scatter. Used in photography to soften shadows caused by direct light such as a flashgun and also to produce a soft-focus effect in photographs.

Directional Lighting
Lighting that will produce a scene, as seen by the camera, that is well lit on one side and shadowed on the other.

Direct Vision Viewfinder
Common in all compact cameras, the direct vision viewfinder allows the user to view the subject directly without the aid of a mirror and pentaprism, as utilized on 35mm SLR cameras.

Downloading
The reception of data (files) from another computer device.

DPI
Abbreviation for dots per inch. Refers to how many dots of ink a printer can produce per linear inch.

DX
Code system for automatically setting the film speed and length in a camera by means of electrical contacts in the camera's film chamber, which read a pattern stamped on the film cassette.

Dye Sublimation (dye-sub)
A digital printer capable of producing excellent prints.

8-bit, 16-bit, and 24-bit images
An 8-bit image contains 256 colors or fewer, while a 16-bit image contains 32,000 colors, and a 24-bit image contains 64,000,000 colors.

Electronic Flashgun
A device designed to provide illumination (rated at daylight color temperature) that can be either built into the camera or a stand-alone accessory.

Enlargement
Any print that is bigger than the original file, negative, or slide that was used to produce it.

Expiration Date
A date, usually printed on the film package, by which time the film's maker recommends you have the film processed in order to get the optimum results. (Does not apply to digital photography).

Existing Light
See Available Light/Ambient Light

Exposure
The end result of the combination of the quantity (intensity) of light (controlled by the aperture) and the amount of time this light is allowed to strike the film or imaging sensor(controlled by the shutter).

Exposure Latitude
Refers to the amount you can either underexpose (not enough light intensity or time, or a combination of both) or overexpose (too much light intensity or time, or a combination of both).

Exposure Meter
A device designed to measure the amount of light either falling on or being reflected by an object. Most modern cameras have exposure meters built in but there are also hand-held models for specific applications.

Fast Film or High ISO Number
Imaging sensor or film that has a high ISO number and thus is very sensitive to light.

File Format
The way an image is stored in a computer file,such as TIFF, JPEG, or EPS.

Fill Light
Additional lighting introduced into a scene, designed to lighten shadows.

Film
A thin transparent plastic material coated with a light-sensitive emulsion, which after exposure and processing carries a visible image. This image can be a negative (as is the case with film designed to produce prints) or a positive (as in the case of slides or transparencies).

Film Speed or ISO Number
The degree to which an imaging sensor or film is sensitive to light. The higher the ISO number, the more sensitive to light it is and it therefore needs less light to produce acceptable results. However, higher ISO numbers can produce photographs with a grainy result if they are enlarged.

Filter
Normally a glass attachment (although other materials are used) that attaches to either the front of the lens or in some cases the light source (such as a flashgun) and modifies the light that passes through it.

Filter Factor
The amount by which exposure calculations must be increased to allow for the reduction of light caused by the filter. (Not applicable to 35mm SLR cameras where the cameras meter is used to calculate exposure settings.)

Flare
Glare that has been transmitted from shiny backgrounds, which can result in reduced contrast, and shadow areas that lack detail. May also result in a bright hot spot in your image.

Flash Synchronization
A method (usually electrical) of firing a flashgun at the precise moment that the camera's shutter is fully open.

Flat Lighting
A term that describes low-contrast lighting that fails to model the subject. In photographic terms this expression is also used to describe front lighting where a single light source is mounted on the camera quite close to the lens.

Noon day gun, Hong Kong

f-stops

Numbers engraved on the rotating ring located on a lens barrel that controls the size of the aperture. They are calculated by dividing the focal length (see Focal Length) of a lens by the effective aperture. For example, a 100mm lens with an effective aperture of 25mm results in f4 (100mm/25). The same f-number on different lenses will allow exactly the same amount of light to pass through to the imaging sensor.

Higher f-numbers allow less light to pass through to the sensor. For example, on a 50mm lens an f16 setting means that the aperture has an effective opening of 3.13mm (50mm/16), whereas an f4 setting on the same lens means that the effective aperture is 12.50mm. Obviously an aperture of 12.50mm will allow more light to pass through to the sensor than a 3.13mm aperture. Each f-number indicates either a doubling (lower f-number) or halving (higher f-number) of the amount of light allowed to pass through to the sensor. Remember that the higher f-number used, the greater the depth of field (see Depth of Field).

Focal Length

The distance between the face of the rear lens element and the film plane when the lens is set to infinity.

Focal Plane

The point within the camera where the light being reflected through the lens is in focus when the lens is set to infinity. It is at this point that the imaging sensor is positioned.

Focal Plane Shutter

Used in most 35mm cameras, this is a curtain or blade that is positioned directly in front of the film and controls the amount of time that the light, passing through the lens, is allowed to strike the imaging sensor (not used in digital cameras).

Focus

Achieved when light that is passing through a lens converges to form a sharply defined image on the imaging sensor.

Focusing Scale

Markings etched on the focusing ring of the lens. They indicate the distance between the camera and the subject.

Gamut

The range of colors that a device such as a monitor or printer can reproduce. Colors that cannot be reproduced by these devices are said to be out of gamut.

GIF

Stands for Graphics Interchange Format, which is one of the two image file formats used on the World Wide Web (WWW). The other format is JPEG.

Gigabyte

1024 Megabytes or 1 billion bytes. Abbreviated GB.

Grayscale

Where an image consists of tones that run solely from white to black.

Guide Number (GN)

A number used to indicate the strength of light that is output by a flashgun. Unless otherwise stated, it is calculated using ISO 100.

Highlights

The brightest area in any particular subject.

Hot-shoe

A fitting on top of the camera, normally directly over the lens (unfortunately!) that allows a flashgun to be mounted. Most modern cameras with hot-shoes (usually 35mm SLRs) have electrical contacts that allow data to be passed between camera and flashgun.

Incident Light

Refers to light that is falling onto a subject. Light that is reflected by a subject is called reflected light. Understanding the difference can be important in determining exposure setting, especially in difficult lighting situations.

ISO

International Standards Organization. Current standard for determining an imaging sensor's or a film's sensitivity to light. It has replaced the older ASA and DIN systems. A doubling of the ISO number indicates a doubling of the sensor's or film's sensitivity to light. For instance, a sensor or film with an ISO number of 200 needs half as much light as one with a 100 number to correctly expose the same scene.

Jaggies

Refers to an image that has edges that appear jagged due to being printed at too low a resolution. Also known as Aliasing.

JPEG

One of the two formats used on the World Wide Web (WWW). The other is GIF.

Key Light

The main light illuminating a subject.

Kilobyte

1024 bytes. Abbreviated as K or KB.

LCD

Liquid Crystal Display. A type of viewing screen found on digital cameras.

Lens

An optical device capable of both collecting and bending light.

Low-Key Lighting

Lighting that produces results that are dark, heavy, and have few highlights. The term low-key image refers to a photograph that is the result of such lighting.

Marquee

An outline (dotted) that results when you select a portion of an image with one of the image-manipulation applications selection tools.

Megabyte

1024 kilobytes, abbreviated as MB.

Megapixel

1,000,000 pixels. A term used by some digital camera manufacturers to describe their product's ability to capture large amounts of image data.

Memory Stick

A virtually new storage device that at the moment is exclusive to Sony digital cameras and other Sony products.

Mode

Some compact and 35mm SLR cameras have a number of different modes under which they may operate. For instance, a 35mm SLR might possess both an aperture priority mode and a shutter priority mode. In the aperture priority mode the user selects the desired aperture and the camera automatically sets the shutter speed. The reverse applies in shutter priority mode. Some cameras have a program mode where both the shutter speed and aperture settings are calculated automatically.

Monochrome

In real terms this means single color. However, in photography the term is used to denote black-and-white film or prints.

Motor Drive

A device, either built-in or attached to a camera, that automatically advances the frame once an exposure is made. Some models allow for rapid firing of frames (up to 10 frames per second). On some cameras the motor drive will automatically rewind the film after the last frame has been exposed.

Negative

Developed film where the image highlights (light areas) and shadows are reversed. When projected onto photographic paper and developed this is reversed and the final image is comparable to the original scene.

Negative Film

Film that, when processed, will produce a negative (see Negative)

Opening Up
A photographic term used to describe the adjustment of an aperture to allow more light to pass through (lower f-stop). The opposite of closing down.

Overexposure
This occurs when film, imaging sensor, or photographic paper is either exposed to too much light or for too long a period, or a combination of both.

Parallax Error
A problem that occurs in compact cameras (but not 35mm SLRs) where what the camera user sees through the viewfinder is not exactly what is recorded. Compact camera manufacturers usually provide parallax error lines in the viewfinder to help in countering this problem. Short distances (less than 2 meters) may make this assistance redundant.

PCMCIA Card
Storage device used in some digital cameras. Most often simply called a PC Card.

Perspective
The use of various elements in a photograph to portray an impression of depth. Elements that can be used include lines that converge, differences in scale, and changes of tone.

Pixel
The basic building block of an image. The word pixel is a derivative of picture element.

Positive
A photographic image, normally either a print or slide, that reflects the scene as originally viewed.

PPI
Pixels per inch. A term used to define image resolution, which measures an image in the number of pixels per linear inch. The higher the ppi, the better the image.

Program Mode
See Mode.

Red Eye
The effect created when a flashgun illuminates the blood in a subject's eyes, and as a result turns them red.

Reflector
Any apparatus that is used to collect light and redirect it to another area. In photography, reflectors are used to lessen shadows within an image.

Resampling
Refers to the process of either adding or deleting pixels from an image.

Resolution
Refers to the number of pixels per linear inch in a digital image. In general, the higher the resolution, the better the image. Resolution can refer to digital images, printers, scanners, and computer screens.

RGB
Stands for red, green, blue—the standard color model for digital images.

Sharpening
Using an image manipulation application to apply an image-correction filter to a digital image that will create the appearance of sharper focus.

Sharpness
A photographic term used to describe image clarity, which is affected by the accuracy of focus, lack of movement within the subject, and contrast.

Shutter
A device that is used to control the amount of time light is allowed to strike the film.

Shutter Priority
See Mode.

Shutter Speed

The amount of time a shutter stays open and allows light to fall on the sensor. Shutter speeds are mainly expressed in fractions of a second starting at perhaps 1/2000 of a second and ending at 1, 2, 3, or 4 seconds. Each shutter speed setting represents either a doubling or halving of the time that the light is allowed to fall on the film. For instance, if you change the shutter speed from 1/250 to 1/125 of a second, you double the amount of time that the light is allowed to fall on the film. Conversely if you change the shutter speed from 1/250 to 1/500 of a second, you halve the amount of time light is allowed to fall on the film.

Slave Unit

A small electronic device that when attached to a stand-alone flashgun will automatically fire it at the same instant as the primary flash is fired.

Slide Film

A film type that produces slides that are intended for projection. Sometimes called transparency film.

Slow Film

A film that, due to its low light sensitivity, will require more exposure than a fast or medium film.

SLR (Single Lens Reflex)

A camera system that allows the photographer to see the subject by means of light passing through the lens and being reflected, via the mirror, to the viewfinder in the pentaprism. When the shutter is fired the mirror flies up and allows the light passing through the lens to strike the sensor.

SmartMedia

Another type of removable memory card used to store images in digital cameras.

TIFF

Tagged Image File Format—a way to store digital images without compression and possible image degradation.

Time Exposure

A term designating an exposure time that is considered long (normally longer than one second).

Transparency

See Slide Film

TTL (Through the Lens)

A metering system that measures the actual light that passes through the lens. Normally found only on 35mm SLR digital and film cameras.

TWAIN

Computer software that allows digital cameras and scanners to link directly with image-editing applications.

Underexposure

The result achieved when you either allow too little light to reach the sensor, or allow it to fall on the sensor for too short a time, or a combination of both.

Unsharp Mask

A function of scanner and image-editing applications that creates the appearance of a sharply focused digital image. See Sharpening.

Uploading

The transmission of data (files) from another computer device.

White Balance (WB)

The adjustment of a digital camera to compensate for the type of light that illuminates the subject being photographed. For instance, the correct white balance setting can remove the green color cast that results from photographing a subject under fluorescent lights.

Kookaburra Balloon, Canowrinda, NSW Australia

Index

A

AC adaptor port 27
Adobe Photoshop 12, 15, 106, 108, 110, 112, 116, 117, 118, 144
AE/AF lock button 45
AF (autofocus) 29, 43
AF (autofocus) start button 45
African impalas 140
Allied War Graves 151
Aperture 49, 50, 122
Aperture selection ring 50
Aperture setting 54, 131
Archival life 105
Archival life inks 105
Arch of Constantine 144
Auto bracketing button 43
Auto levels 111
Autumn 137

B

Background 110, 155
Background layer 110, 112, 114
Basic digital compact camera 23
Batteries and cold weather 97
Battery chamber 97
Battery failure 96
Battery leakage 97
Blank frame 75
Blooming 11
Blower brush 85
Bounce flash 78
Bounce reflector 69
Bracketing 130
Bright, cloudless days 136
Brightness 114
Brightness/contrast controls 111
B setting 138
Bubble jet 105
Bubble-jet printer 104
Built-in flash 24, 29
Built-in self-timers 86

Burning 106
Burst facility 10

C

Cable release 86, 138
Calculating flash exposure manually 73
Calibrating a monitor 106
Camera cases 83
Camera shake 51, 94, 95, 123
Camera shake warning light 52
Camera straps 83, 98
Canon Powershot Digital Ixus 28
CCD 13, 39, 48, 49, 131
CCD chip 11
CD burner 92
CD-R 92
CD-ROM 102
CD-RW 92
Center-weighted metering 128
Center-weighted metering system 126
Central Park 146
Charge-coupled device 11
Cleaning cloth 84
Cleaning your camera and lenses 98
Click drive 90
Close down 57
Close-up button 26
CMOS 13, 48, 49, 131
CMOS chip 11
Color balance 116
Color cast 76
Color channels 12
Color correction filters 89
Colosseum 144
Command dial 36
Command lock/menu button 45
Compact cameras 53
Compact camera with built-in flash 72
Compact flash 33, 37, 90, 91, 102
Compact flash card 18, 19
Compact flash card reader 91
Complementary metal-oxide semiconductor 11
Composition 144, 147
Computer noise 11

Golden Gate Dawn, San Francisco, USA

Acknowledgments

Some bright spark once said that things are easier the second time around. I would like to meet that genius and explain to him or her the error of this thinking, at least in respect to writing easy-to-understand books on photography, especially digital photography.

However, it seems that I got there, but not without considerable assistance from a diverse group of knowledgeable people who were unstinting with their time, knowledge, and advice.

I need to thank these people from the bottom of my heart. If I inadvertently miss anyone, my heartfelt apologies.

For their photographic talents:

Steve Hlavenka
Tina Jaworski
Izzy Perko
Warrrewyk Williams
Owen Wilson
Maxwell Optical Industries Pty Limited
Canon Australia Pty Limited
Epson Australia Pty Limited
Hanimex Pty Limited

Not only was their photographic talent appreciated but their advice and technical assistance was greatly valued.

For their technical talents:

The staff of Fletchers Fotographics in Sydney, especially Mark Queenan, Warrewyr Williams, and Anthony Edwards.

John Swainston, Kim Delprado, and the staff of Maxwell Optical Industries Pty Limited

Ian Thresher, Stuart Poignand, and the staff of Canon Australia Pty Limited

Andreas Johansson and the staff of Epson Australia Pty Limited

David Bevan and the staff of Hanimex Pty Limited

Matthew Green and the staff of L C Matthews & Associates Pty Limited

Guy and Lyn Parsons

For their artistic talents:

Mark Swadling
Bret Cullen

For their faith:

Andrew Dent
Jim Hasson
Bob Leitch
John Rowe
Judy Rowe
Barbara Santangelo
Michael Santangelo

And last, but certainly not least:

My long-suffering family (especially my wife) for putting up with the (by now usual) chaos that surrounded the production of this book.

Bill Corbett
December 1, 2000